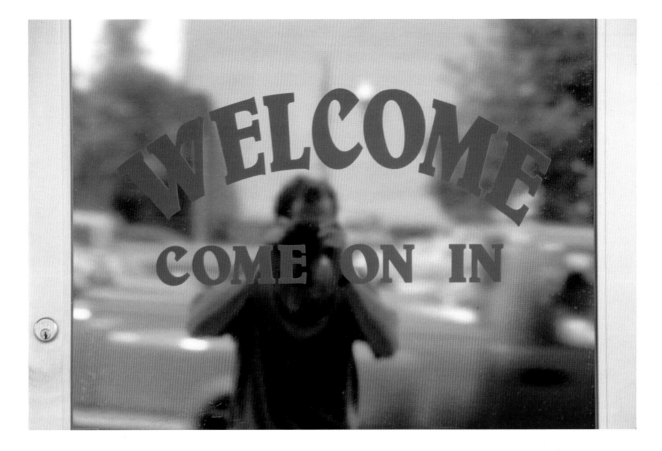

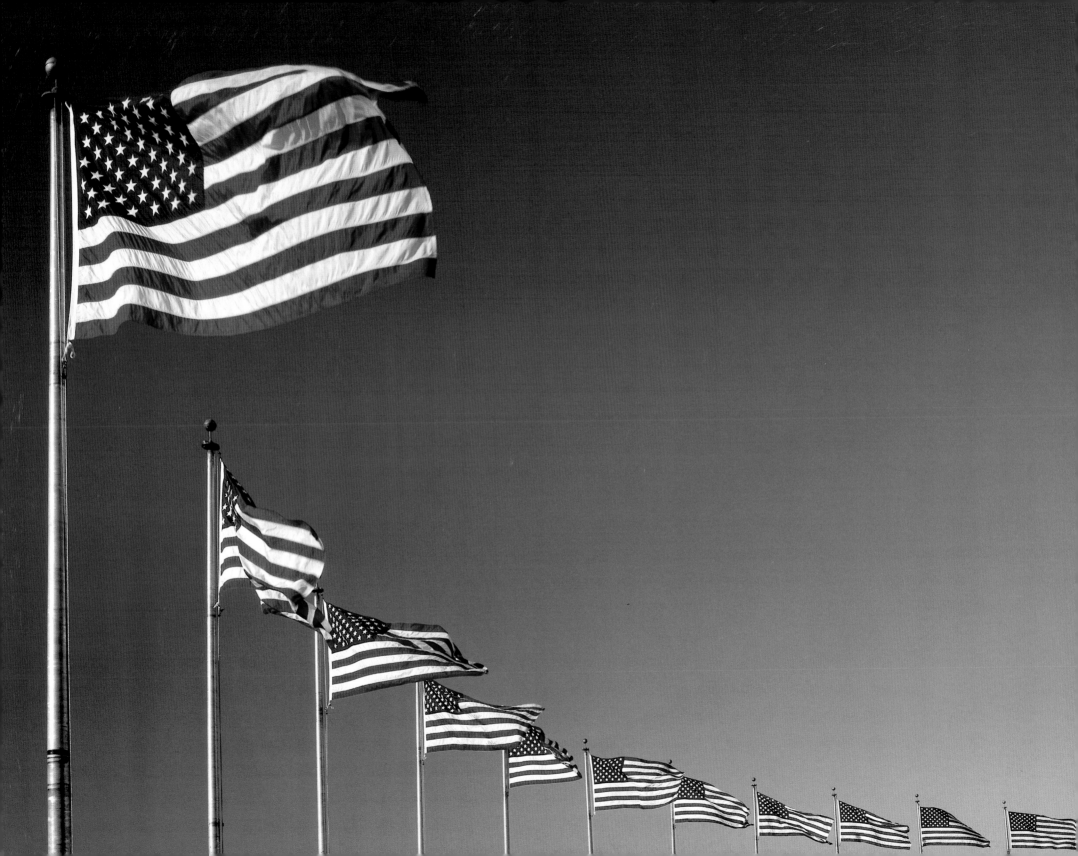

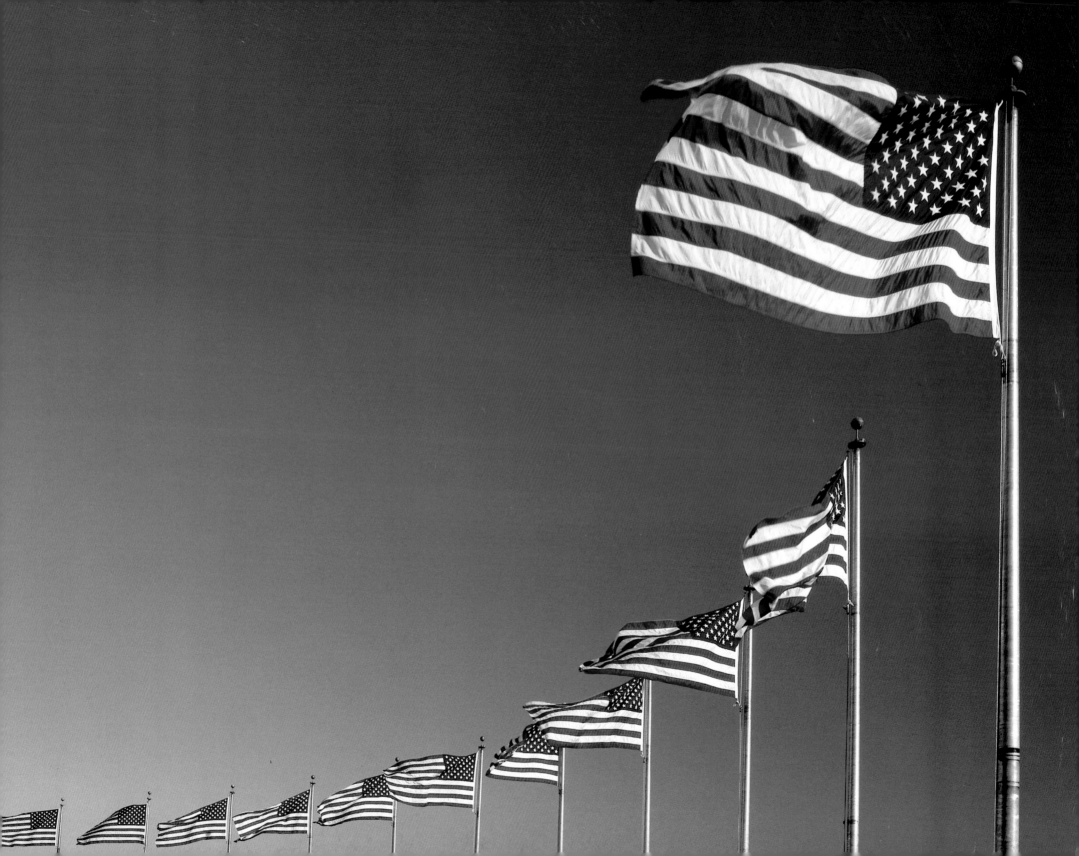

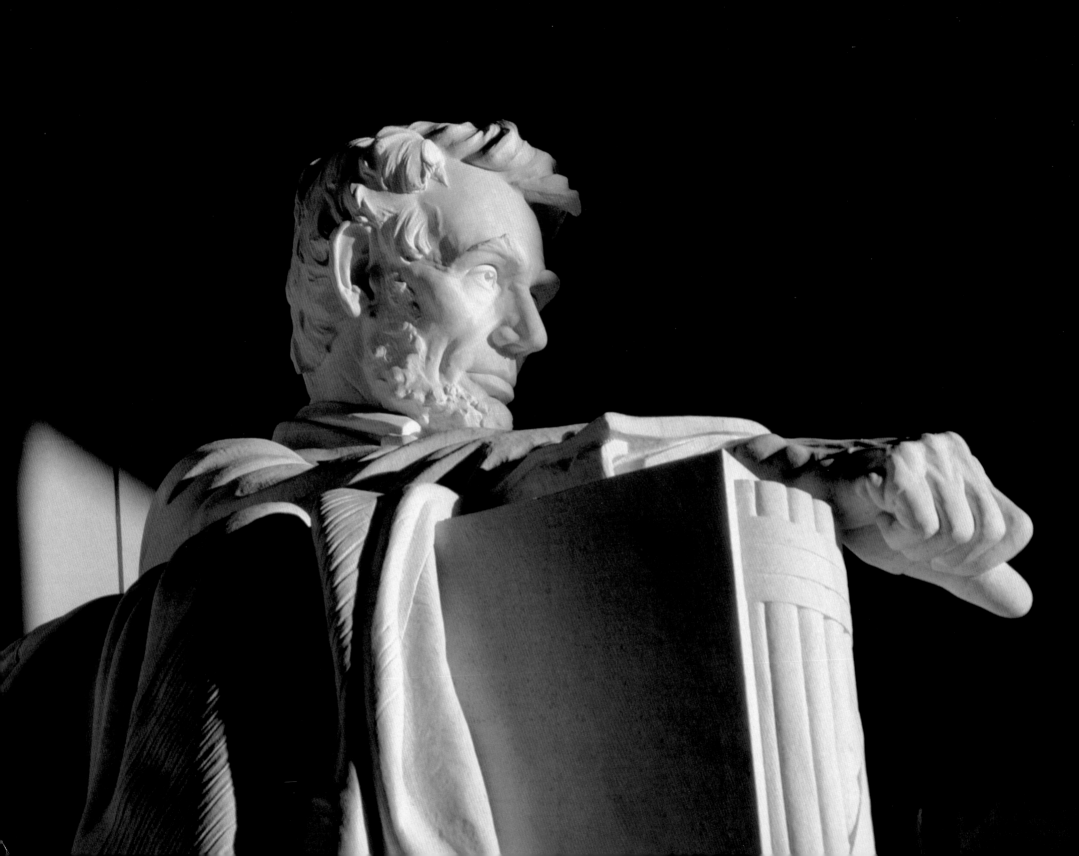

AMERICAN ICONS

PHOTOGRAPHS BY STEVE GOTTLIEB

ROBERTS RINEHART PUBLISHERS

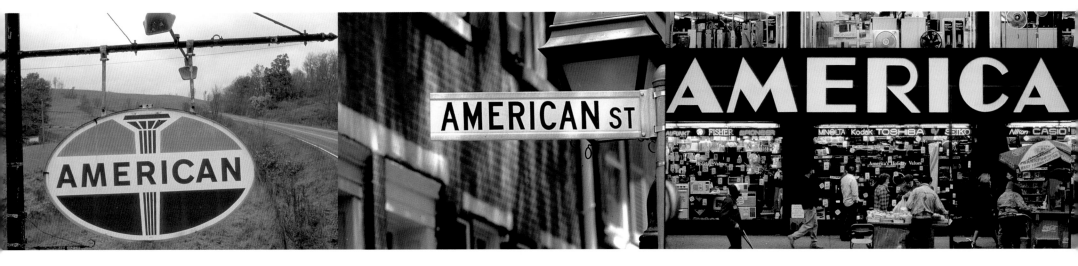

To my sons,
Brian and Jason

American Icons
Photographs and Text ©2001 Steve Gottlieb

Book Design: Steve Gottlieb

Fine art prints and stock usage of images in this book are available.
Direct inquiries to: steve@gottliebphoto.com.

Library of Congress Catalog Card Number 2001087274
International Standard Book Number 1-57098-401-8

ROBERTS RINEHART PUBLISHERS
An imprint of Madison Books
4720 Boston Way
Lanham, MD 20706

Distributed by
NATIONAL BOOK NETWORK
1-800-462-6420 ˋ

INTRODUCTION 11

MAIN STREET, USA 15

METROPOLIS 31

HIGHWAYS & BYWAYS 45

GRAND LANDSCAPES 59

THE OLD WEST 77

THAT'S ENTERTAINMENT 91

THE SPORTING LIFE 105

AMERICA'S PALATE 121

ARCHITECTURAL TAPESTRY 135

WAR & REMEMBRANCE 149

SYMBOLS OF FREEDOM 161

Introduction

For more than twenty-five years I've been photographing things that symbolize our country. National Parks and famous landmarks; Main Street and Wall Street; classic American faces. If it felt authentically American, I've always wanted to see it and, because I love camera as well as country, to photograph it. By virtue of history, nostalgia, culture, and physical splendor, many of these subjects have become completely ingrained in my psyche. They are what I have come to refer to as my "American Icons."

My "icon odyssey" began long before I became a professional photographer. On a 1974 cross-country trip, I caught Yellowstone National Park's Old Faithful Geyser erupting. From 1975 to 1984, when I practiced law in Washington, D.C., I photographed the Lincoln and Jefferson Memorials and the White House. On out-of-town business trips—with my Nikon and two lenses hidden under the legal papers in my attaché case—I photographed the Rocky Mountains and a San Francisco cable car. In 1985, when I changed careers and became a professional photographer, my interest in capturing America's icons on film continued, except now my efforts were part of my work, not a respite from it.

It would be a fascinating challenge, I thought, to create a book devoted exclusively to the most quintessential American symbols and so I developed a list of more than one hundred subjects, my icons "hit parade" you might call it. The list included only contemporary icons, those that are active in my consciousness and part of everyday life. Historical artifacts—the Model T Ford, a steam locomotive, "Whites Only/Colored Only" signs—were excluded. So were famous people; they're covered exhaustively elsewhere. I had already taken shots of more than twenty subjects on that list. I decided that between commercial assignments I would attempt to photograph the remainder.

Completing this icons treasure hunt took years—it's a big country when you're not flying over it—and I confess up front that I missed a few items. I hired a plane so I could photograph Churchill Downs during the Kentucky Derby but it rained that day; a visit to the colorful Albuquerque Hot Air Balloon Festival was cancelled because of problems with an assistant; and so on. Moreover, some subjects on my list had to be sacrificed on the altar of book length: no Barbie doll or G.I Joe; no comic books or peanut butter. (It particularly grieves me that I was unable to include a picture of three women at Graceland, each with deeply expressive faces and gestures, sadly contemplating Elvis Presley's grave.) Still, to my mind, all the truly essential subjects are

contained here.

I'm often asked which of the places I've been is my favorite. That's an obvious question to put to someone who's been to all fifty states, but quite honestly it's not one I can answer. Visiting our nation's grand and famous places—from topographical wonders to cities to great structures—was a thrill, each and every one. At least as memorable have been the people I've met: from the young Italian-American tossing pizza dough in Parkersburg, West Virginia, to Arco, Idaho's Sheriff Van Etten; from the cowboys on "Happy" Shahan's ranch in Bracketville, Texas to the proud, weather-beaten Cherokee Indian sitting by the Oconaluftee River of North Carolina. My interaction with these people was often brief—in some cases few words were exchanged—but each person became, at least for a moment, my intimate partner in gathering icon gold. Each person and each location has made this an extraordinary adventure, and it is with considerable regret that I now bring this saga to an end.

Back when I labored as a lawyer, working largely in the arenas of litigation and politics, it was easy to develop a cynical impression of Americans as a people in constant conflict. Individuals and groups seemed forever battling over issues large and petty. (That impression was, and still is, powerfully reinforced by media coverage.) But to judge Americans from that perspective would be like judging the institution of marriage by watching divorce court. Of course, no one would deny that in this vast nation of 280 million people you can find many differences—regional, religious, racial, ethnic, cultural, political, economic. Still, we Americans are bound together powerfully by common history, economic system, culture, tastes, values and shared physical space. These strong threads of national identity that bind us together are tied, in significant part, to those shared symbols which, over the course of time, have taken on the status of "icons." Our icons are the tangible forms that define much of what makes an American an American; photographing them has given me an exhilarating opportunity to celebrate our national cohesiveness. When I began this book project, I thought of it simply as a collection of pictures. It evolved into a kind of personal love letter to my country.

In closing, let me say that as to what icons have been included or excluded, my rationale is simple: I've responded with my heart, my eye and my own sense of which symbols are most distinctively American. Far from making this a purely personal and even idiosyncratic book, I suspect that my specific choices underscore how much we Americans have in common. There is, I feel certain, a universality to the symbols I have selected for this book. If I am right, then *my* icons are *our* icons.

*　　　　*　　　　*　　　　*

I want to acknowledge the cadre of friends and colleagues,

small in number but large in impact, whose support, advice and encouragement helped sustain and guide me. To all my assistants over the years, most especially John Skowronski and Mark Zaccheo, who were wonderful companions on the road; to my children Brian and Jason, who provided significant input and general support; to Dusty Doster, whose early encouragement gave me confidence to pursue my idea; to Yustin Wallrapp, who kept me plugging away during fair weather and foul; to Mike Travis, who provided essential input on layout, and legendary graphic designer Lou Dorfsman, who reviewed my book design efforts; to Efrat Zalishnick, whose unerring eye and computer wizardry were invaluable in the massive pre-press effort; to Elise Caputo, photographer's rep par excellence, who kept my commercial work flowing so I had the wherewithal to devote time to this book; and to Rick Rinehart of Roberts Rinehart, who is this author's idea of the ideal publisher. My enduring thanks to each of these friends.

Finally, I also want to express my gratitude to those many, many Americans all across the country who lent a hand, a prop, a face; who gave directions, location ideas or a meal; who shared a story or a laugh. (In brief notes concluding each chapter, I've tried to capture the flavor of some of those interactions.) I wish I'd had the time to linger longer with so many of the wonderful folks who made me feel at home wherever I was but, alas, I continually had to push on in search of the next icon. What most stays in my mind about my personal encounters is that the vast majority of people looked for ways to say "yes." Yes, I can get you access to that place. Yes, I'll find someone to pose in the picture. Yes, I can stay after closing and help you out. Yes, I'll draw you a map to where you're going. My thanks to each of you. You have made my icon odyssey joyous and memorable.

Steve Gottlieb

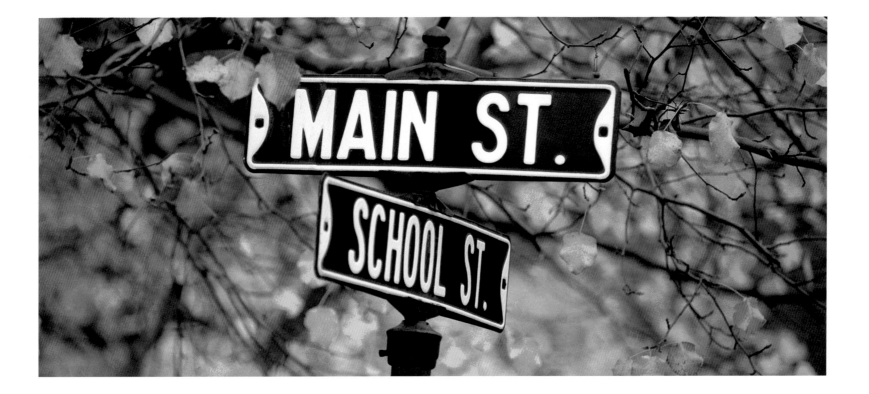

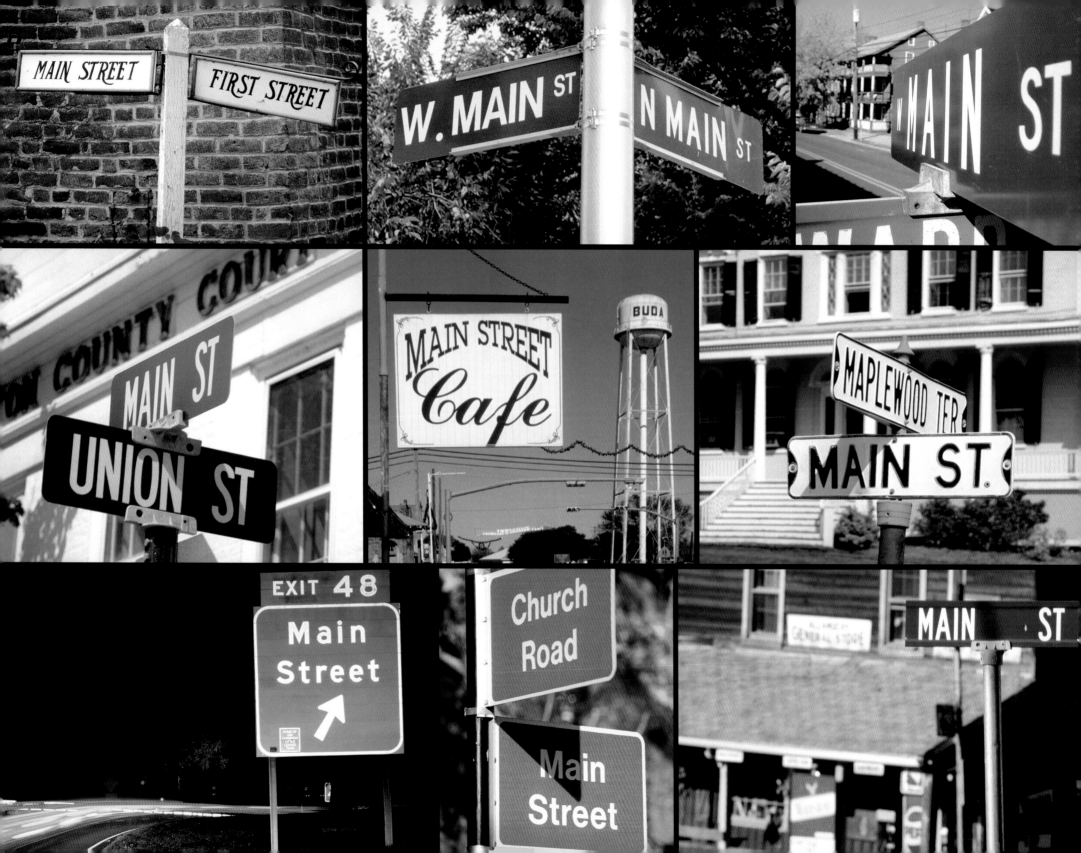

It was inconceivable that a nation so firmly attached to small-town ideals, so dedicated in its fantasies to small-town notions, could not have somewhere built one perfect place....In this timeless place Bing Crosby would be the priest, Jimmy Stewart the mayor, Fred MacMurray the high-school principal, Henry Fonda a Quaker farmer, Walter Brennan would run the gas station, a boyish Mickey Rooney would deliver groceries, and somewhere at an open window, Deanna Durbin would sing.

Bill Bryson, *The Lost Continent: Travels in Small-Town America*

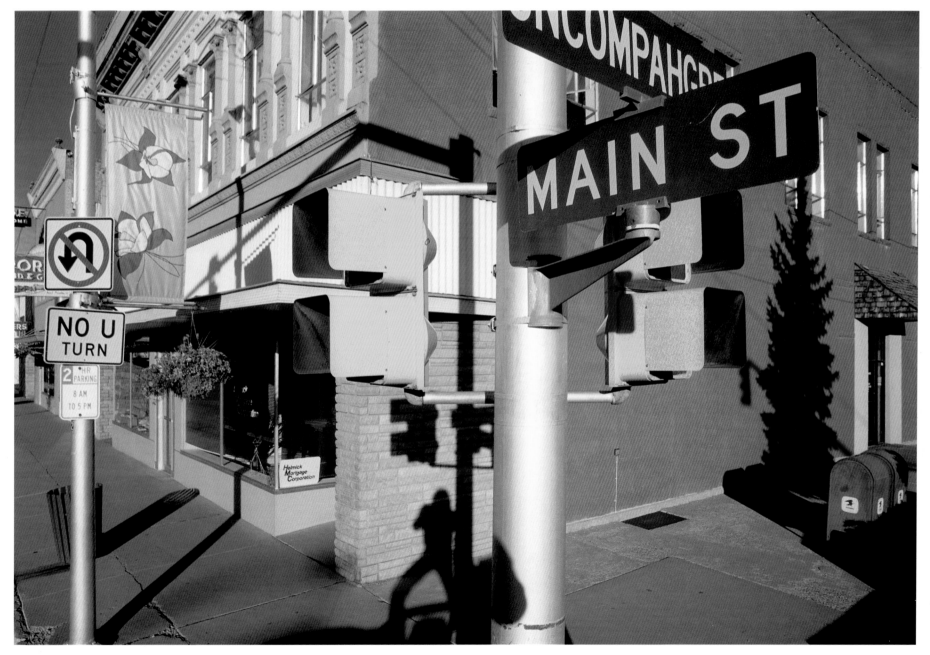

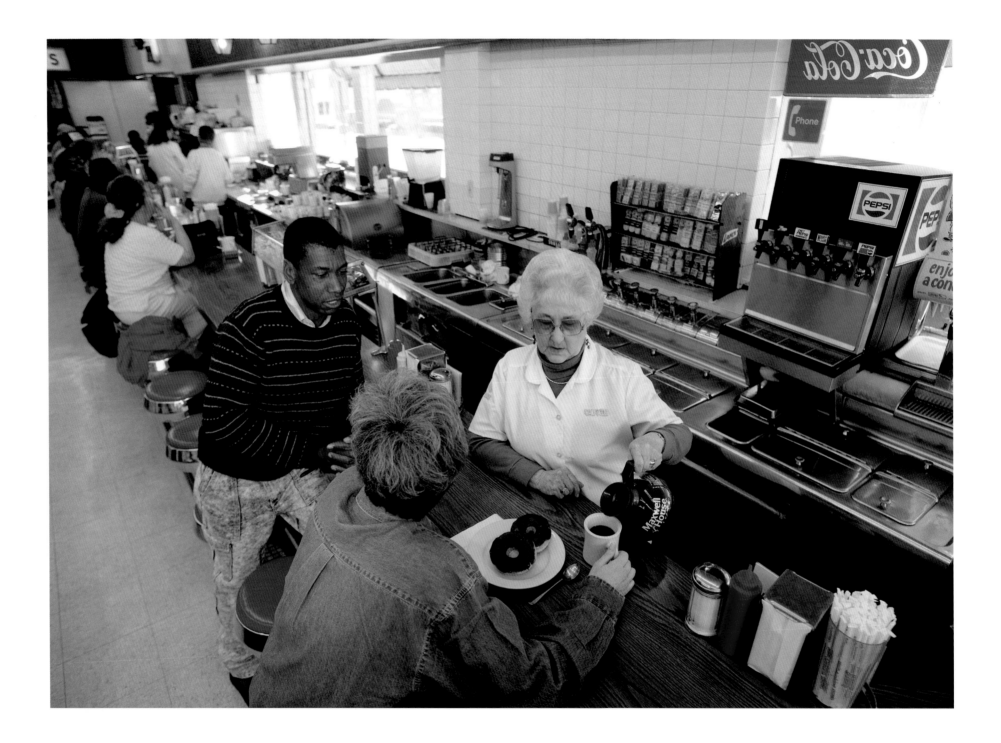

18 Culpepper, Virginia

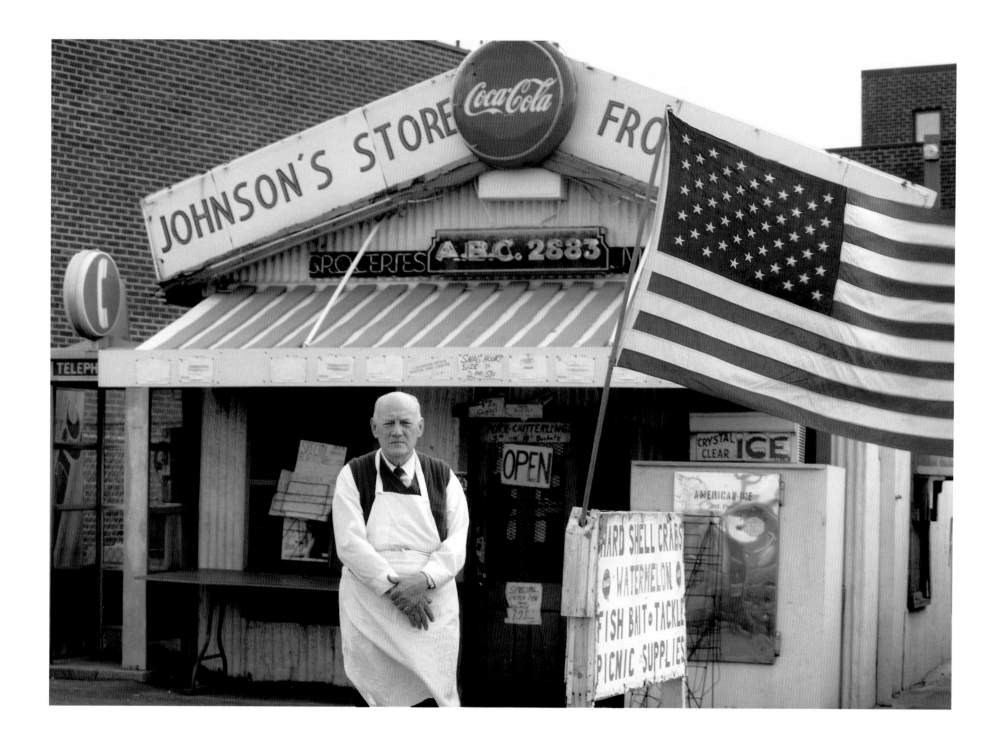

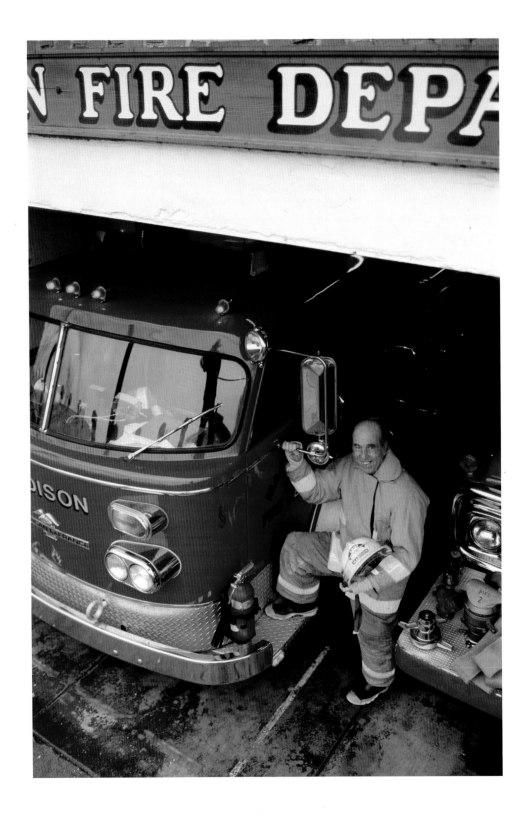

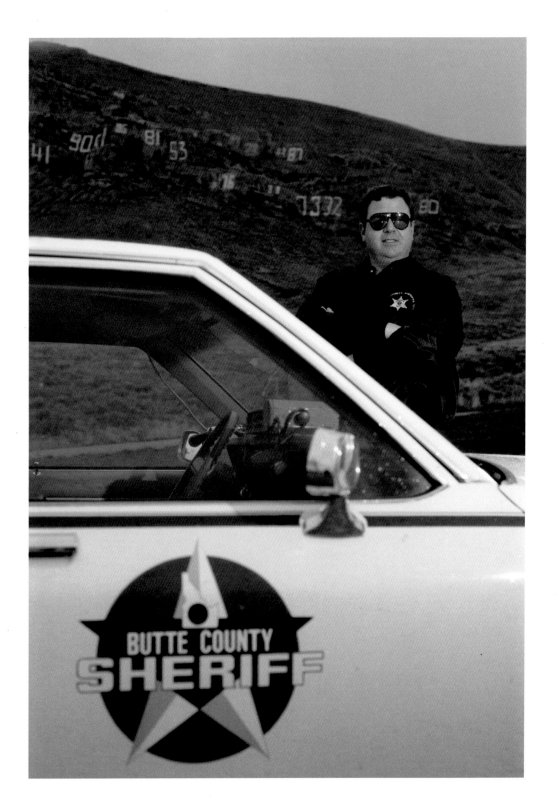

You sure you want to photograph me?
I don't much look like a real sheriff.
 Cary Van Etten, Butte County Sheriff

[Independence Day]...ought to be solemnized with pomp and parade, with shows, games, sports, guns, bells, bonfires, and illuminations, from one end of this continent to the other, from this time forward forevermore.

John Adams, 1776

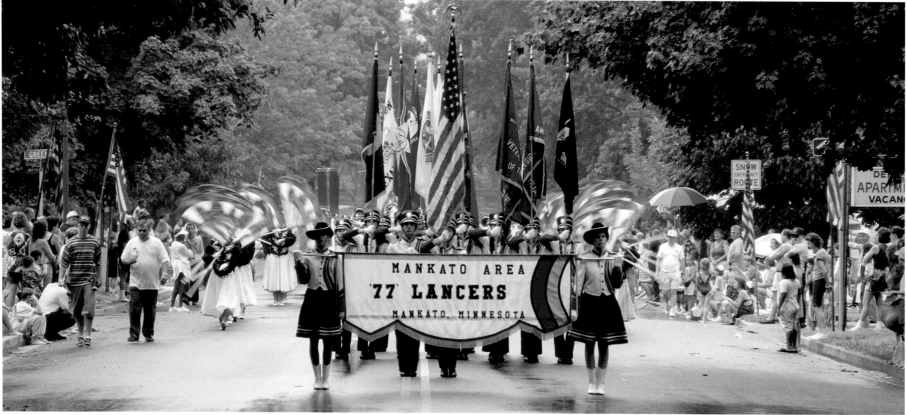

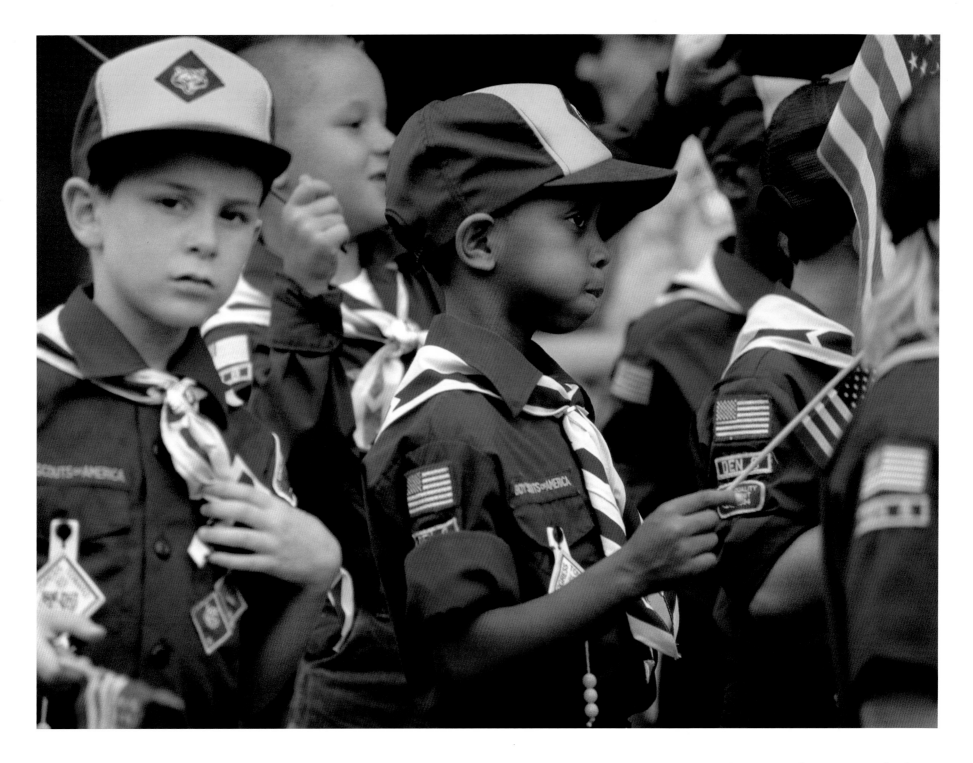

Religious faith is not a storm cellar to which men and women can flee for refuge from the storms of life. It is instead, an inner spiritual strength which enables them to face those storms with hope and serenity.

Senator Sam Ervin

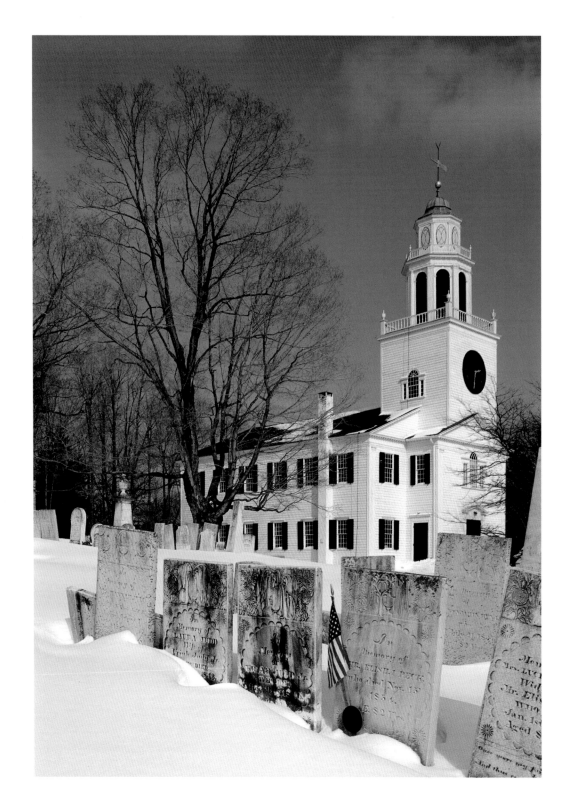

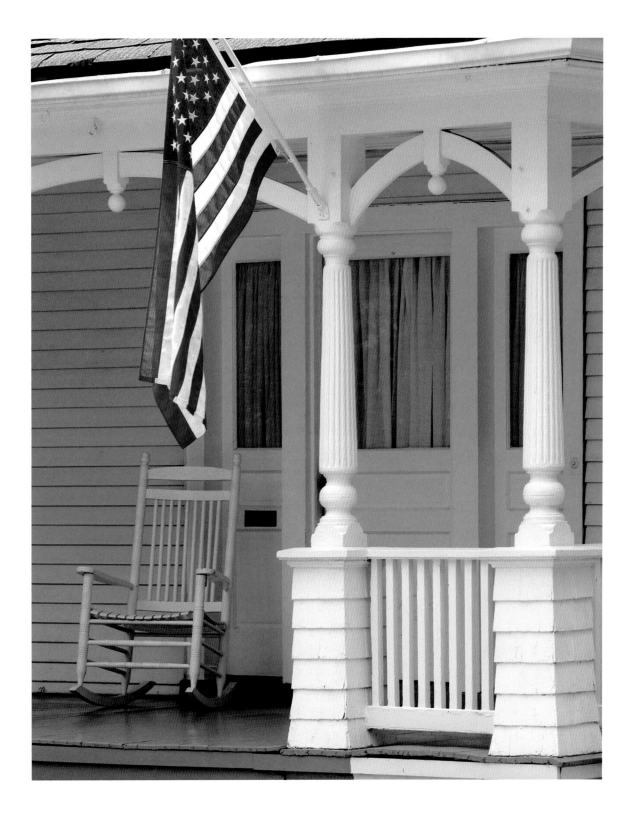

Everyone has, I think, in some quiet corner of his mind, an ideal home waiting to become a reality.

Paige Rense

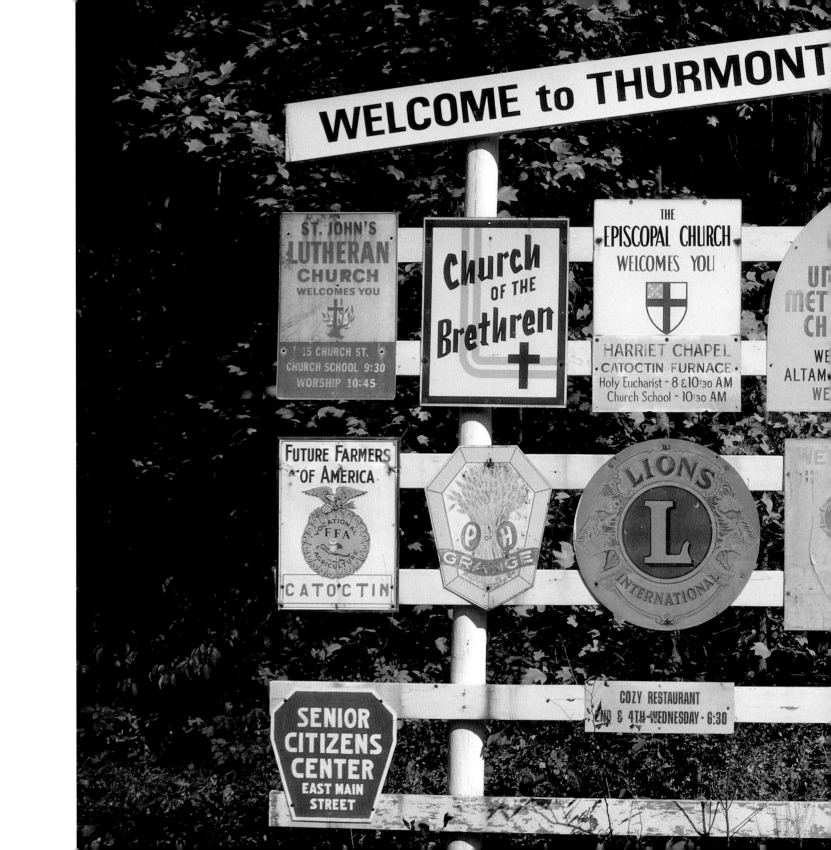

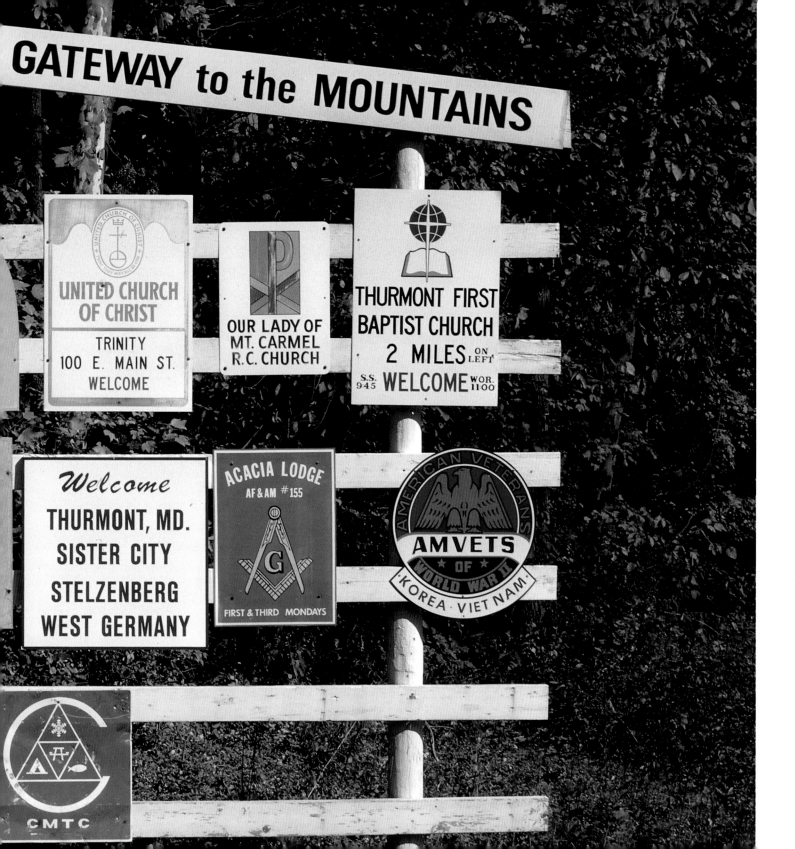

MAIN STREET

Every town's got one. Sometimes it goes by the name First Street or State Street or Central Avenue or Broadway, but mostly it's called what it is: Main Street. Before the advent of the shopping mall, it was the center of commerce and the primary place where people congregated. In many towns it still retains much of that quality.

Main Street refers not only to a physical place but a state of mind. It's synonymous with our nation's small towns, where "real" Americans live, where positive values are intact and national virtues shine. It's where everyone knows one another, and mutual support is a guiding principle. It's America at its best, or perhaps its most idealized. It's where, after a rough month in the big city, I often think about moving.

I've driven along literally hundreds of Main Streets, and stopped on a great many. I've accumulated quite a number of Main Street sign photos along the way, including Clifton, Virginia (15) and Waterford, Virginia, Thurmont and Ellicott City; Maryland, Goshen, New York, East Haddam, Connecticut, Manchester, Vermont, and Buda, Texas (16). In Montrose, Colorado, I was virtually the only soul up and about one early Sunday morning, so I parked right in the middle of a traffic lane and, undisturbed, took a shot from my van roof, my telltale crouch evident in my shadow on the wall (17).

Beyond the colorful signs, I've tried to capture some of the colorful fixtures of Main Street life, starting with the general store. Because of some powerful childhood memories, I confess to being particularly sentimental when I'm in one, meandering through aisles containing food and fishing gear, clothes and ammunition, chain saws and table cloths. The general store on p. 23 was an anachronism, surviving in the Washington, D.C. suburb of Alexandria, Virginia. When an incredulous Mr. Johnson came out to ask why I was photographing his humble, even rickety, store he obliged me with this unaffected pose. When Mr. Johnson died several years later, his daughter called me (she had seen the picture published) and asked for a large print as a remembrance. "That's exactly what he looked like," she said. With the passing of Mr. Johnson, so did his store.

Just down the street from the general store, you might find the luncheonette. To a person like me who grew up in the 1960s, lunch counters weren't simply fixtures of Main Street, they were the focus of memorable Civil Rights confrontations in the South. It was a common sight on television news to see Black Americans denied service and often intimidated when they tried to order food. Consequently, it was especially poignant when I was photographing a lunch counter in Culpepper, Virginia, and a young black man entered; without a trace of discomfort, he struck up a conversation with the waitress (named "Cutie"–check the rhinestone brooch), her customer and me, and offered to participate in the picture (18). Prejudice still exists, of course, but that moment symbolized to me the extraordinary progress our nation has made over the past generation.

Firemen and policemen are central figures on Main Street. Though my photographs of them were taken more than two thousand miles apart, I think of them as a matched pair. In both cases, I entered town late in the afternoon, as drizzle was verging on rain and daylight was quickly fading. In Madison, Georgia, a woman from the Chamber of Commerce spotted me photographing–what else–a Main Street sign. When she introduced herself, I asked if the town had a classic-looking firehouse. Without hesitation, she brought me to her office, made a phone call, then sent me to meet the town manager who, in turn, introduced me to the volunteer fire chief (who had to take a break from his job at the bank); he in turn called one of his volunteer firemen to be my subject (20). All this took place in the space of about thirty minutes and without a hint of rush or inconvenience. In similar fashion, the deputy sheriff of Arco, Idaho used her walkie-talkie to call in the sheriff to meet me. The sheriff demurred at first–he thought one of his deputies might cut a more sheriff-like

figure—but upon my reassurance we drove together to the outskirts of town, where he posed in front of "Numbers Mountain," where high school graduates have painted their graduating class years on rock faces for six decades (21). In taking these two portraits it struck me that both subjects posed with the naturalness and patience of professional models. Most Americans, even those along the smallest Main Streets, are so accustomed to the camera that we are relatively at ease in its presence.

On many a Main Street, the most enduring and memorable ritual is the Independence Day parade held every Fourth of July. No parade could have a more American flavor than the one in the quaint (but not cutesy) Chesapeake Bay town of Havre de Grace, Maryland. With marching bands arriving from as far away as Mankato, Minnesota, the marchers and spectators (about equal in number) seemed intimately connected, and a mid-parade downpour dampened spirits not at all (22), though it slowed things up: the cub scouts had a long wait before joining the procession (23).

At the center of every New England town, no matter how small, is a white church, often two or three, with a steeple that often becomes visible long before you can see the town itself. In the shadow of the steeple you will usually find a small cemetery with gravestones dating back as far as the Revolutionary War era (24).

Lined up on Main Street just beyond the town center are generally some of the town's finer homes, often sporting a flag and sometimes a rocking chair on their porches. This photo (25), I must confess, was actually *not* one of them. In fact, on a commercial assignment to find and photograph such a stereotypical house, I scouted dozens of Main Streets and hundreds of houses, from Winchester, Virginia to Dover, Delaware, but none comported exactly with the graphic layout for the ad. I ended up adapting a house inside the city limits of Washington, D.C. of all places—propping it with flag, rocker and drapes, and eliminating front yard bushes—to simulate the

classic look we've all seen in our mind's eye a thousand times.

Americans see themselves as rugged individualists, yet we also love to be part of groups. Still, how do you explain that in a typical Main Street town like Thurmont, Maryland (population 3,400), residents can support the many different religious and fraternal organizations posted on the outskirts of town? (26-7) I'm being candid, not cute, when I say that one day I might well move to Main Street and find out.

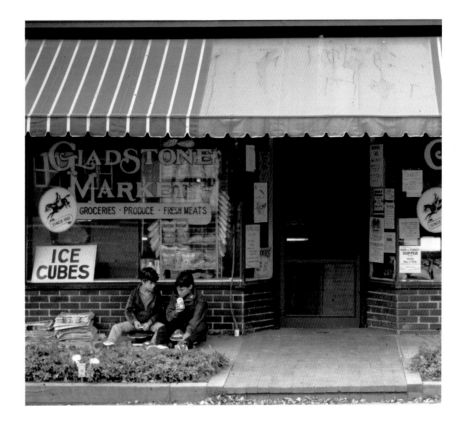

METROPOLIS

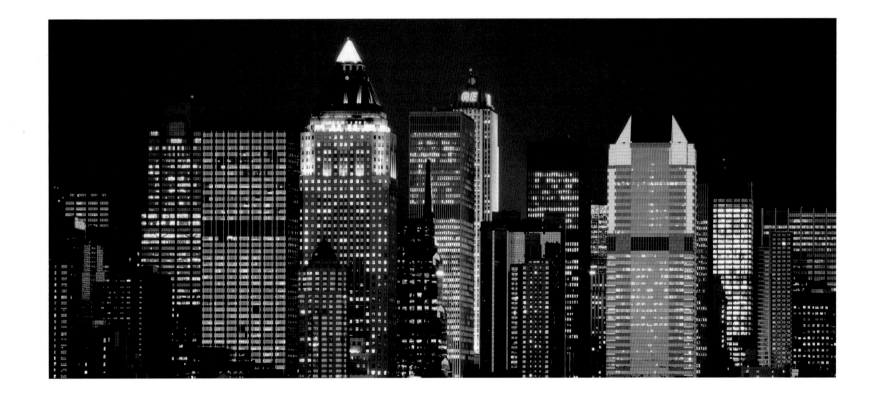

I look across the river...to see range upon range of towers, racing upwards to a chaotic variety of heights, yet so compressed as to make an orderly form out of the chaos.

Lord Kinross, *The Innocents as Home*

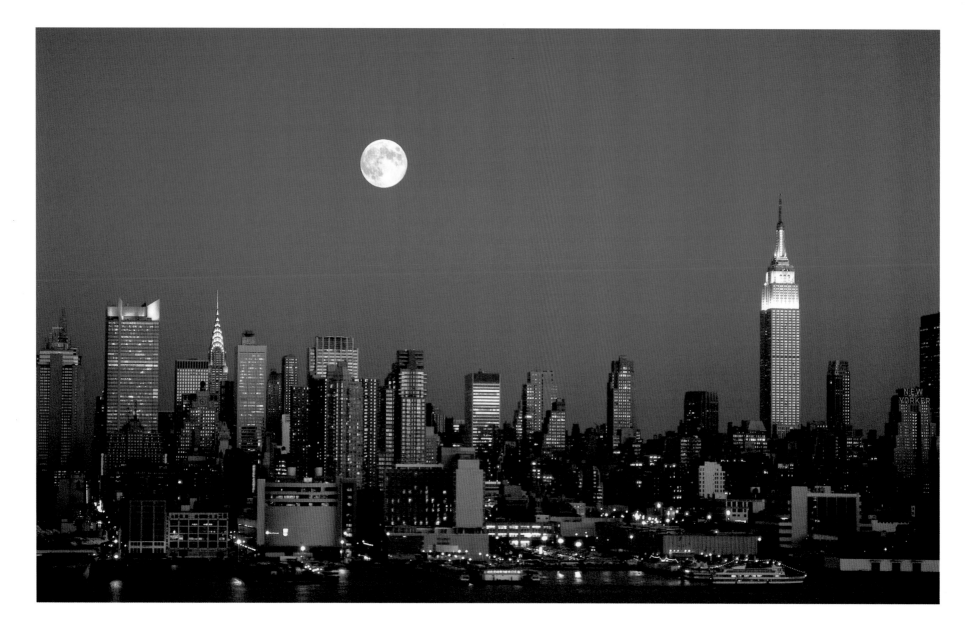

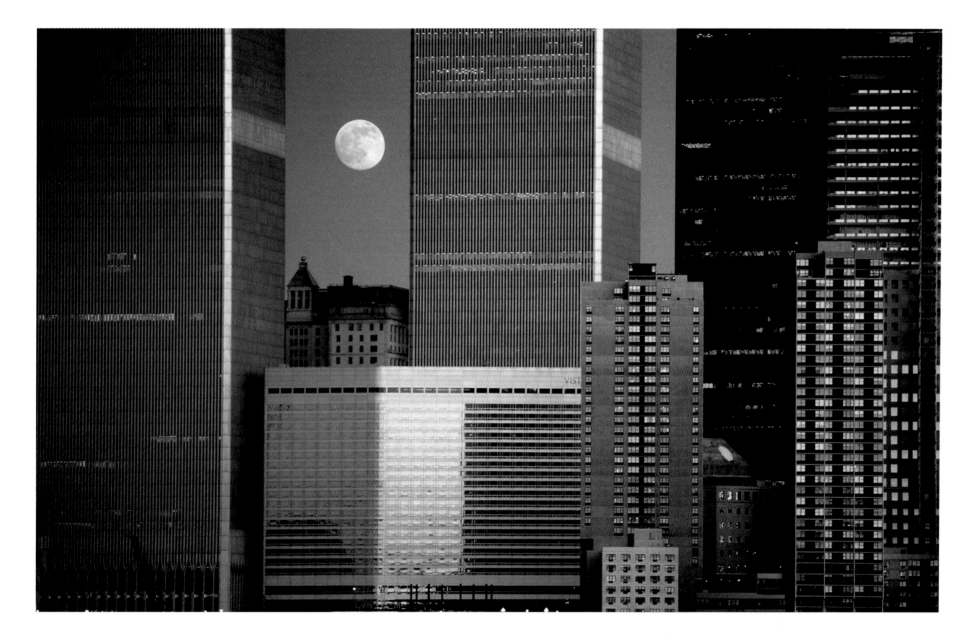

New York City, Financial District 33

I know of no country, indeed, where the love of money has taken stronger hold on the affections of men.

Alexis De Tocqueville, 1835

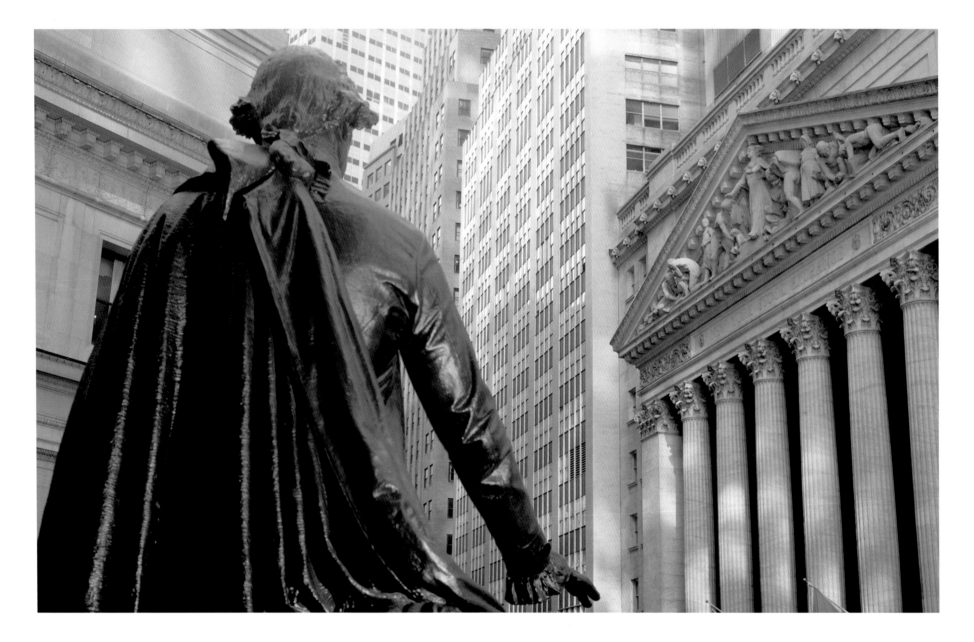

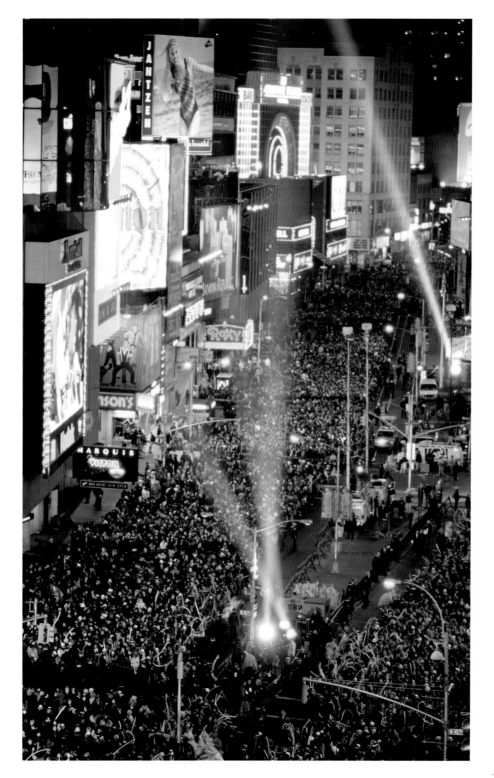

In October, 1871, the booming city, already boasting a population of almost a third of a million people, burned level in one of the major catastrophes of the century. But that proved an incentive rather than a deterrent. Within less than a decade the city was not only rebuilt, but greatly enlarged....in a few years it would initiate contributions to American architecture that were in some ways greater than those of any other contemporary city, as its skyscraper structures would so proudly testify.

G.E. Kidder Smith, *Architecture in America*

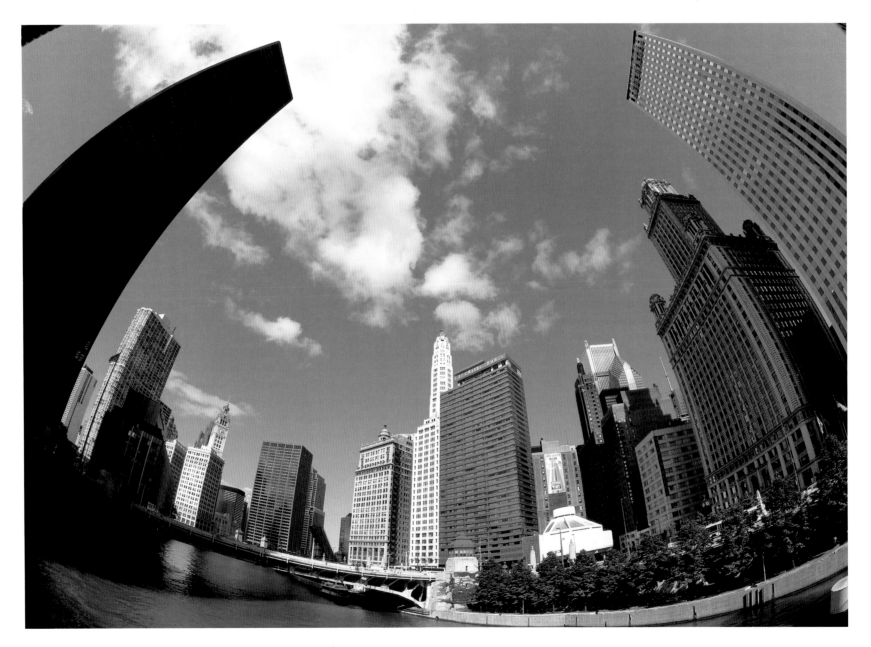

We have the urge to soar great distances with our new materials and to reach upward and outward. In a way, this is man's desire to conquer gravity.

Eero Saarinen, Architect of the St. Louis Arch

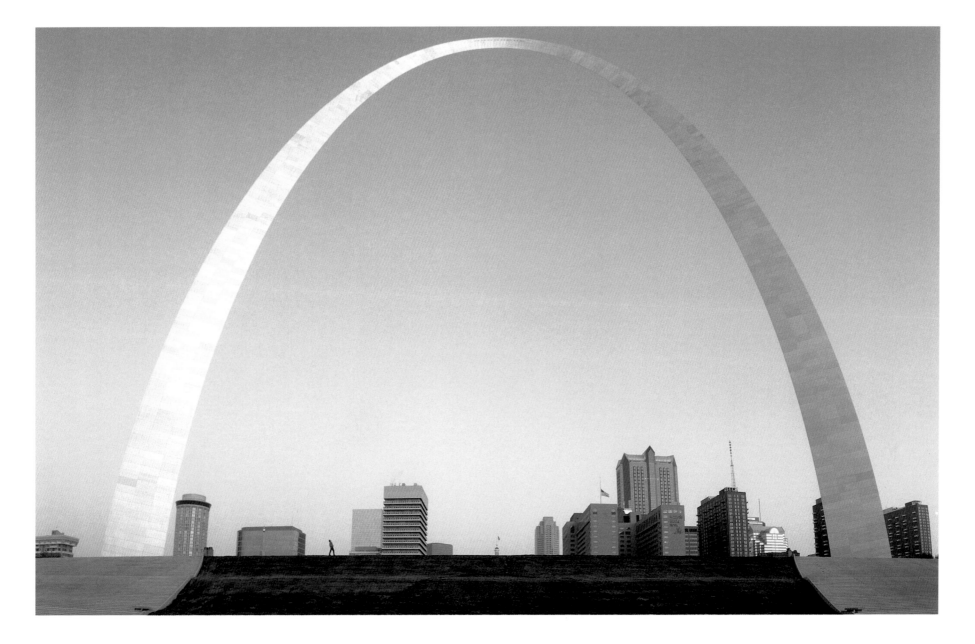

The completed work, when constructed in accordance with my designs, will not only be the greatest bridge in existence, but will be the greatest engineering work of the continent, and of the age.

John Roebling, Proposal for the Brooklyn Bridge, 1867

The second longest single span bridge on the planet...has become the absolute symbol of San Francisco. For over sixty years it's pure, red-orange silhouette has soared above the green, ocher and blue waters of the bay, withstanding seismic tremors, high winds and increasingly dense traffic.

Knopf Guide: San Francisco

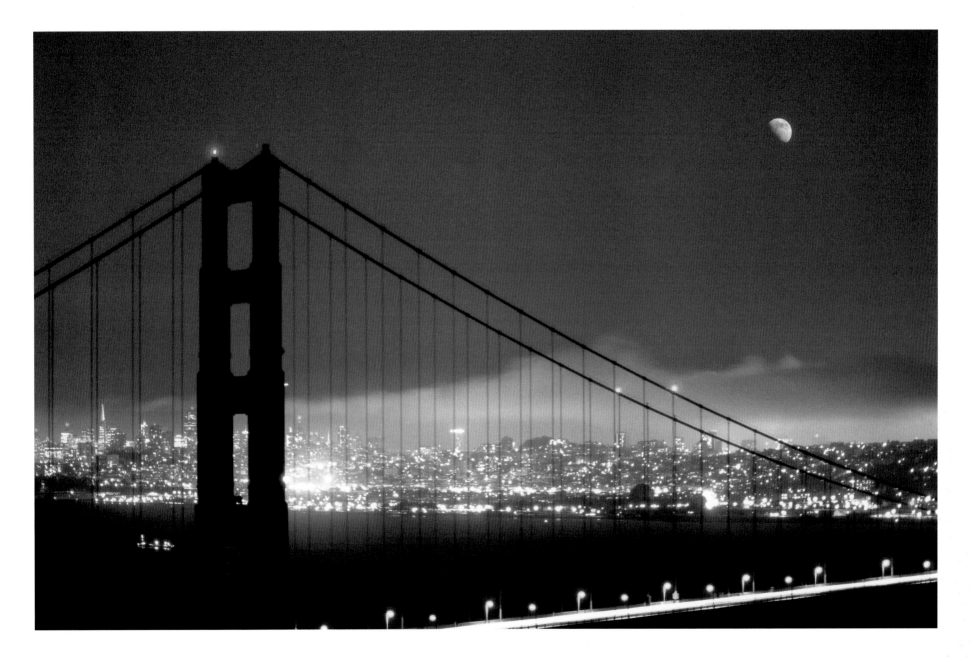

World's Tallest Buildings: Metropolitan Life (1909), Woolworth (1913), Chrysler (1930), Empire State (1931), World Trade Center (1972) and Sears Tower (1973).

William Van Allen, designer of the Chrysler Building, was accused of being the Ziegfeld of his profession....His virtuoso performance was a building stunt. In 1930, he hid the "vertex" or "pike" of the Chrysler's top inside its summit until the builders of a downtown rival in height had complacently topped off their building. Then he lifted the shiny steeple through the top and took possession, for a little while, of the title of the world's tallest building.

Phil Patton, Made in USA

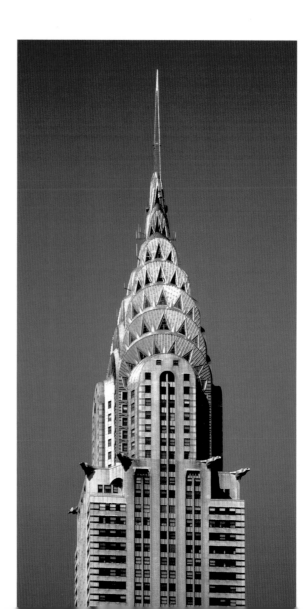

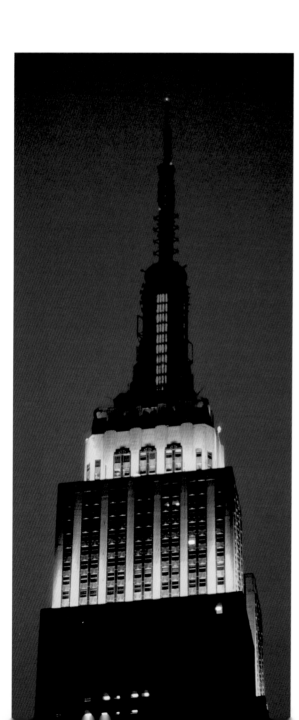
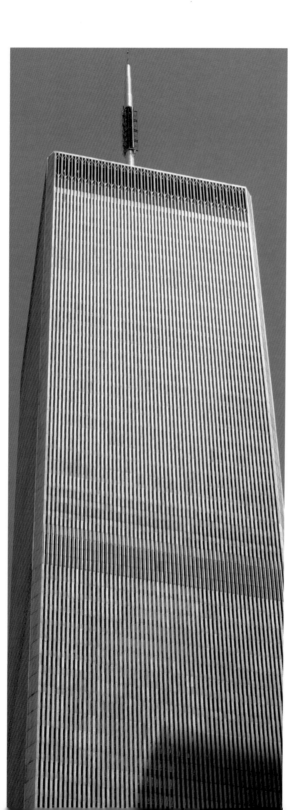
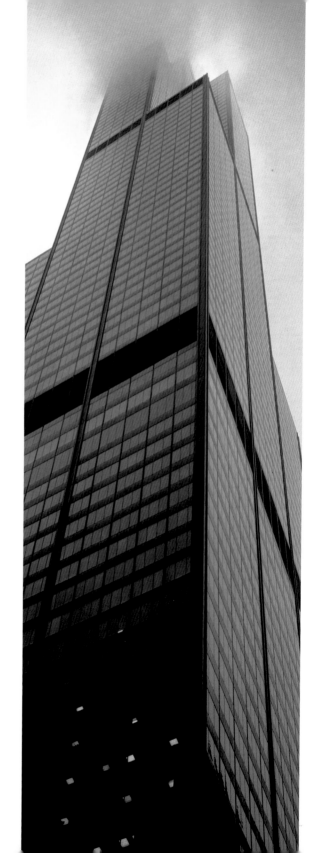

METROPOLIS

No, not the city where Clark Kent and Lois Lane are reporters for the Daily Planet. We're talking about big cities here, where millions of us live, rub shoulders, do business, get stuck in traffic. Main Street may be where America's idealized spirit resides, but our bodies are far more likely to live in and around our big cities. I've divided most of my adult life between two of them, New York City and Washington, D.C., but have spent time in every major city in the country.

Our most prominent metropolis—home to a disproportionate number of icons (found in other chapters as well as this one)—is New York City or, more specifically, the island of Manhattan, the heart of the city. For starters, there is the skyline, so vast it is best encompassed in separate photos, each taken from across the Hudson River in New Jersey. There is midtown, from the Empire State building north to the West 60s (32) and then there is the financial district in lower Manhattan, where the moon sits between the two massive World Trade Center towers (33). Yet another view is the chapter opener (31), a tight view of the West Side of Midtown, shot with a lush sunset over my shoulder reflecting in the skyscrapers.

Amidst the claustrophobic megaliths of the downtown financial district is a narrow road that runs just a few short blocks, yet which is famous the world over: Wall Street. There you will find the New York Stock Exchange, being "watched" by a statue of George Washington, standing (with his hand out metaphorically on a bible) on the spot where he was inaugurated as President in 1789 (34). If you make a right turn off Wall Street and go up Broadway for four miles you'll arrive at Times Square, once a notoriously seedy and tawdry section of the asphalt jungle, now renovated to become a business, tourist and entertainment hub, as well as the billboard capital of the universe. Every New Year's Eve, crowds of more than half a million patiently stand for hours awaiting the drop of a large ball of lights and a torrent of confetti which marks the beginning of the new year (35). As no entertainment is provided for this immense captive audience, I deem it the nation's largest non-event. Incidentally, I live just six blocks from Times Square. Whenever I have a hankering to feel absolutely anonymous, get buffeted by crowds, hawked at by street merchants and generally overwhelmed by sensory input, I need only take a short walk. Just the same, when friends come to town, I take them first to Times Square—it's so brazenly "over the top."

New York is filled with famous and fabulous architecture, but its buildings are so tall and compact it's hard to get a really good look at them. (When I receive a commercial assignment to photograph one, the challenge is less the photography itself than finding a suitable vantage point from which to shoot.) In fact, if you watch New Yorkers go about their business, it's rare to see them crane their necks upward to take in the architecture. If you're inclined to enjoy great urban architecture—produced by many of our most distinguished architects it should be noted—then go to Chicago, where you can generally get far enough back to see it comfortably. My favorite view of Chicago's famous Loop is from one of the many bridges over the Chicago River, whose waters were mighty green that day due to the St. Patrick Day celebration (36). (To capture the full sweep of buildings required the use of a fisheye lens.)

And now for some of the individual iconic structures within the American metropolis, beginning with the St. Louis Arch (37), the world's tallest monument. (The Washington Monument would pass under it easily; for scale, note the person looking up from directly underneath.) Designed by Eero Saarinen to symbolize St. Louis as the "gateway to the West," it is a breathtaking subject for the eye and the camera from most any angle. (I generally find elementary designs the most memorable.) I photographed it looking eastward, back toward the St. Louis skyline.

Two of our nation's bridges can fairly compete with the Arch for

photogenic quality, and naturally both are very special favorites of photographers. The Brooklyn Bridge (38), with its famously elaborate cables and massive stone trusses, was designed before the automobile age with a wonderful wide walkway down its center, providing a perfect vantage point for taking photographs. The Golden Gate Bridge (39) is renowned not just for its beautiful design but because it joins one of our most photogenic cities at one end with the spectacular Marin Headlands at the other, with fog constantly moving in and out for breathtaking atmospheric effects.

The preeminent symbol of the American metropolis is the skyscraper, an American invention. These behemoths are not an essential component of a city–witness Washington, D.C., a large metropolitan area with not a single skyscrapers–but, with that one exception, we have chosen to organize our cities around these massive structures. We like big. Bigger is even better than big. And biggest is best. And how we love to brag that we have the biggest–or tallest or longest or deepest or widest–of one thing or another. We Americans love to stand out, individually and as a nation. Braggadocio and self-congratulation do not get my vote for our most admirable traits–humility and reserve are much better adjuncts to our size, power and influence in my opinion–but be that as it may, the spread on pp. 40-41 is my visual anthem to "biggest," metropolis-wise. Each of these buildings was, when it was built, the tallest in the world. The tallest building today–though there is some debate depending on how one treats pinnacles as opposed to antennas–is located in Malaysia. Another country besting us...what nerve! I have little doubt there is an architect working at this very moment, trying to put the U.S. back on top again.

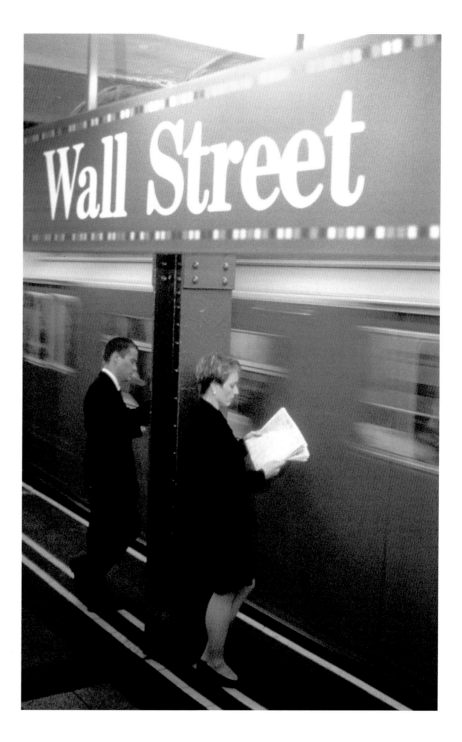

For my part, I travel not to go anywhere, but to go. I travel for travel's sake. The great affair is to move.

Robert Louis Stevenson, 1878

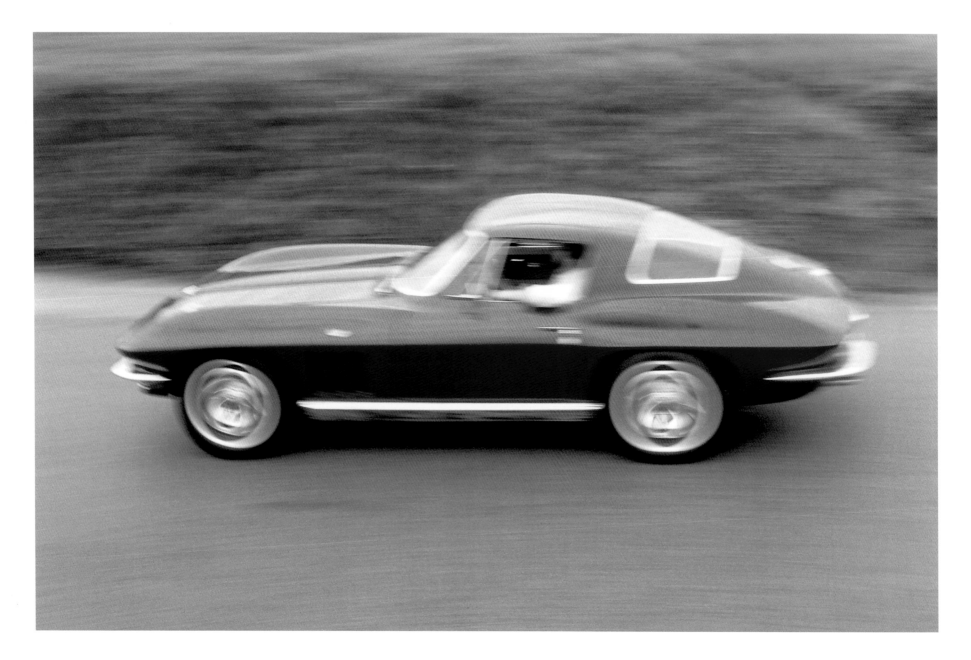

In a car you're always in a compartment, and because you're used to it you don't realize that through that car window everything you see is just more TV. You're a passive observer and it is all moving by you boringly in a frame. On a cycle the frame is gone. You're completely in contact with it all. You're in the scene, not just watching it anymore, and the sense of presence is overwhelming.

Robert Pirsig, *Zen and the Art of Motorcycle Maintenance*

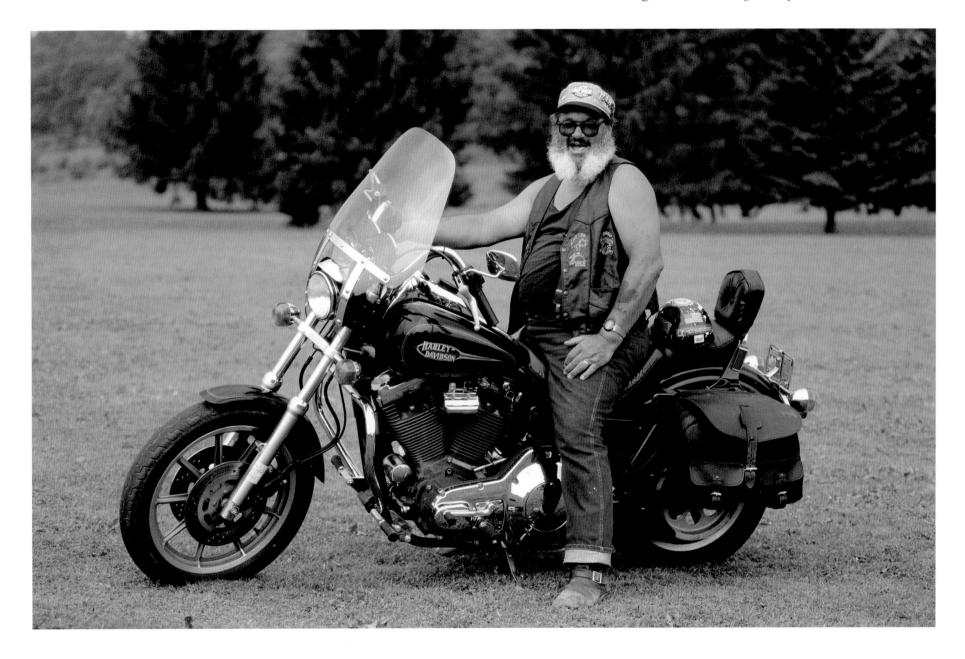

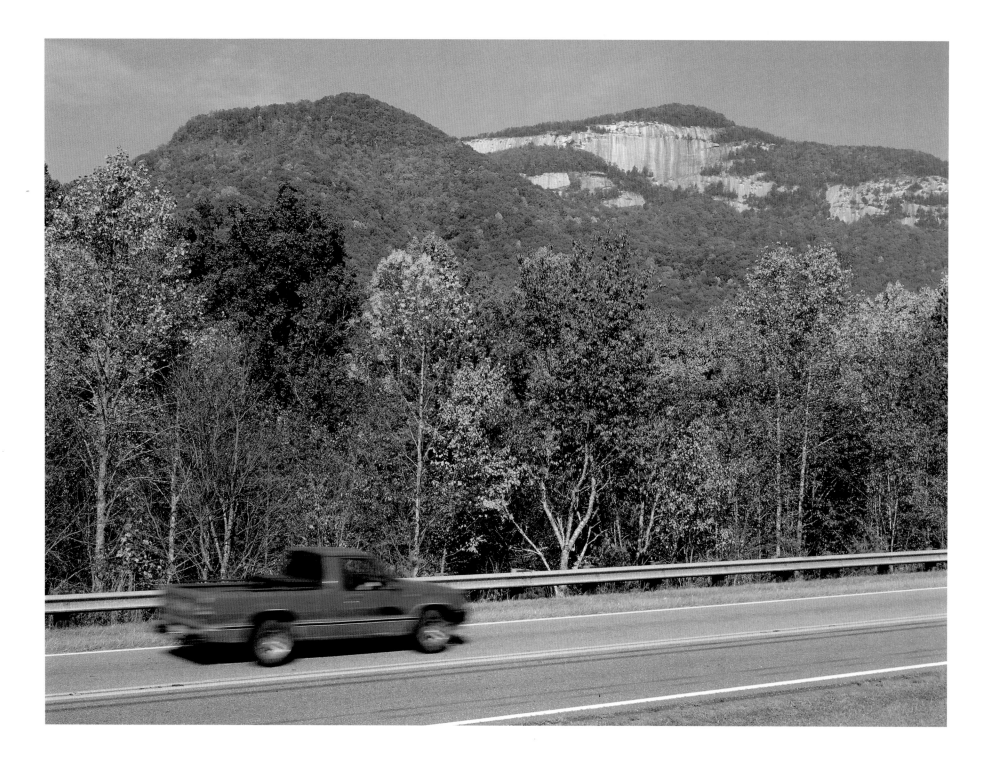

48 Pickens County, South Carolina

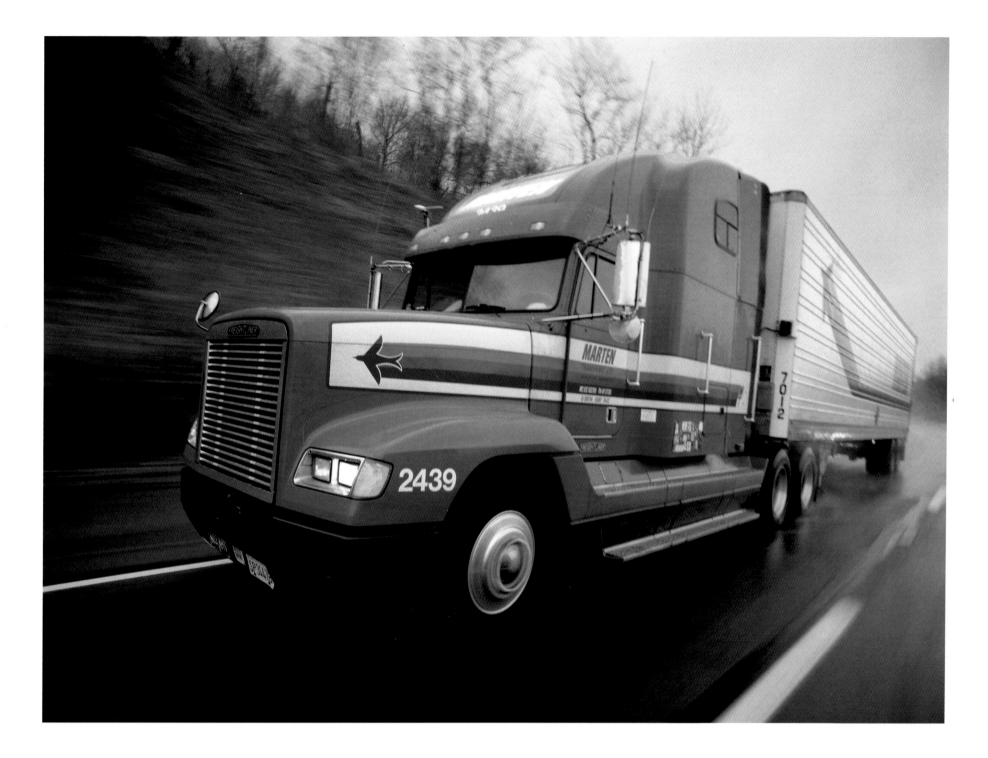

During the whole of their era, steamboats rarely lasted more than five years. By 1849, snags, collisions, fires, groundings, and explosions of poorly tended boilers had sent 520 of them to the bottom. But profits ran high and in that same year 600...worked the river despite all hazards.

Bern Keating, *The Mighty Mississippi*

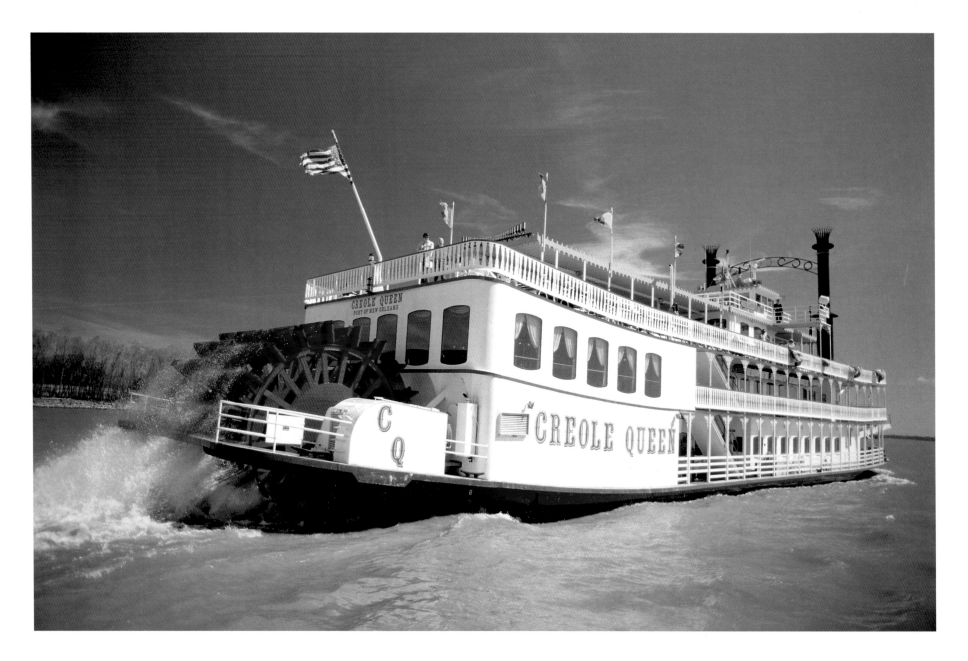

In 1869, Andrew Hallidie saw five horses die on the slopes of Nob Hill, killed by the load they were pulling. This prompted him to work on a system of transport that would be better suited to this city's topography.

Knopf Guide: San Francisco

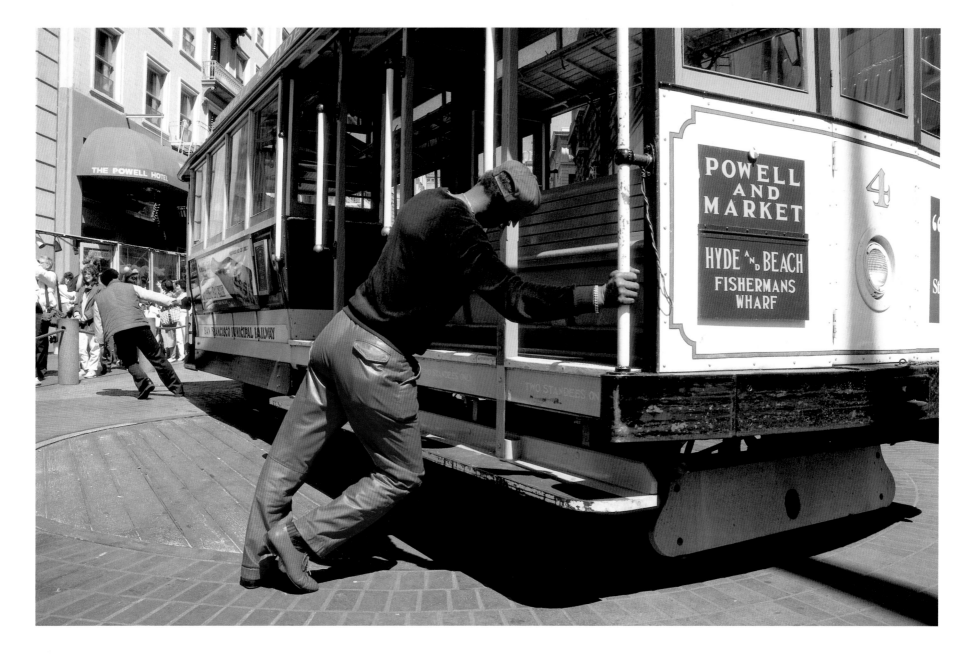

The real and only reason for covered bridges—discounting all tales, theories and legends—was to protect the wooden skeleton and thus preserve the bridge itself....That's all there was to it.

Richard Sanders Allen

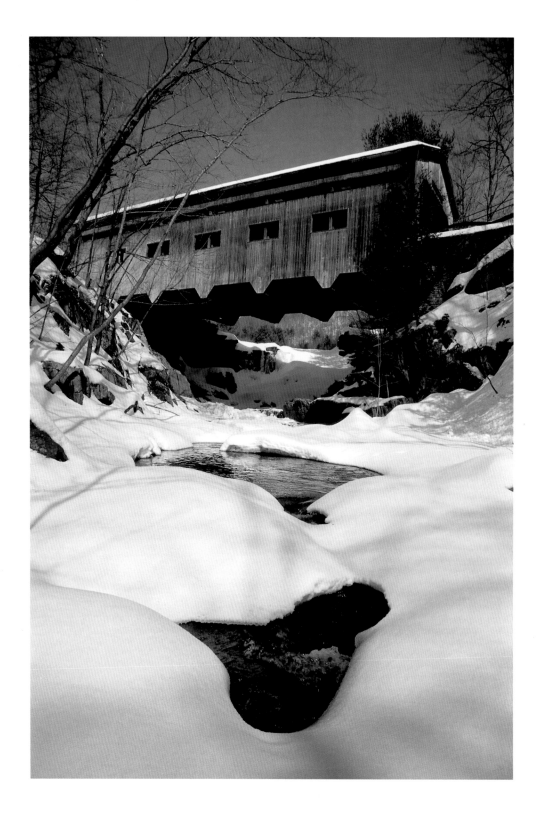

Travelers from around the world flock to this region of SE Pennsylvania to catch a glimpse of the quaint and simple life led by the "plain people," the members of several different religious orders that have been quietly going about their business in this countryside for close to 300 years.

Douglas Root

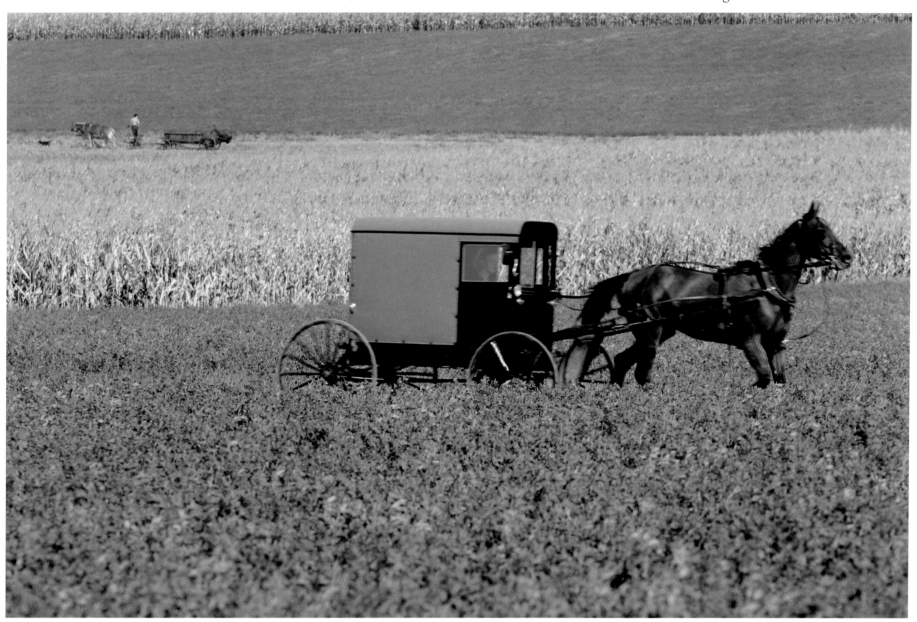

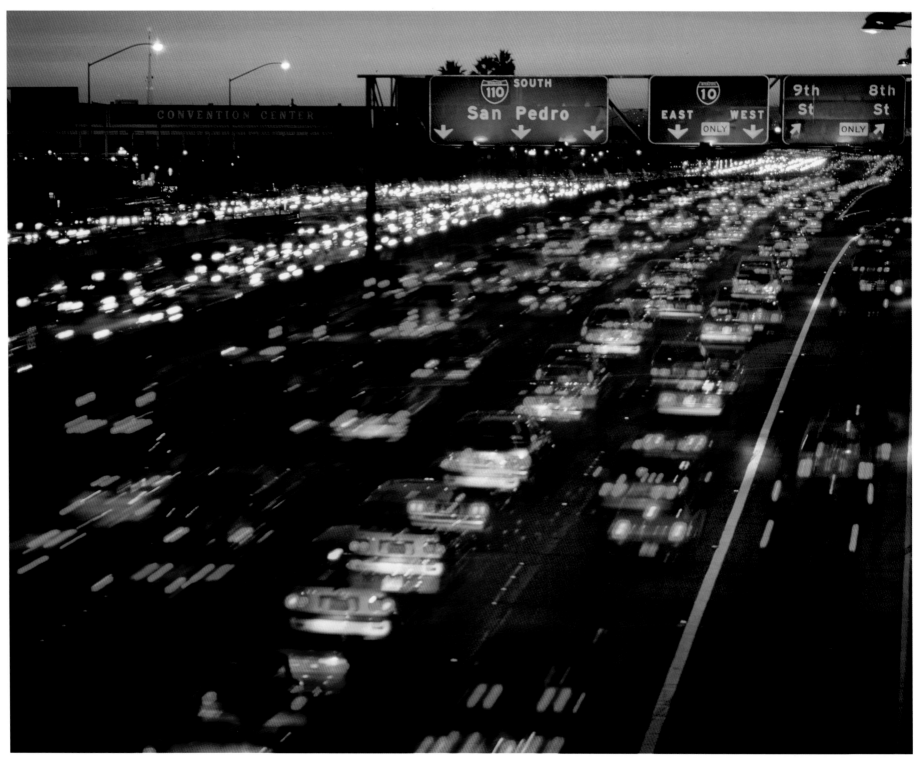

54 Los Angeles, California

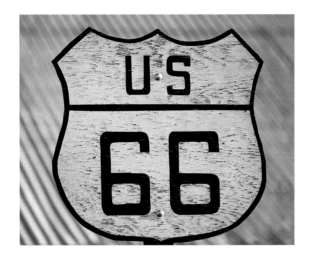

If you ever plan to motor west:
Travel my way, the highway that's the best.
Get your kicks on Route 66!
Bobby Troup, *Route 66* (popular song)

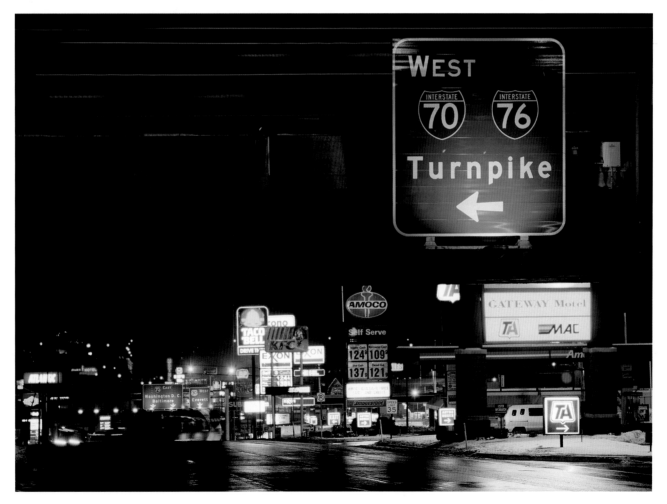

HIGHWAYS & BYWAYS

Americans are forever in motion, an unusually restless people speedily traversing along highways and byways in the automobile, our beloved machine that serves us on multiple levels. It gets us from point A to point B; it provides us with a certain level of comfort en route; and it frequently serves to make a statement, to ourselves and to the world, about who we are…in terms of wealth, power, sexuality, judgment, individuality. Our desire for freedom, adventure, control and speed is often expressed in our choice of cars. Just how important are cars to Americans? I recollect an analysis of the amount of time we devote to them directly or indirectly; if memory serves, the time spent in the car plus the time spent earning money to buy it, fuel it and maintain it, totals over a third of the average person's waking hours.

Our pervasive and enduring love affair with the car is dispersed amongst a wide range of makes and models. No one car can serve as *the* generic icon. The convertible is pure Americana; in the 1950s, cars with tailfins were the rage; early Ford Thunderbirds, which you still see on the road, may well be the most beautifully designed American car; the Jeep is the symbol of American practicality and grit; today, the SUV and the minivan are the hot items. But for distinctiveness, longevity, recognition and sheer impractical romance, you can't beat Chevrolet's Corvette, that stylish American sports car which can sweep you, your passenger and a thimble's worth of luggage along at three times the legal speed limit. Over a span of forty years, "Vette" owners have purchased more than a million vehicles; they are a passionate lot, frequently joining clubs whose members share a reverence for their machine bordering on religious fervor. Wherever you may be in the country, if you need to find a Corvette to pose for the camera, just contact the local club and, presto: a proud owner appears, ready to take his car through the paces which, in this case, was along the road near the Pigeon Point Lighthouse in California (46).

There are clubs in America not just for Corvette owners, but for owners of Saturns and antique roadsters and who knows what other automobiles. Members gather periodically all over the country to revel in one another's company. Such gatherings aren't limited to cars, however. No group seems to collect in such large numbers as the owners of Harley-Davidson motorcycles. I've witnessed the annual Harley gatherings in Sturgis, South Dakota and Wiers Beach, New Hampshire, where for several days the ground under these otherwise quiet towns rumbles to the tune of thousands of engines that seem connected to amplifiers instead of mufflers. It was at a more modestly sized Harley rally in upstate New York that I caught up with this muscle-bound biker with the cherubic smile (47).

The tangible fruits of this nation's great capitalistic economic engine is stuff, all kinds of stuff, which we constantly move from here to there. Our highways and byways overflow with two kinds of stuff-moving vehicles in particular: the pickup truck and the eighteen-wheeler (48,49). I find it hard to comprehend the vast quantity of stuff being moved around and how it finds its way to the right place. Did you ever see the trailer of an eighteen-wheeler with signage that said something like "Aunt Hattie's Cupcakes," and wonder: Just how many million cupcakes are in that trailer and why is it headed toward central Nebraska?

The eighteen-wheeler of the 1800s was the paddle wheeler, a historic relic that has been reborn on the Mississippi and its tributaries as a vehicle favored by tourists and, more notably, gamblers. Some states, anxious for revenue from gambling without the appearance of condoning that "depraved" activity on their soil, have politically finessed their conundrum by restricting the activity to off-shore vehicles. Incidentally, from the vantage point of my chase boat, you get a graphic sense of why they refer to the river as the "Muddy Mississippi" (50). You also get the impression that the river is so large it must be easily navigable, calling to mind Mark Twain's

recollection in 1875: "I entered upon the small enterprise of 'learning' twelve or thirteen hundred miles of the great Mississippi River with the easy confidence of my time of life. I supposed that all a pilot had to do was to keep his boat in the river, and did not consider that that could be much of a trick, since it was so wide."

The famed cable cars of San Francisco remind me of a very favorite personal story unrelated to either photography or icons. Back in my days as a lawyer I wrote a heartfelt note to a wonderful boss after his departure but never heard back. Two years later, when I had become a photographer and was in San Francisco on an assignment, I spotted him on the sidewalk while I was riding a cable car. The cars traverse the steep hills so slowly you can jump off while they're moving, which I did, and walked over directly to him. "You don't know how relieved I am to see you, Steve," were the very first words out of his mouth, which puzzled me. He immediately opened up his slim attaché case and rifled through his legal papers. With a triumphant grin, he held up…my handwritten note. "I never got around to thanking you for this….Thanks."

As I was driving across Iowa I passed a sign which announced: "Entering Madison County." Could that have been the setting for the fictional best-selling book and blockbuster movie *The Bridges of Madison County*? A gas station attendant confirmed it was. I had a half day free, so I dashed about photographing covered bridges, all the while keeping an eye pealed for Francesca—or Meryl Streep—or any reasonable facsimile. Sad to report, it was an unsuccessful afternoon; no sign of a good woman, and no book-quality pictures. Fortunately, I had more success, at least photographically speaking, in Franklin County, Massachusetts (52).

It's an unfortunate irony that the Amish people, who have a well-known aversion to being photographed (they believe it's a sign of ungodly vanity), seem to turn most photographers, amateur and professional alike, into invasive, relentless paparazzi. I, for one,

prefer not to photograph people who don't like to be photographed. However, getting a shot of an Amish horse and buggy seemed non-intrusive (53). Then again, this buggy may have been owned by the Mennonites, a related sect that is less camera-averse.

The chapter closes as it opened: with the automobile. Our love for the automobile is revealed, I think, by our widespread tolerance of traffic. When it comes to the saturation of cars on the freeways, Los Angeles is our undisputed capital. Ironically, I went aloft to get an aerial shot of bumper-to-bumper rush hour traffic but, to the astonishment of both me and the pilot, we couldn't find any; anyway, traffic feels more like traffic when you're on the ground (54).

The interstate highway system (55) is a wonder: multiple routes from the Atlantic Ocean to the Pacific without a single traffic light. Of course, there are times I want to actually see what the country really looks like, so I exit the highways and enter the byways. Just how many miles of each I've traversed in doing this book I don't know, but I've surely given my van's odometer a serious workout.

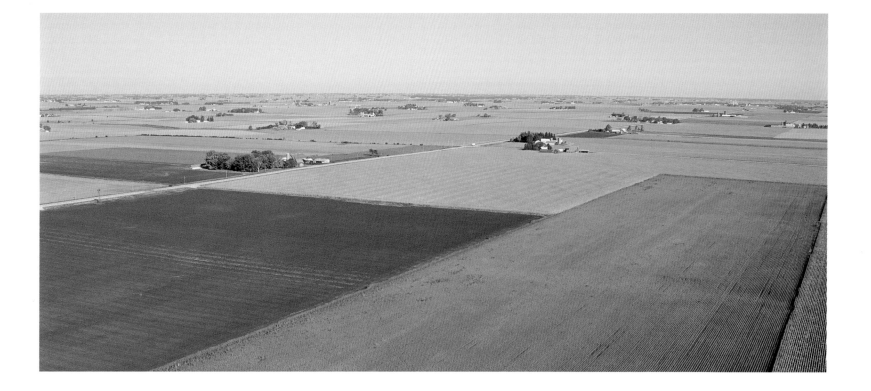

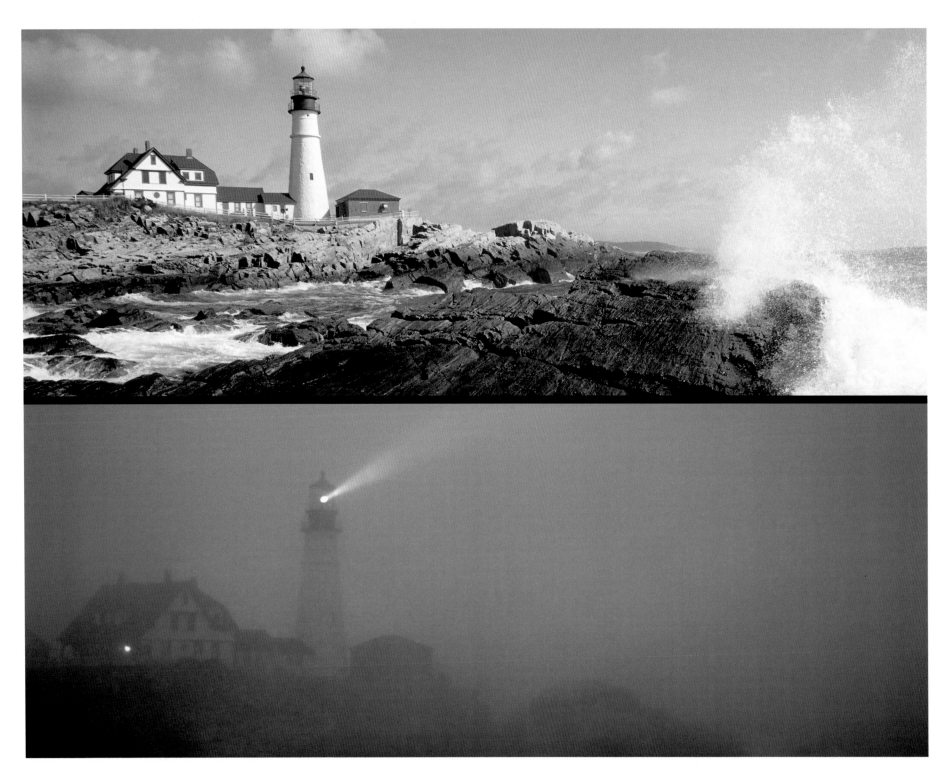

60 South Portland, Maine (preceding: Linn County, Iowa)

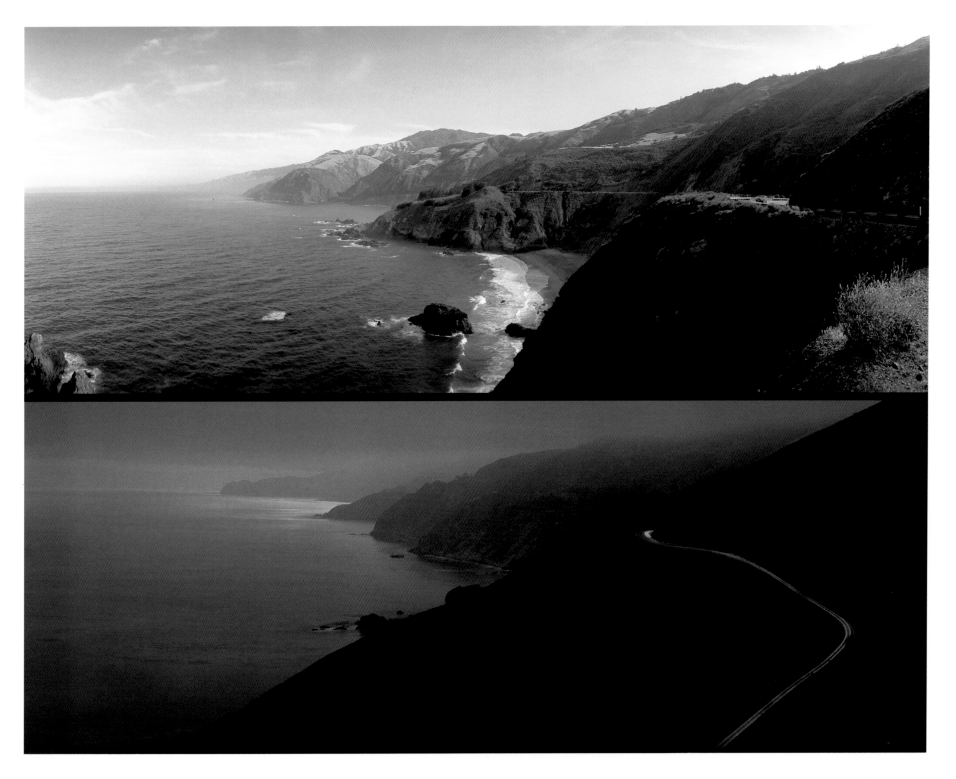

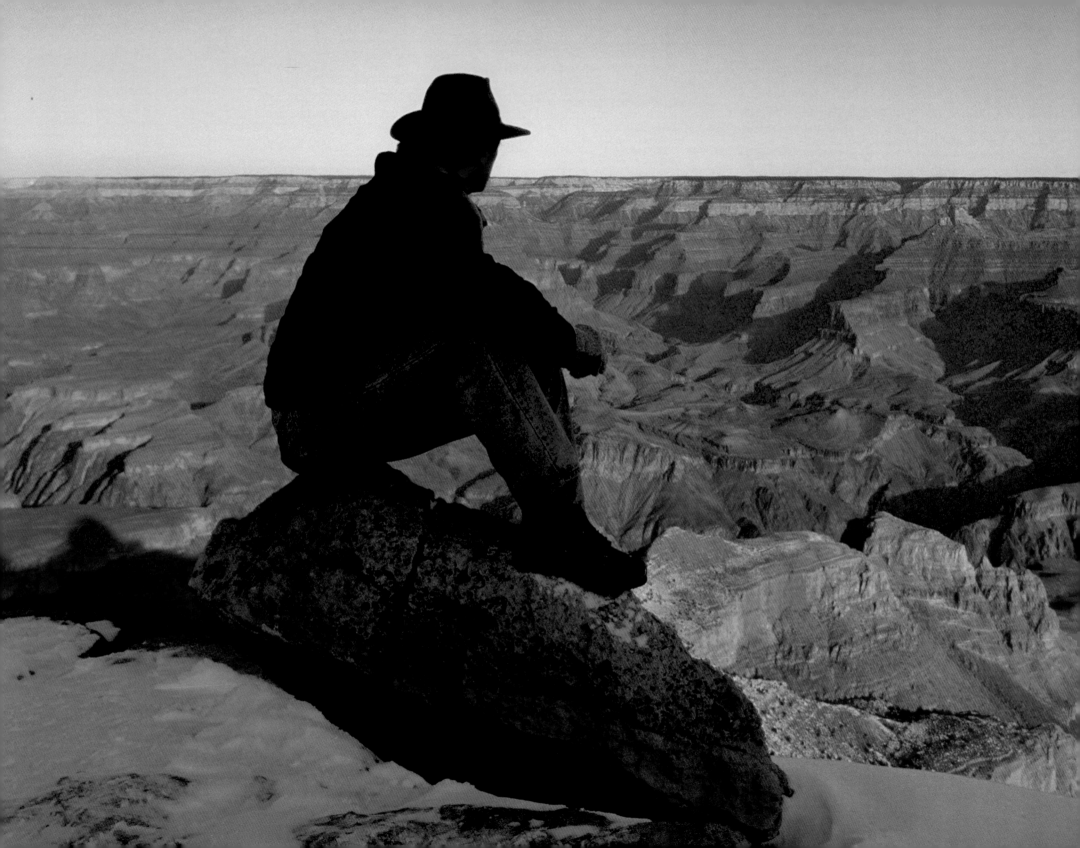

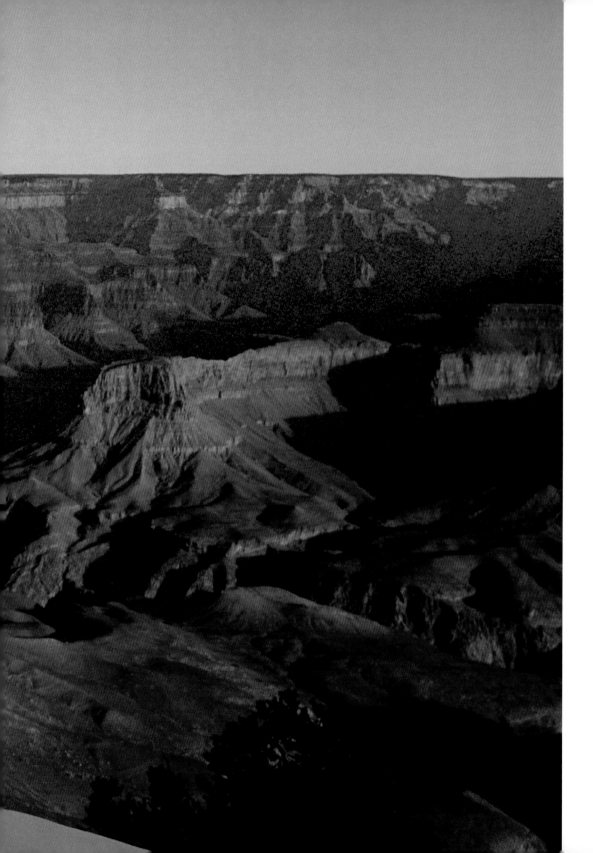

I shuffled cautiously over and looked down, but could see nothing but gray soup...[A] miraculous thing happened. The fog parted. It just silently drew back, like a set of theatre curtains being opened, and suddenly we saw that we were on the edge of a sheer, giddying drop of at least a thousand feet. "Jesus!" we said and jumped back, and all along the canyon edge you could hear people saying "Jesus!" like a message being passed down a long line. And then for many moments all was silence...because out in front of us was the most awesome, most silencing sight that exists on earth.

Bill Bryson, *The Lost Continent: Travels in Small Town America*

The Badlands are like the work of an evil child...[D]ry and sharp, desolate and dangerous, and for me filled with foreboding. A sense comes from it that it does not like or welcome humans.

John Steinbeck, *Travels with Charley*

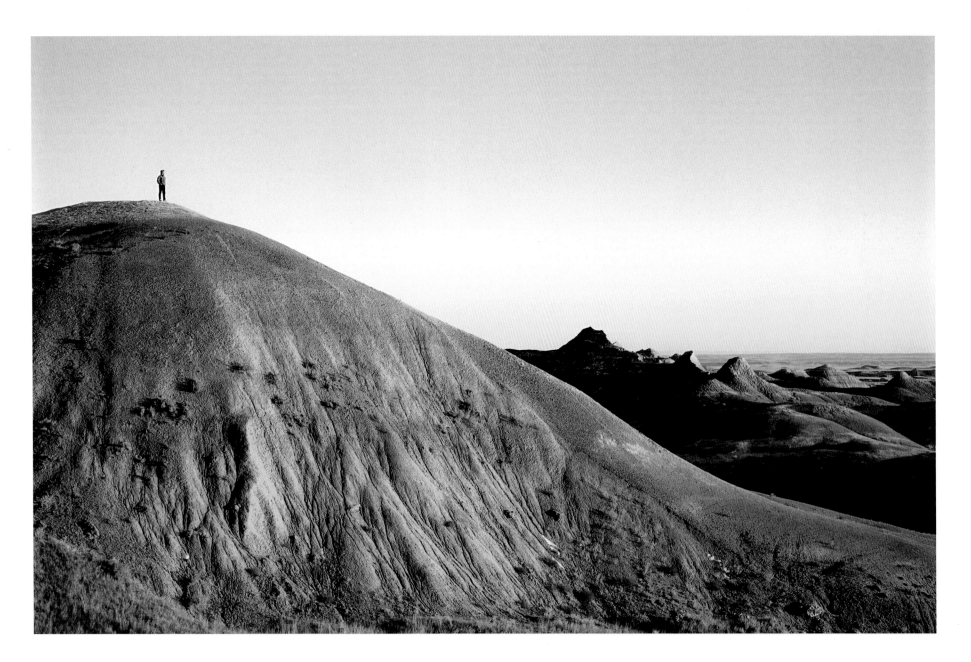

The loneliest, the hottest, the most deadly and dangerous spot in the United States.

Anonymous, 1894

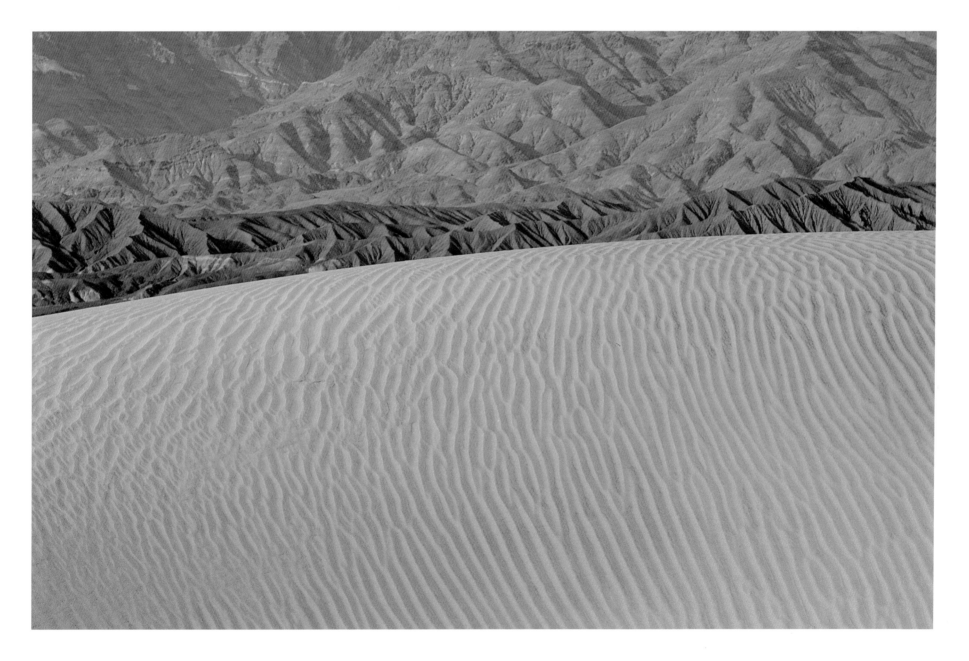

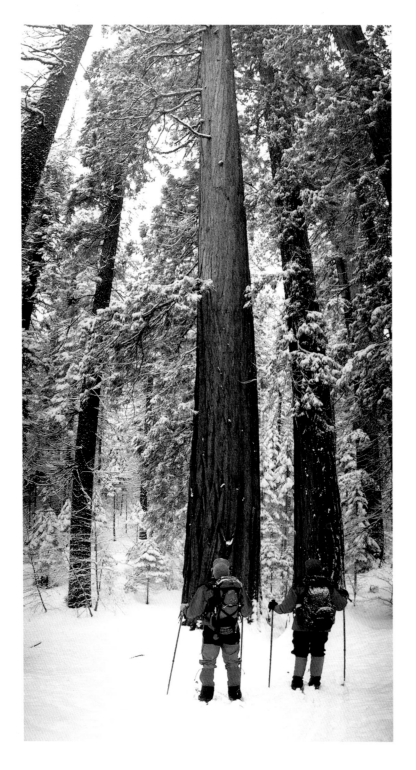

Thousands of tired, over-civilized people are beginning to find out that going to the mountains is going home; that wildness is a necessity; and that mountain parks and reservations are useful not only as fountains of timber and irrigating rivers, but as fountains of life.

John Muir, *Our National Parks, 1899*

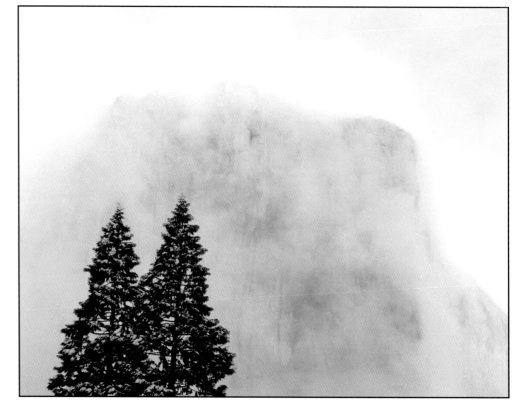

Columns of water, of various dimensions, projected high in the air, accompanied by loud explosions and sulphurous vapors...highly disagreeable to the smell....The Indians who were with me believed them to be supernatural and supposed them to be the production of the Evil Spirit. One of them remarked that hell, of which he had heard from the whites, must be in the vicinity.

Warren Ferris, *Life in the Rocky Mountains,* 1884

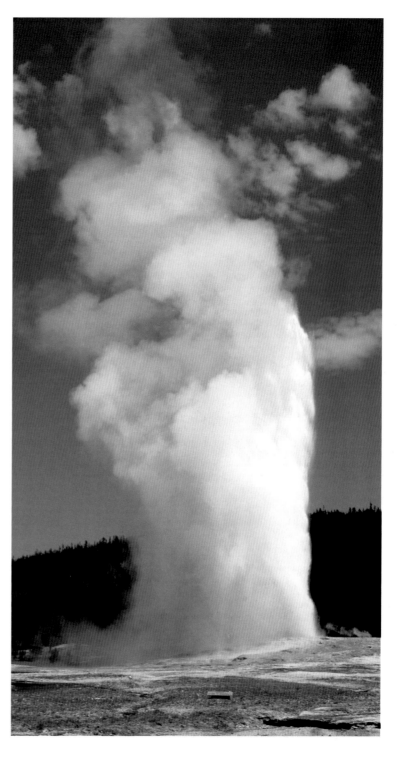

[S]tarring across the rapids and down a 170-foot drop...we thought not of God's great universe but of people like Annie Taylor, the 63-year-old schoolteacher from Michigan who was the first over the falls in 1901 (she survived), and George Stathakis, a Greek chef from Buffalo who took the plunge in 1930 (he did not), and 7-year-old Roger Woodward, probably the only sane one in the bunch, who fell over accidentally, wearing nothing but a life jacket, and surfaced with barely a scratch.

Jody Alesandro

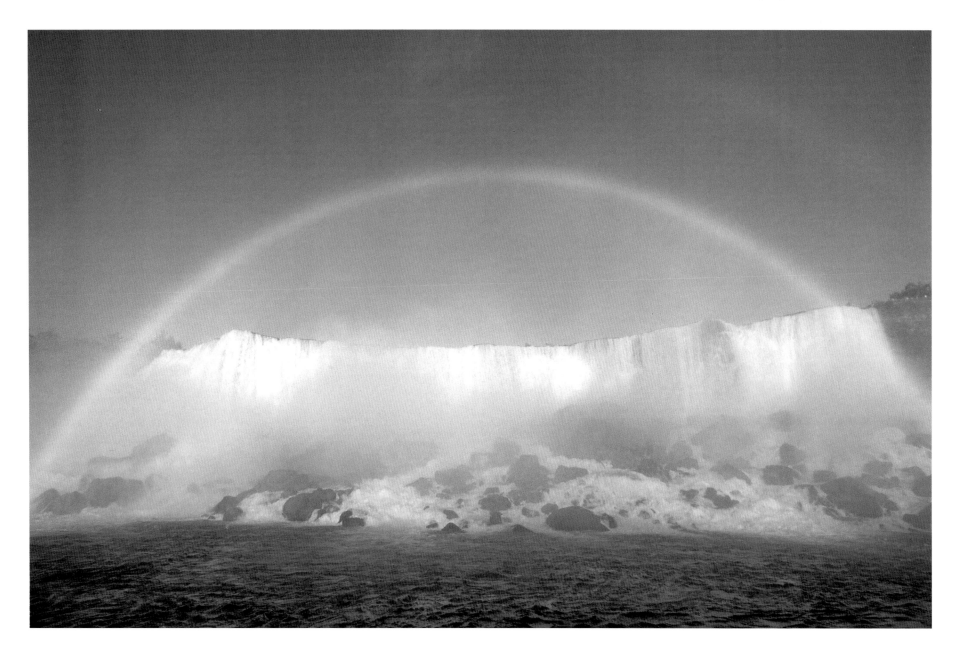

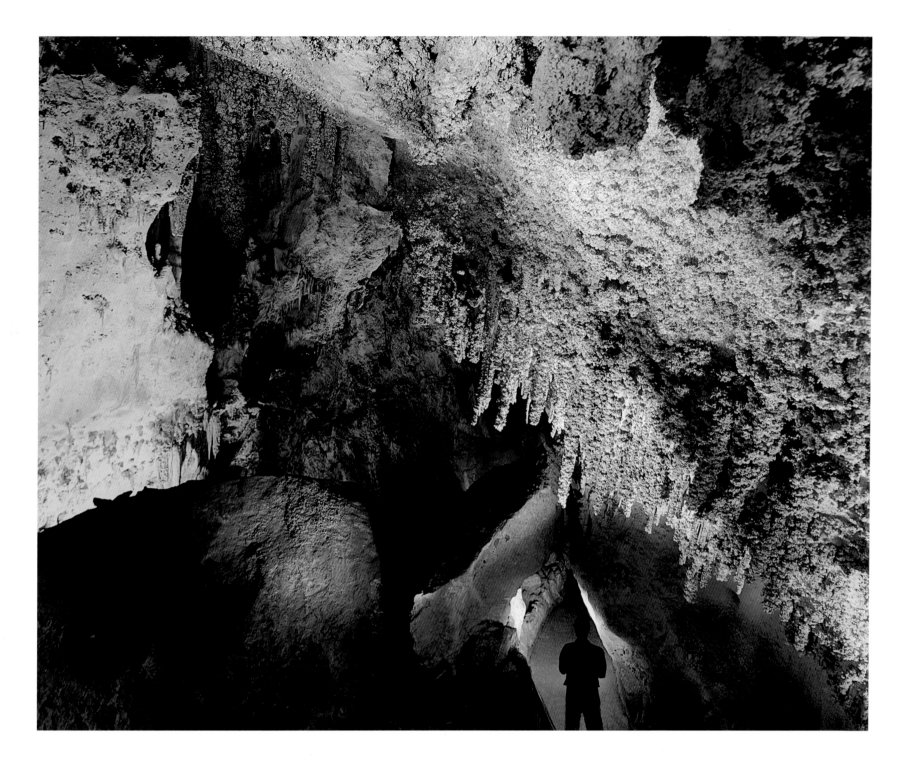

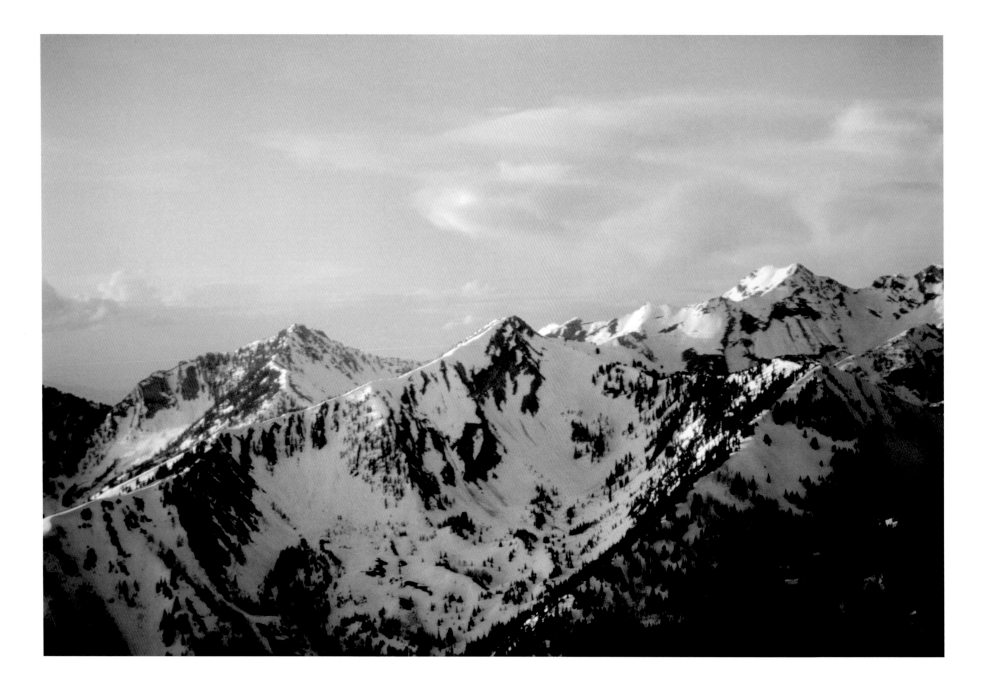

70 Rocky Mountains, Utah

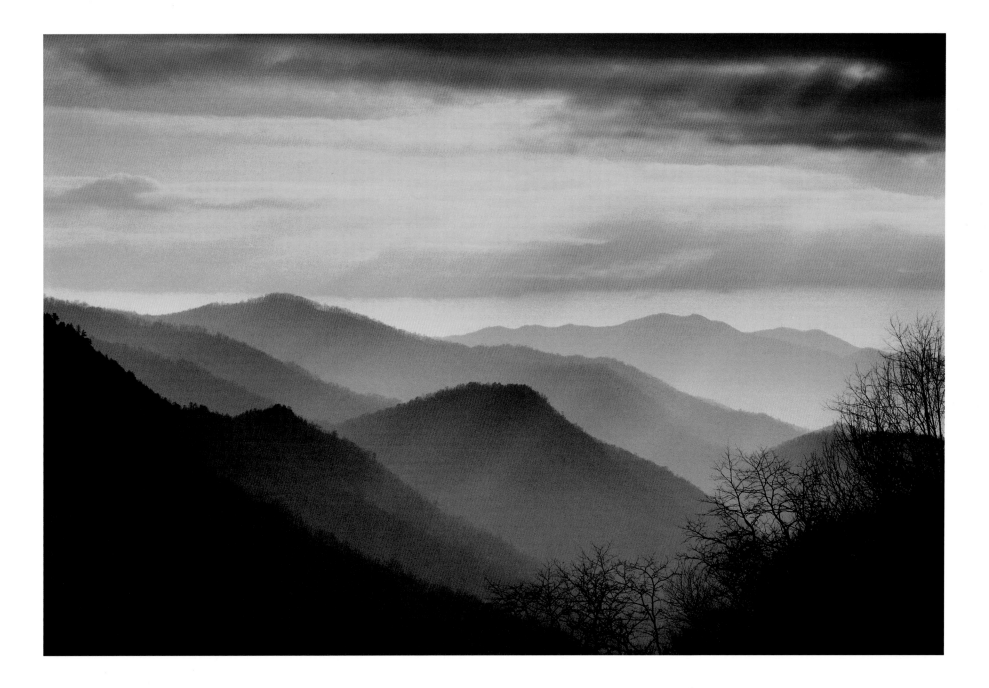

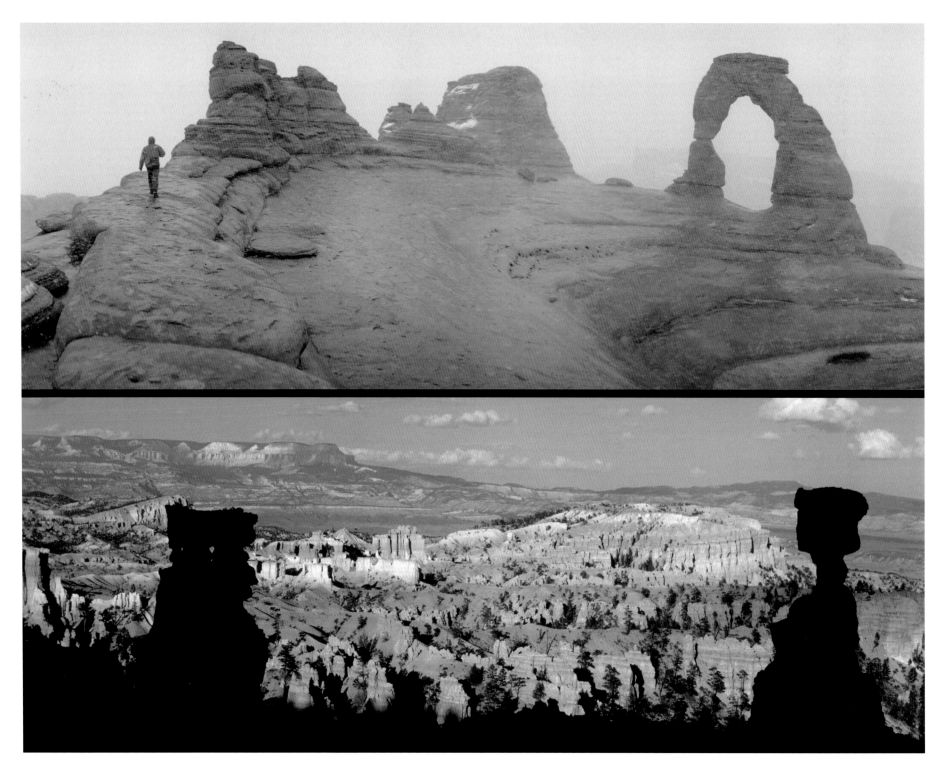

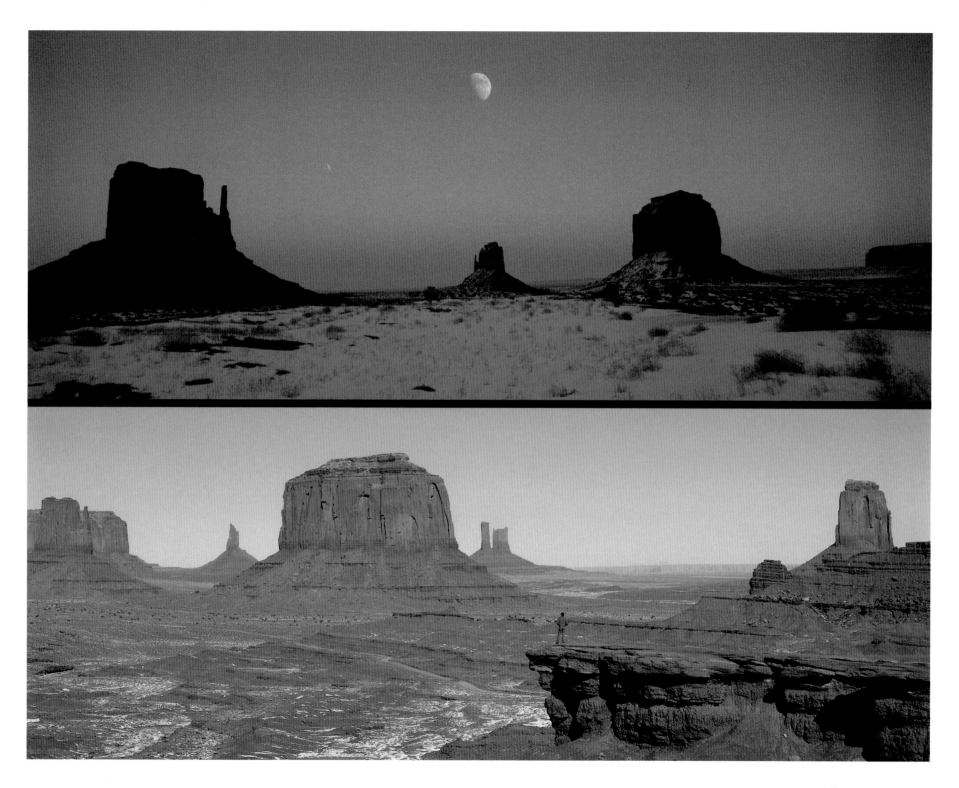

GRAND LANDSCAPES

The Grand Canyon, Niagara Falls, Death Valley, Yellowstone, the Rocky Mountains—our nation is blessed with a vast number of extraordinary natural wonders. Year in and year out we visit them by the tens of millions. Day in and day out, we view images of them on TV, in the movies and in print advertising. Having been fortunate enough to have visited each of our most iconic landscapes, my reaction is best expressed through the words of the legendary photographer Ansel Adams: "Sometimes I do get to places just when God's ready to have somebody click the shutter." Attempts at verbal description would quickly wear out my supply of adjectives—breathtaking, unique, superlative, magnificent, etc—better to let the pictures speak for themselves. Instead, here are a few recollections of events associated with taking these pictures, which often are at least as memorable as my reaction to the landscapes themselves.

In taking the morning shot of the lighthouse in South Portland, Maine (60), I waited by water's edge to capture a wave breaking on the rocks in order to give my composition dramatic punch. I dismissed the anxious warnings of my kids, nine and twelve at the time, with a casual remark about the necessity of taking risks in the line of duty. The crashing wave in the photo knocked me back onto the rocks with life-threatening severity. Picking myself up, I could see in the terrified look in my children's eyes their overwhelming sense of impending loss; more than at any other single moment in my life, I felt their profound connection to me.

After spending an entire day driving back and forth along the Pacific Coast Highway in Big Sur, California, the location of the most impressive juxtaposition of mountains and surf in the United States, I was dejected—my shots seemed too similar to what I'd seen others do before. (Capturing these much-photographed icons with a fresh eye presents an ongoing challenge.) As the sun set and I knew that I had to leave the area early the next morning, I was certain I'd missed my chance for a great shot. I drove up into the Big Sur hills to the house where my assistant and I were staying, lost in my own bad mood, eyes straight ahead. Andrew, my assistant, tapped my arm with some immediacy: "Look…Alpenglow [post-sunset sky color]." I slammed on the brakes, we hopped out of the car, Andrew quickly secured the camera on the tripod, while I estimated the appropriate f/stop needed for an extended time exposure. On the road below, several cars drove in our direction, their headlights glaring into the camera. "Oh [expletive deleted]," I kept mumbling. Just as the sky color was fading to black, a single car drove by in the other direction with bright red tail lights. Click. One exposure (61). It was enough. When people ask me what my assistants do, I tell them that part of the job is to serve as a second set of eyes. On the other hand…

Some assistants cause me grief. For example…my schedule at the Grand Canyon allowed just one day, so I decided in advance how I'd approach my shot: a panorama from the south rim with a silhouetted person in the foreground. We arrived at the canyon's south rim long after dark and scouted for an ideal location by flashlight. Well before sunrise the following morning we returned to the chosen spot and positioned the tripod and camera by flashlight. "Before the sun breaks the horizon," I instructed my assistant Vince, "you'll need to jump quickly on that snow covered rock…it should stay in shadow for a couple of minutes after the sun hits the north side of the canyon." As dawn broke, we both saw what hadn't been visible in the dark—beyond that perch rock was a sheer vertical drop of at least four hundred feet. Both of us suffered from acrophobia. "Before we began this trip I told you you'd have to get out by a ledge," I hectored, but he steadfastly refused to budge. As the sun was coming up it we had a testy standoff. I'd traveled too far to let this shot get away, so I haltingly climbed up on that rock myself, trying to maintain a relaxed posture while breaking out in cold sweats, and Vince clicked the shutter (62-3).

My memory of California's desolate Death Valley (65) was of driving way, way off the beaten track–a dirt road where you rarely saw another car–before I noticed that the gas gauge needle was on empty. My photographic objective was several miles ahead, the nearest gas station more than twenty miles behind, and it was three hours to sunset. (Hasn't everyone faced this predicament in one form or another?) Foregoing the prospect of a great picture hurts me more than a night of discomfort so, trepidatiously, it was full steam ahead. Happily, I made it back to the motel that night without incident. There've been similar occasions where I haven't been so lucky.

The Badlands of South Dakota (64) are a moonscape of steep hills with brittle, sharp ground and such impossible footing that you never see people walking off-road. I attempted a very modest hike to check out different camera angles. Slipping, falling down, and bumping into the sides of the steep hills, I never noticed that the pocket of my camera bag had ripped open and film from the prior day's shooting spilled out. That was the first time I ever lost exposed film; I made sure it was the last.

I enjoy nature far more in solitude than surrounded by hordes of people, which is why I travel whenever possible during the off-season. (Why replace the numbing grind of New York City congestion with that of our national parks?) Unfortunately, I found myself at Niagara Falls–which has over ten million visitors annually–during a busy period. My expectations were very, very low, and it was with little enthusiasm that I hopped onto the crowded tour boat "Maid of the Mist." First, it chugged by the sweeping American Falls where the water spray created an exquisite rainbow (68); it then moved into the thunderous heart of the Canadian (Horseshoe) Falls, providing an experience of sight and sound so thrilling that I became completely unconscious of the surrounding crowd.

A few additional "grand landscape" memories in brief:

Arches National Monument: During the long climb to Grand Arch during an ice storm (72) I fell and my camera case careened one hundred feet down a slippery slope. A miracle: all cameras intact.

–Carlsbad Caverns (69), a leading example of many enormous caverns to be found across the country, maintains subdued, monochromatic light to prevent organic growth. I gave the stalactites and stalagmites the Hollywood lighting treatment with a nine-shot multiple exposure using colored gels on my flash, the very last of which captured my silhouette.

–Yosemite Park: My moody then-thirteen-year-old son preferred napping in the car to walking in Yosemite Valley to view the famed granite monolith, El Capitan (66). So we'd travelled over 3,000 miles to get there...think I'd let his lethargy bother *me*? His mood later improved and we trekked through deep snow to see the noble giant sequoias at Mariposa Grove (66 and back cover).

–The Great Smoky Mountain Range of the Appalachians (71) may not be as visually dramatic as the other "grand landscapes" in this chapter, but it evokes in me even more powerful emotions, for I contentedly spent many childhood summers in a spot like this. There are things you love to look at and then there are things you love.

The Old West

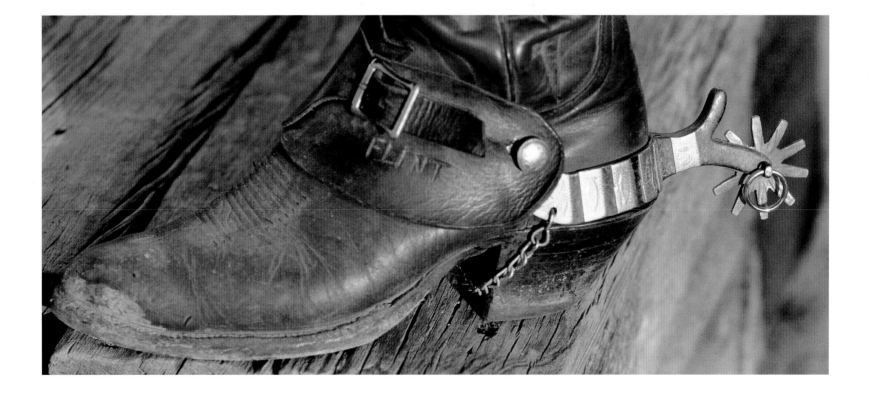

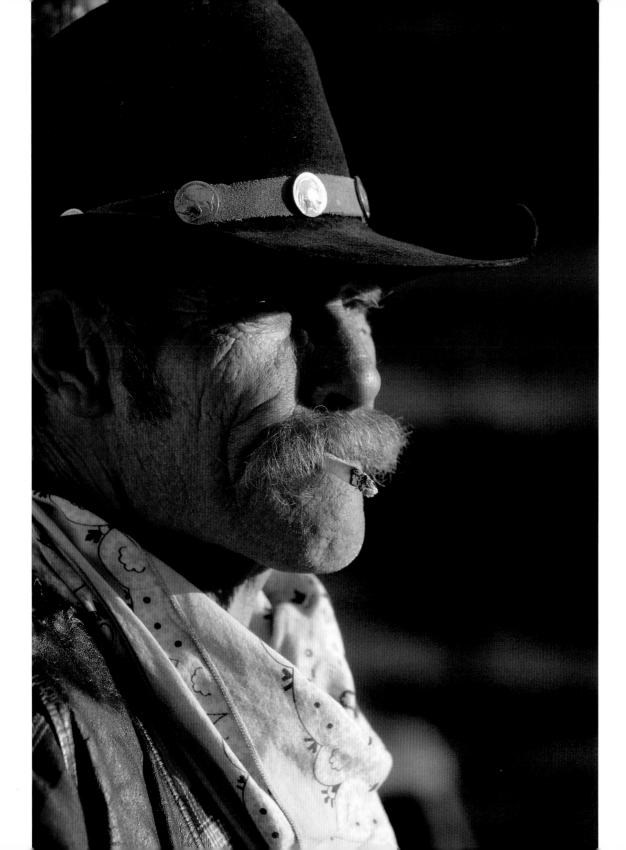

In the West the past is very close. In many places, it still believes it's the present.

John Masters

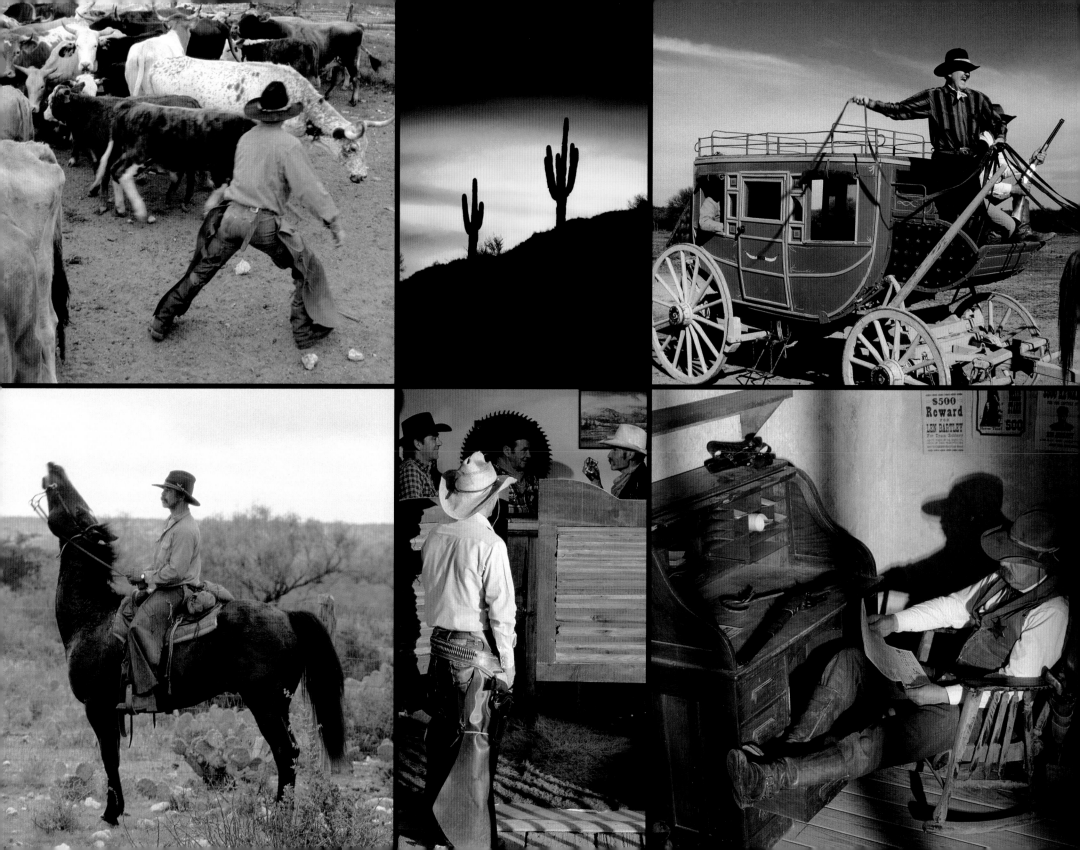

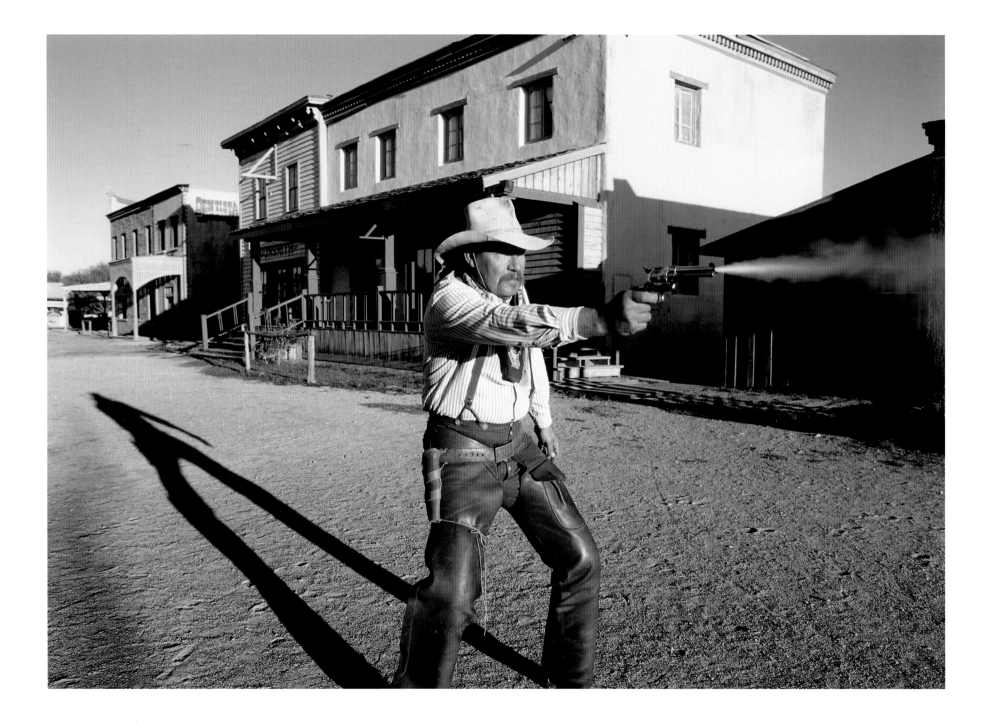

80 Bracketville, Texas (preceding: Goldfield, AZ & Kinney County, TX)

For a shining moment in history, the individual stood supreme, outside of society, class, and petty restrictions, and seemed to have all possibilities within grasp. It seems not to matter that it was all at the expense of the Indian, or that the mountain men, prospectors, and cowboys were quickly followed and overwhelmed by fur companies, mining companies and cattle companies....The image of the heroic, solitary individual, free of all restraints and able to reinvent himself at will, was burned into our imagination.

Gerald Kreyche, *Visions of the American West*

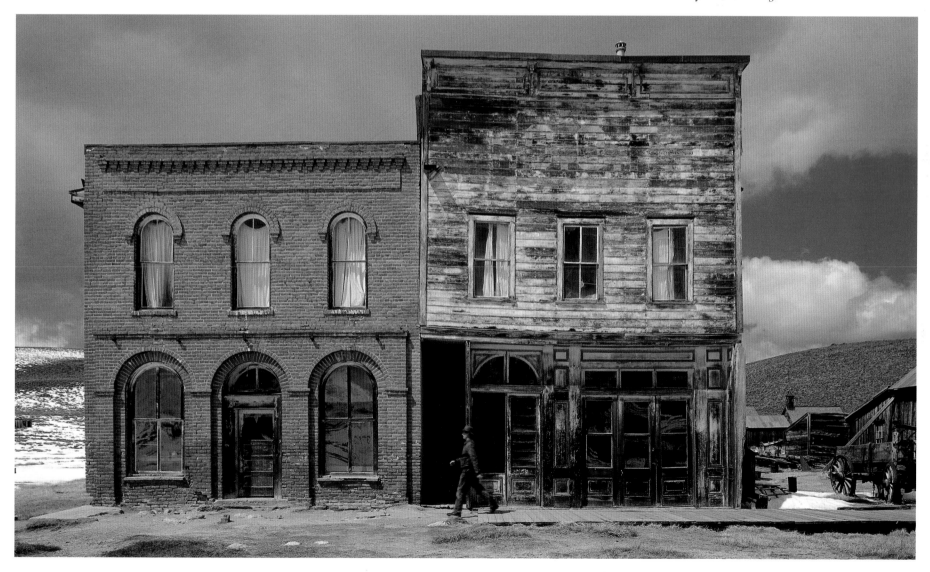

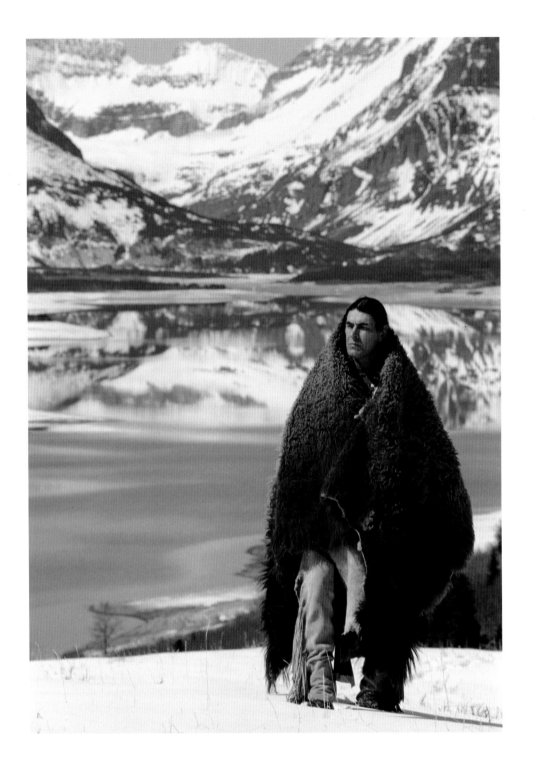

Only to the white man was nature a "wilderness" and only to him was the land "infested" with "wild" animals and "savage" people. To us it was tame. Earth was bountiful and we were surrounded with the blessings of the Great Mystery.

Luther Standing Bear

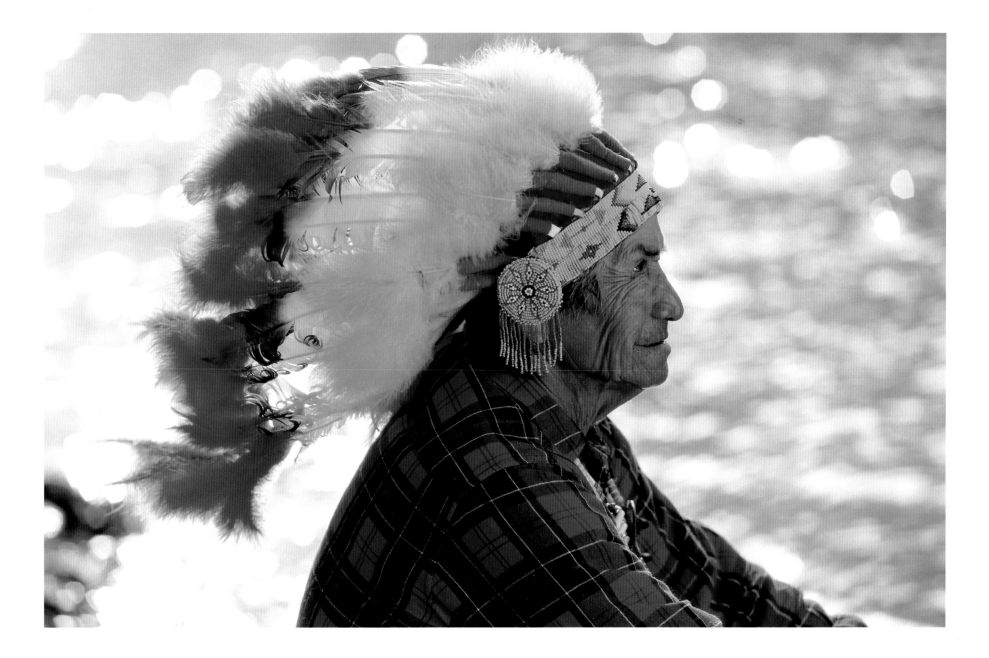

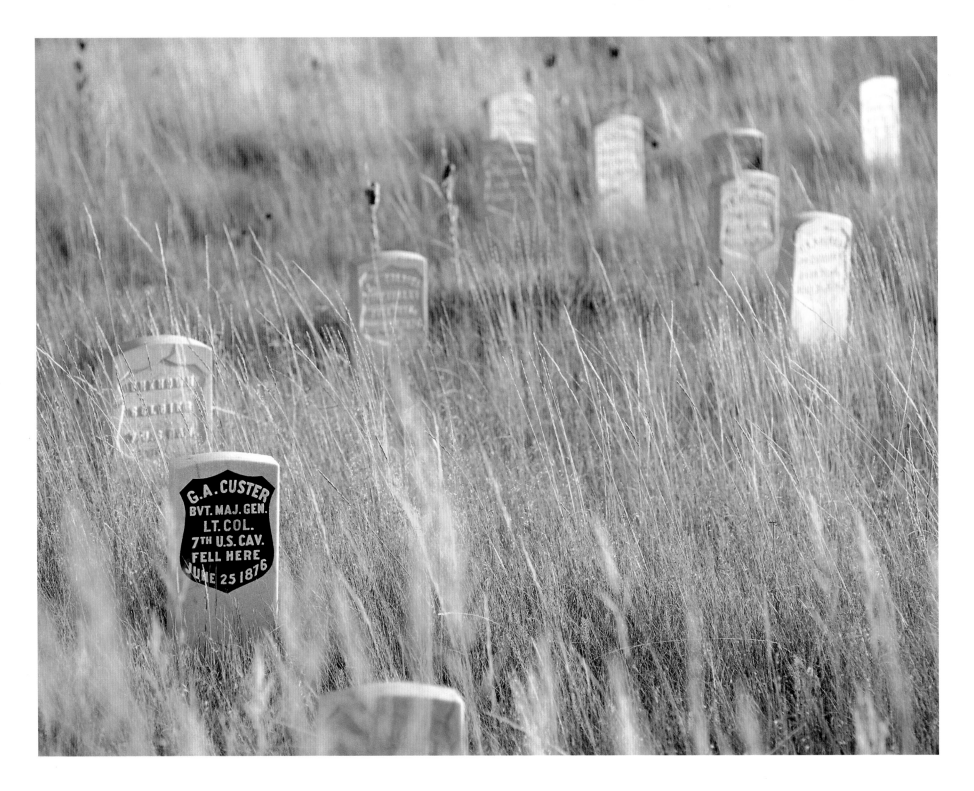

The gravestone in the foreground reads:

G.A. CUSTER
BVT. MAJ. GEN.
LT. COL.
7TH U.S. CAV.
FELL HERE
JUNE 25 1876

84 Little Bighorn River, Montana

To the people of Texas and all Americans in the world, I am determined to sustain myself as long as possible and to die like a soldier who never forgets what is due to his own honor and that of his country. VICTORY or DEATH.

Col. William Travis, Alamo Commander, 1836

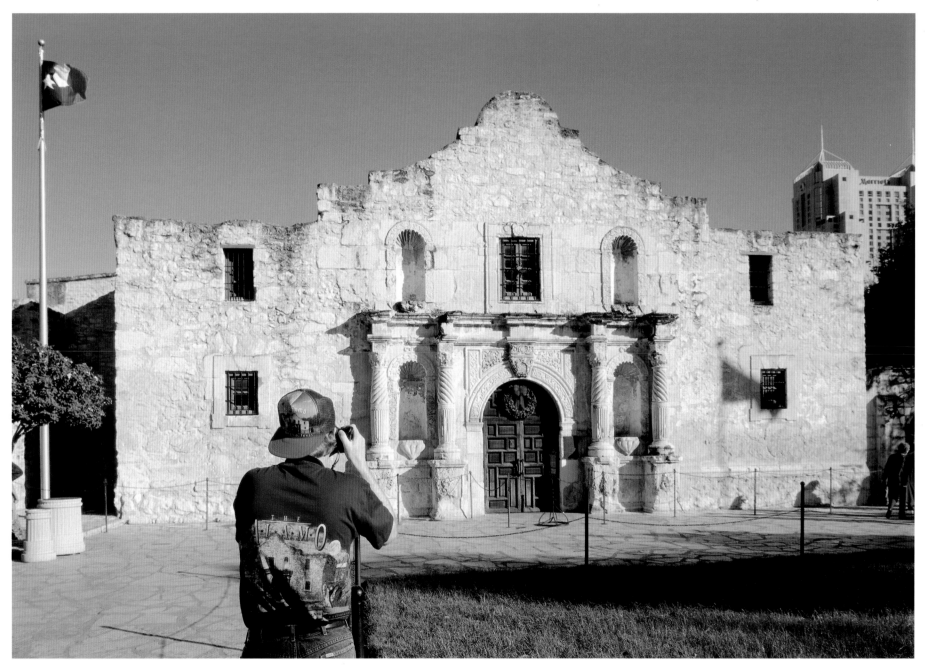

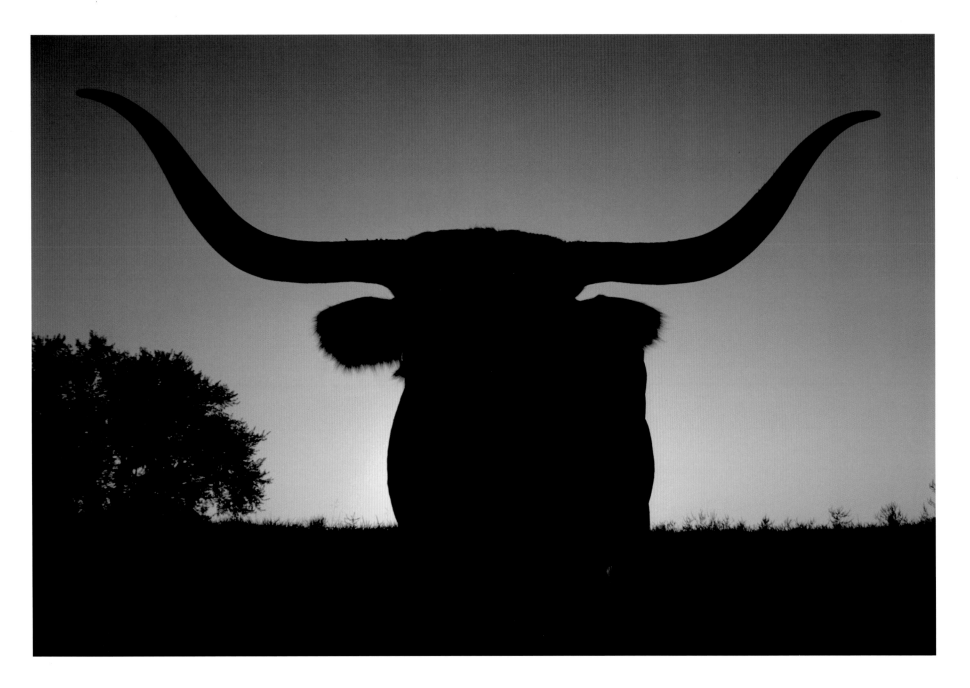

86 Pecos County, Texas

Once there were 70 million buffalo on the plains and then the people of the West started blasting away at them...By 1895, there were only 800 buffalo left, mostly in zoos and touring Wild West shows.

Bill Bryson, *The Lost Continent*

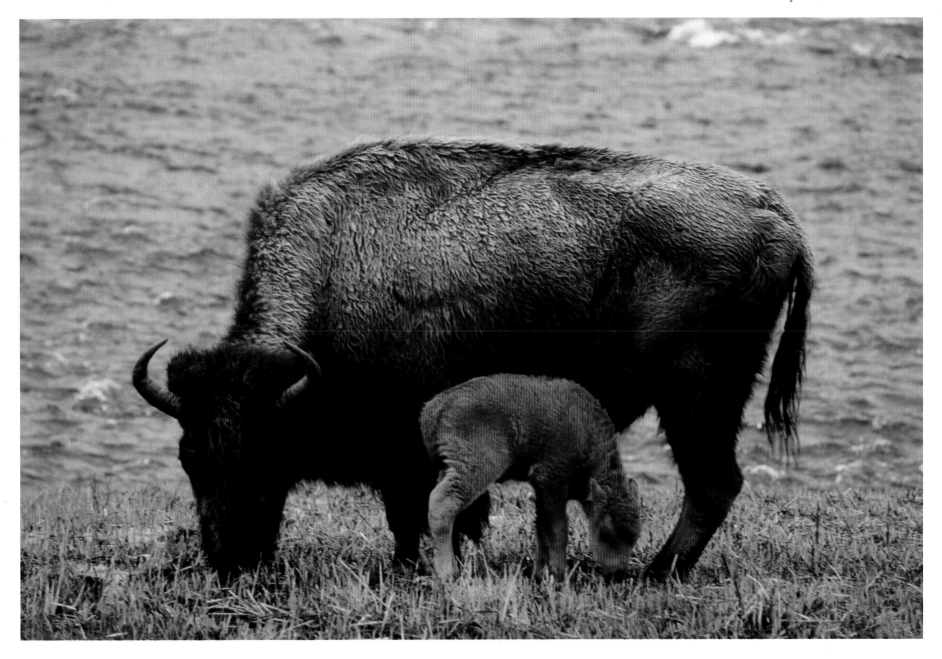

THE OLD WEST

The American frontier closed a century ago, but the spirit and mythology of the Old West is very much alive today. It is a central part of our national ethos, instilled in us since childhood. For those of us growing up in the 1950s, 60s and 70s, our role models included, among so many others, Roy Rogers, The Lone Ranger, *Gunsmoke's* Marshall Dillon and *Bonanza's* Cartwright clan; we identified with the sheriff in *High Noon*, the reformed gunfighter in *Shane*, the lone cavalryman in *Dances with Wolves*, and, of course, John Wayne in any saddle. (Wayne was voted America's favorite male actor in a recent survey, even though he died years ago.) Our archetypal Western hero was courageous, decisive, strong, composed, restrained, stoic, resourceful, soft-spoken, honest, self-sufficient, free-spirited, overpoweringly masculine and lightning quick on the draw. Modest, too. When I was a little kid, I aspired to be just like that. I owned many Western-style cap pistols and a ten (well maybe three) gallon hat; I wore blue jeans and coveted cowboy boots. As soon as I grew up, I wanted to travel out west.

In the past couple of decades, the characteristics of the classic Western protagonist have been transmuted into more contemporary characters—cops, private eyes, righteous vigilantes, outer space adventurers, sometimes even doctors and lawyers. While the icons of the Old West may be slightly passe, they are still commonly found in tourist towns and ghost towns, dude ranches and *real* ranches. In Goldfield, Arizona, where local denizens have one foot planted firmly in the present and the other deep in the past, I met "Flint," whose weather-beaten boot and Stetson-topped face open the chapter (77,78). That's also Flint behind the "batwing doors" (a Hollywood fabrication I found out), belly up to the bar, shot glass in his hand, jawing with his gun-totin' companions (79). "Can I send you a picture?" I asked this taciturn, roll-your-own, real-life Marlboro man. "Nope," he replied. "Got no mailbox…live on the range out

there [pointing]…over there by the Superstition Mountains."

In Bracketville, Texas, I found real-live cowboys and vaqueros punching a herd of longhorns on one of those modest 10,000-acre ranches (79). Nearby, on the site of the still-intact movie set for John Wayne's classic *The Alamo*, I photographed a stagecoach and a sheriff with his Winchester carbine and "Wanted" posters (79).

"Get your gun—I'll meet you in the street in five minutes," snapped Kirk Douglas as Doc Holliday in *Gunfight at the OK Corral*. The shootout, that staple of Western folklore, has been repeated with only minor variation in scores of movies, TV shows and books: on a dusty Main Street, our hero reluctantly metes out justice with a single bullet from his Colt 45 after letting the outlaw reach for his gun first (80). Before the villain's body is cooling in Boot Hill cemetery, our intrepid, unassuming warrior rides off into the sunset, frequently accompanied by the most beautiful woman in the territory, and surrounded by the famously shaped saguaro cactus, like the two I found in South Mountain Park near Phoenix, Arizona (79).

Ghost towns—mining towns gone bust—can be found in various states of decomposition scattered throughout the West. One that is beautifully preserved is Bodie, California, remotely located high in California's Sierra Nevada Mountains (81). From 1876 to 1883, with a population of 12,000, it is said that Bodie averaged one killing every single day. Talk about your tough town.

In a small, run-down cafe in northern Montana I met a ruggedly handsome Blackfoot Indian named "Volley" Reed who I wanted to photograph. Volley suggested that for a dramatic backdrop we four-wheel it through mountain snow to property he owned on the Blackfeet reservation. We had to dig his pick-up out of a couple of snowbanks along the way but I was rewarded with as breathtaking a mountain vista as I'd ever seen: the snow-capped peaks of Glacier National Park, just south of the Canadian border (82).

Most Indian reservations are out West, but not all. I met

Sampson Lossiah, a World War II paratrooper and one of the very last remaining full-blooded Cherokees, in North Carolina, located just across from the reservation (83). Sam made his living posing for snapshots in a town saturated with tourists and their beloved traps. Leaving his posing stool behind, we found a natural setting, the nearby Oconaluftee River. Looking through the viewfinder at his dignified, deeply etched face and his elaborate headdress, I could almost touch the spirit of Edward Curtis, the famed turn-of-the-century photographer who for thirty years brilliantly documented the extraordinary faces of the last generation of Native Americans who were born before Western reservations were created.

Relatively few people visit this small, simple cemetery by the Little Big Horn River in remote southeastern Montana, but most everyone knows what happened there. On a grassy hillside in 1876, vainglorious General George Armstrong Custer and his entire company were annihilated in the most famous battle of the Indian wars, famous no doubt for its aberrant outcome (84). To this day, the tragic extermination of the majority of this continent's indigenous population and the exile of most survivors to reservations remains, along with slavery, the greatest blight on our nation's history.

In 1836, four decades before Custer's Last Stand, all 182 defenders of a mission church called the Alamo perished in a fight for Texas' independence from Mexico (85). Perhaps because that battle has been so mythologized in movies and TV shows (a later battle which earned Texas' independence is all but forgotten), the site is overrun every day by an army of tourists and vendors. If you're tourist and T-shirt averse like me, and want to hear the echoes of the famed martyrs Davy Crockett, Jim Bowie and Colonel William Travis, I would suggest that you leave downtown San Antonio and travel about 100 miles due west to "Alamo Village" in Bracketville. I arrived on the grounds early one morning and wandered about the life-size replica by my lonesome.

Any tribute to the Old West should include the two animals that kept the cowboy, the Indian, and other Westerners fed and clothed: the longhorn steer and the bison (aka the buffalo) (86,87; note buffalo hide on p. 82). These two animals grazed across the vast western lands and still do today, although the bison, once decimated almost to extinction, is now found in defined areas such as Custer, South Dakota and Yellowstone Park, Wyoming. Contrary to my expectations, longhorns seemed threatening—I always kept a barbed wire fence between my camera and those horns—while the bison, even with a calf present, appeared passive and approachable, not that I ever tried to pet one; shooting them with rifles must have been like bagging animals in a zoo.

Although we Americans exhibit a relatively skimpy awareness of our own past, the iconography of our frontier experience remains extraordinarily potent. It is revealing, as philosopher/historian Gary Wills observed, that Americans have "westerns" but no "easterns," "northerns" or "southerns."

THAT'S ENTERTAINMENT

Nothing is real unless it happens on television. Daniel Boorstin

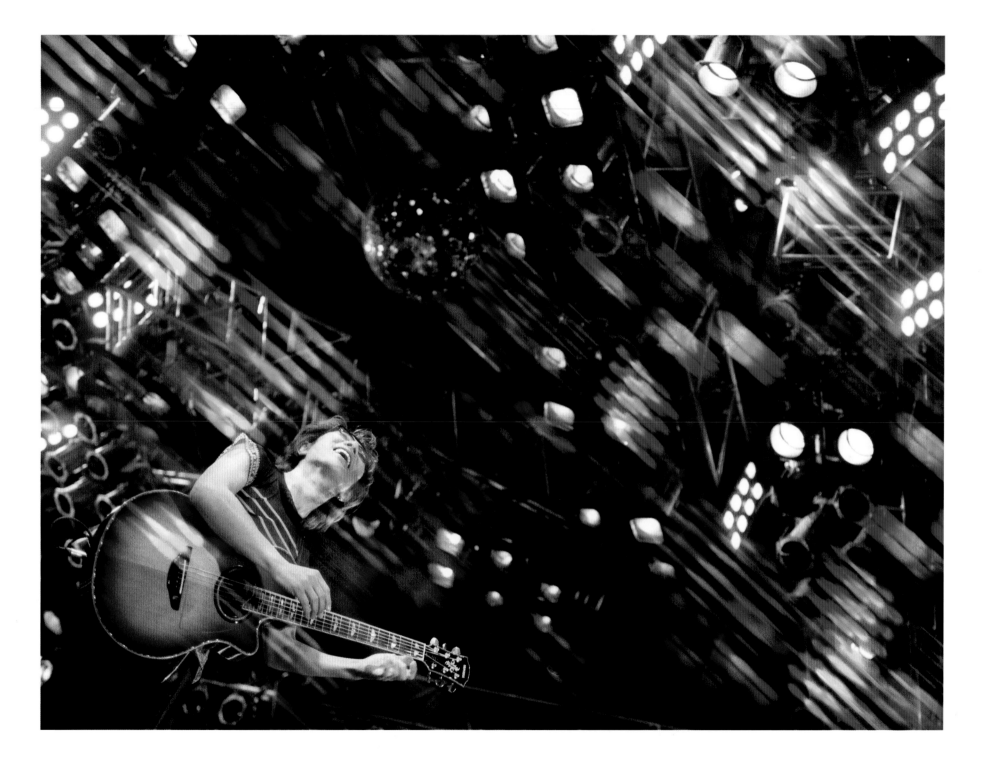

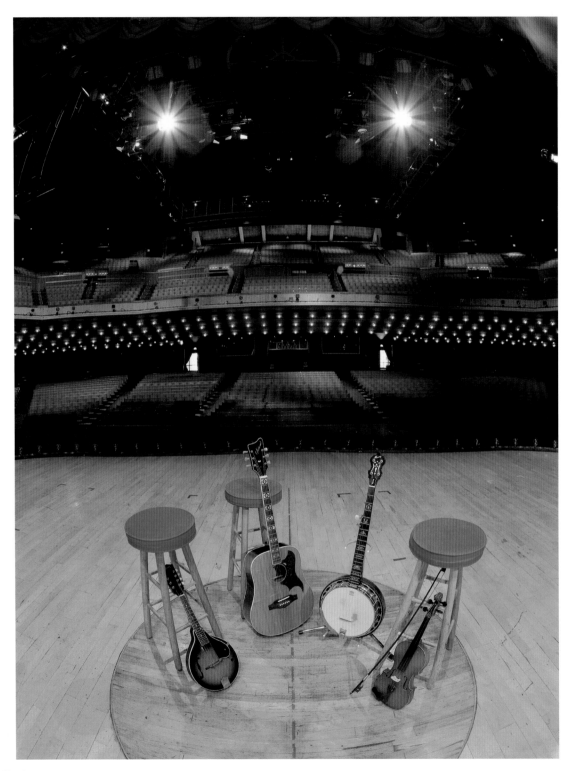

96 Grand Ole Opry, Nashville, Tennessee

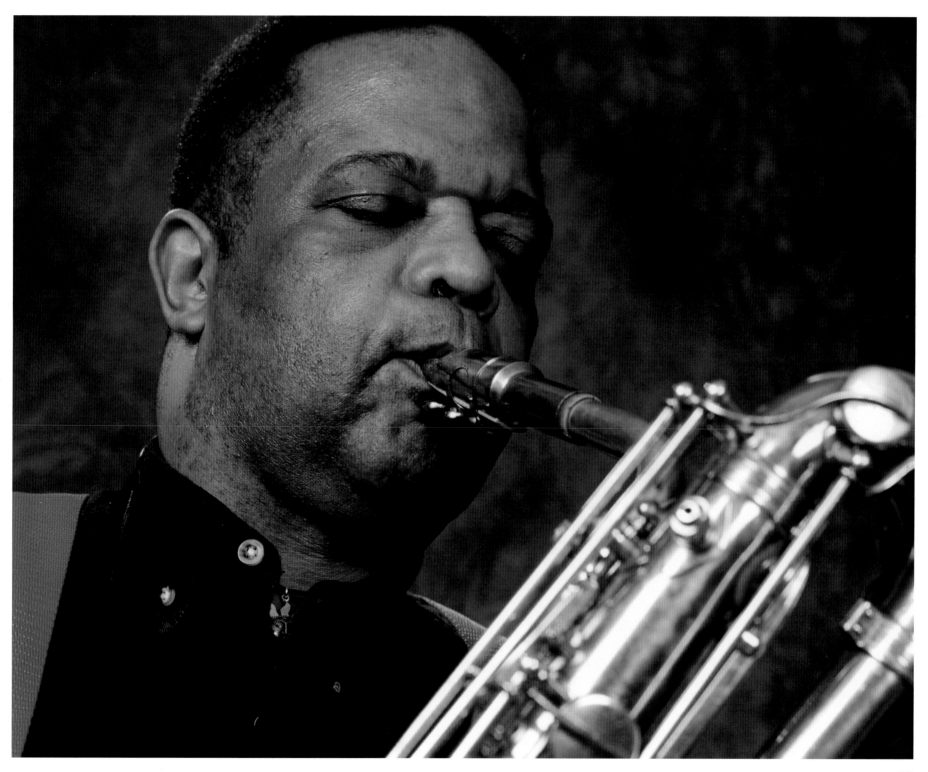

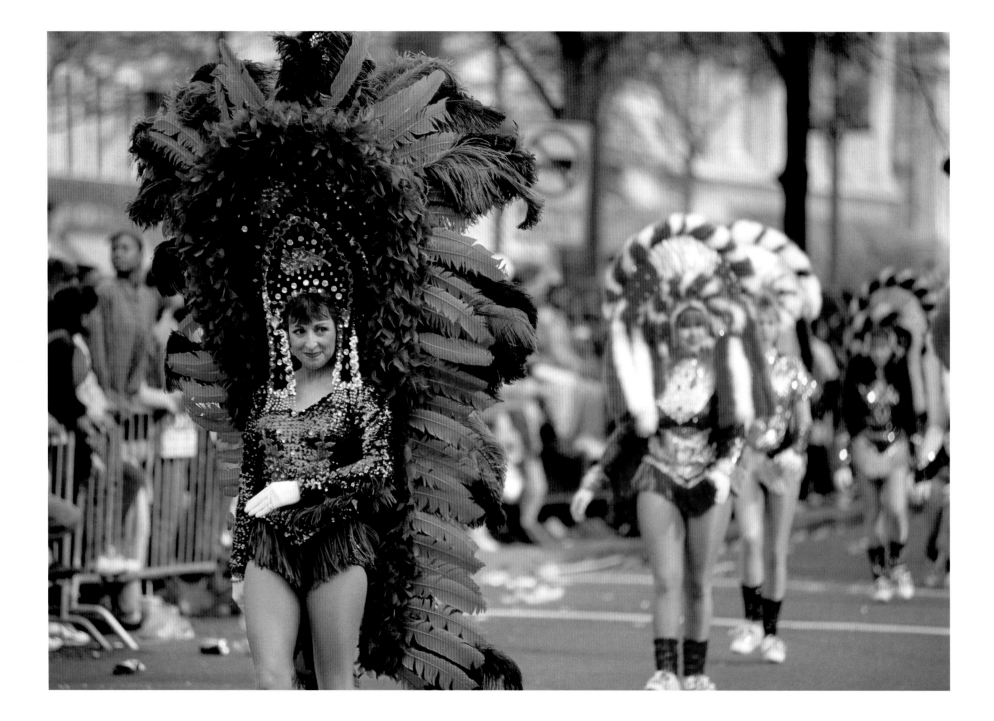

98　Mardi Gras, New Orleans, Louisiana

Maligned by one segment of America, adored by another, misunderstood by about all of it, Miss America still flows like the Mississippi, drifts like amber waves of grain, sounds like the crack of a bat on a baseball, tastes like Mom's apple pie, and smells like dollar bills.

Frank Deford, *There She Is: The Life and Times of Miss America*

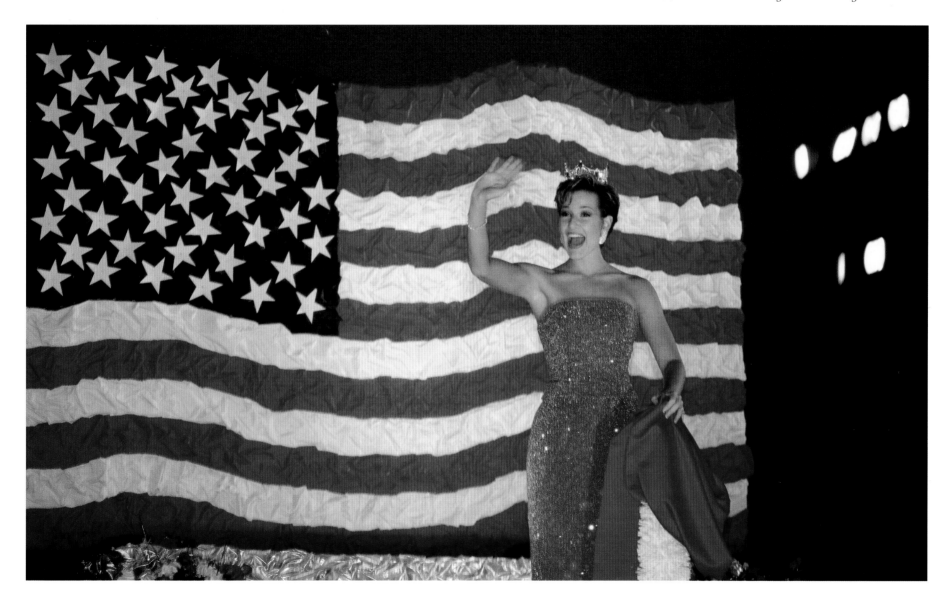

If you aim to leave Las Vegas
with a small fortune...
go there with a large one.

Anonymous

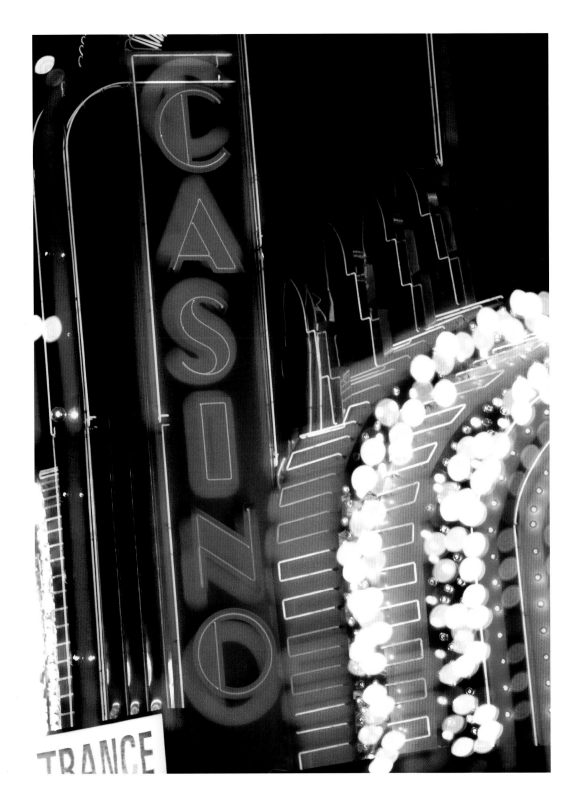

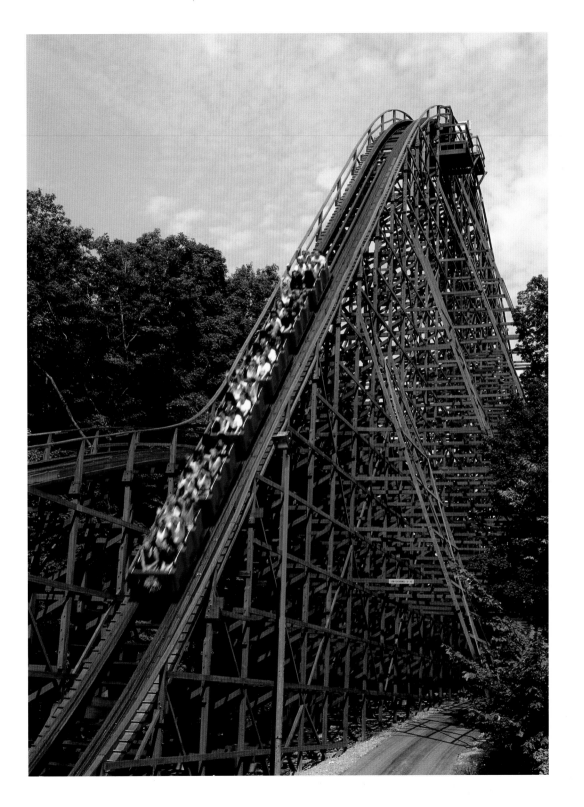

A greater thrill than flying at top speed.
Charles Lindbergh

THAT'S ENTERTAINMENT

Television, movies, music, theater, theme parks, casinos, pageants–Americans produce and consume entertainment at a breathtaking rate. Who better to open the chapter than Mickey Mouse (and Minnie, too), who has transcended his colorless cartoon personality to become a logo for the most successful entertainment empire in world history. Disneyworld, Disneyland, Disney movies, Disney shows (TV & theater), Disney stores filled with Disney toys….I've been there, done that. I expect you have too.

If you had to name one single tangible thing that most represents American culture, it would surely be the television set (92). We invented it, are continually refining it, and spend more time watching it than doing any other activity apart from working and sleeping. With television sets in 98 percent of American households, it is the ultimate tool of cultural homogenization. TV entertains us and informs us, tells us how to live, what to buy, and even what our problems are. Whether TV is a positive force in our lives is a question I leave to philosophers, sociologists, anthropologists and you.

From small screen to silver screen: I love to watch movies, talk about them and read about them. Movie directors, screenwriters and actors are among the people I most admire. Thank God for videos and cable TV movie channels–even greater blessings than microwaves, cell phones and TV remotes–for they bring decades of American movie treasures back from the archival dustbins. Whenever I see that famous Hollywood sign and stroll along the "Walk of Fame" by the intersection of Hollywood and Vine Streets, I get a tingle (93).

An easy shot for me to take was that of Broadway's theater district, for I live just a few blocks away. The very names of the theaters bring to mind some of my greatest evenings of drama and music and comedy (94).

Americans can rightfully claim several musical forms as their own. Rock music for starters. I grew up with it and it's in my blood. I'm old enough to remember, vaguely, seeing Elvis's historic first appearance on the Ed Sullivan Show that famous Sunday evening in l955...back when TV had seven channels and no color, and swiveling your hips was considered obscene. (Yikes, I couldn't possibly be that old; I must be remembering a rerun!) Rock music is omnipresent–radio, TV, and live shows that lure crowds in unfathomable numbers. The concerts seem to have become as much about lighting effects, ambiance and fashion as about the music itself (95).

Jazz is a special icon category for me. For one thing, I love the music; listening to the rich, driving sounds of baritone sax virtuoso Howard Johnson during the shoot was pure pleasure (97). For another thing, my father, who photographed jazz musicians from the late 1930s to the late 1940s, is recognized worldwide as one of the greatest photographers of that musical genre (the *very* greatest in my opinion.) So with this picture I offer a toast: to jazz...and to Dad!

I listen to country music mostly when I'm out on the open road. The melodies put me in a traveling mood, and listening to the lovelorn lyrics helps me pass the time. The stage of the Grand Ole Opry is country music's most hallowed ground, its Carnegie Hall (96). After completing the shoot, my assistant and I couldn't resist sitting on those stools, strumming randomly on banjo and guitar, and singing loudly, joyously and decidedly off-key to the vacant theater. Then we packed up and it was "On the Road Again."

Segue from three American musical forms to three American parades. First, there's the famously rowdy Mardi Gras celebration in New Orleans, where plastic beads are thrown from wildly elaborate floats, while spectators grasp anxiously for them, often seeking to exchange this otherwise worthless booty for a peek at a willing woman's bare bosom (98). My next parade shot was during the lengthy procession along Atlantic City's famed boardwalk the night before the crowning of the new Miss America. As I set up, I found

myself surrounded by a contingent of folks from Kenosha, Wisconsin, who had traveled more than a thousand miles to cheer on their home town girl. "Put her in your book," they earnestly pleaded. "She's wonderful; she's so beautiful." I'm sorry Kenosha—Miss Wisconsin was lovely, but I prefer my shot of a former titleholder, Kentucky's Heather Renee French (99). My final parade shot was taken during the Macy's Thanksgiving Day procession, whose route runs just 200 feet from my New York City loft. I looked forward excitedly to photographing Bart Simpson, who may be just an imaginary, illustrated character to some but who to me is a living idol. (Kudos to Time Magazine for picking Bart as one of this century's 100 most outstanding people.) The first year I spotted him in the parade it was raining and I couldn't get a good shot; the following year when the weather was good I didn't see him. Good grief! So I had to go with a shot of Snoopy, Charles Schulz's comic creation and an American icon in his own right (103).

If measured by money spent, gambling would be our most popular form of entertainment by far. I've read that more money is wagered on gambling than is spent on all other forms of recreation combined—some forty-five billion dollars of annual losses—a fair portion of which changes hands under the kitschy neon of Las Vegas, a relatively small city that has become the most popular tourist destination in the world (100).

Americans are nuts about amusement parks, where the roller coaster is king. People crave the thrill of hurtling around sharp turns and down precipitous dips at terrifyingly high speed in open cars. (This being America, the parks engage in an unending competition for the fastest...steepest...biggest...longest...most terrifying; the one in Paramount Park (101) claimed to be the longest—or was it the tallest?—wooden coaster.) I've ridden coasters exactly three times in my life. The first was when my kids were quite young and I thought they needed me along for security. The second was when my kids

were teenagers and I wanted to prove to them (and myself) that I could keep up. The third was with friends and I didn't want to be the only wuss in the group. All three times I got so dizzy and sick that it took the remainder of the day and a full night's sleep to recover fully. I've learned that coasters are definitely not *my* idea of entertainment, except when I'm photographing them.

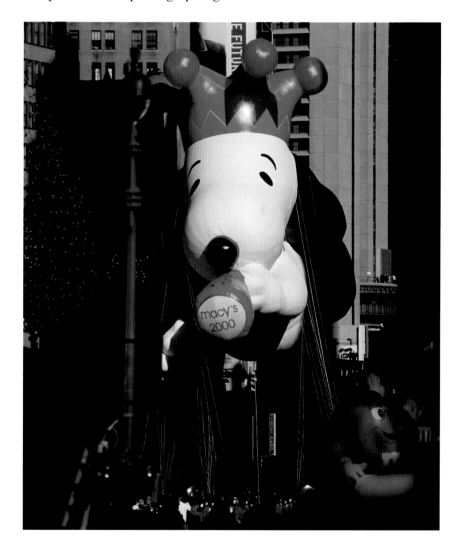

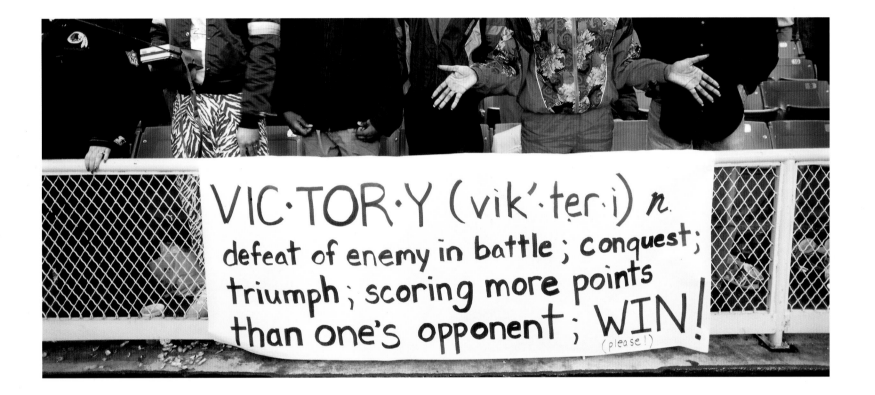

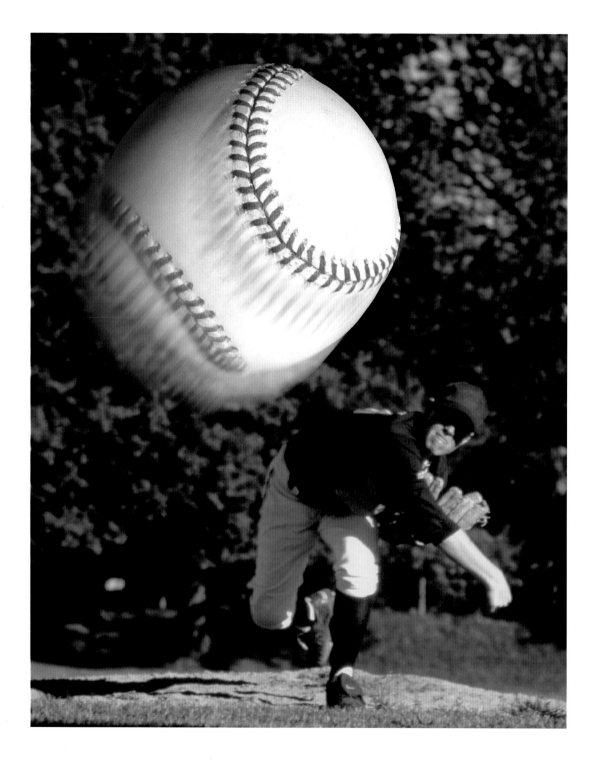

In baseball the ball is in play for around five minutes out of three hours—this makes baseball a game of anticipation, a game for the thinking fan.

W.P. Kinsella

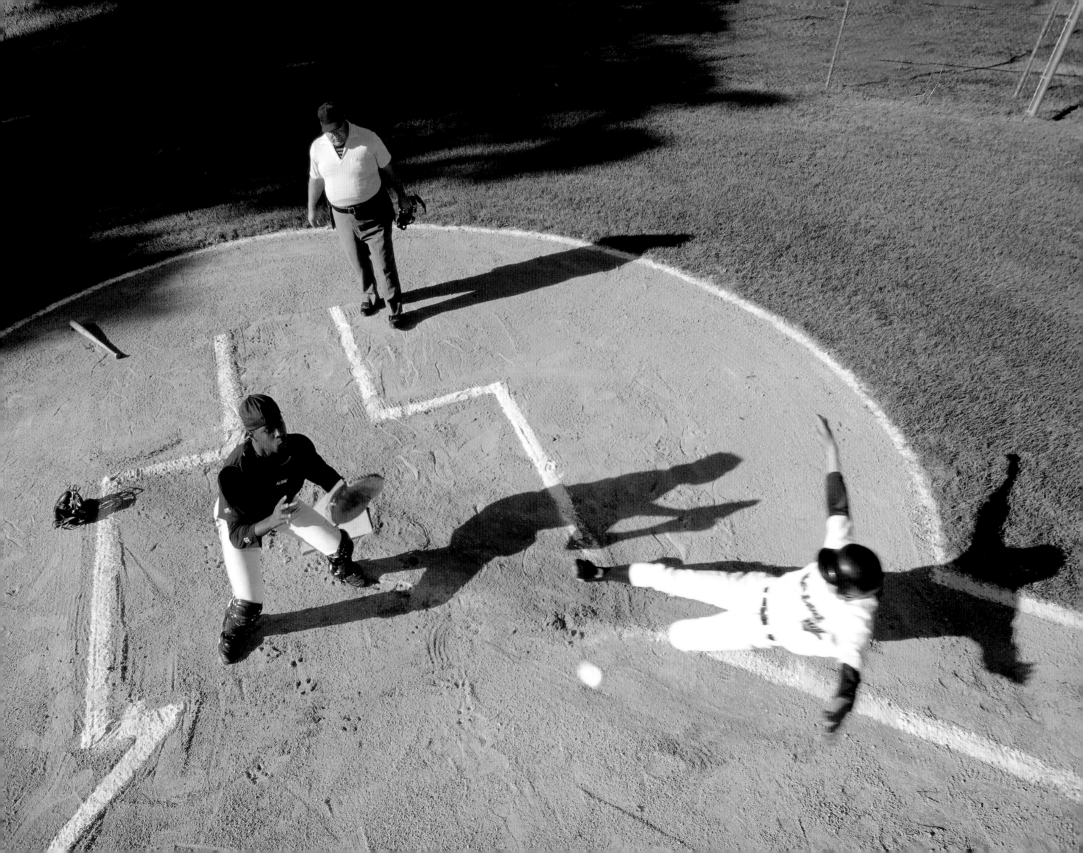

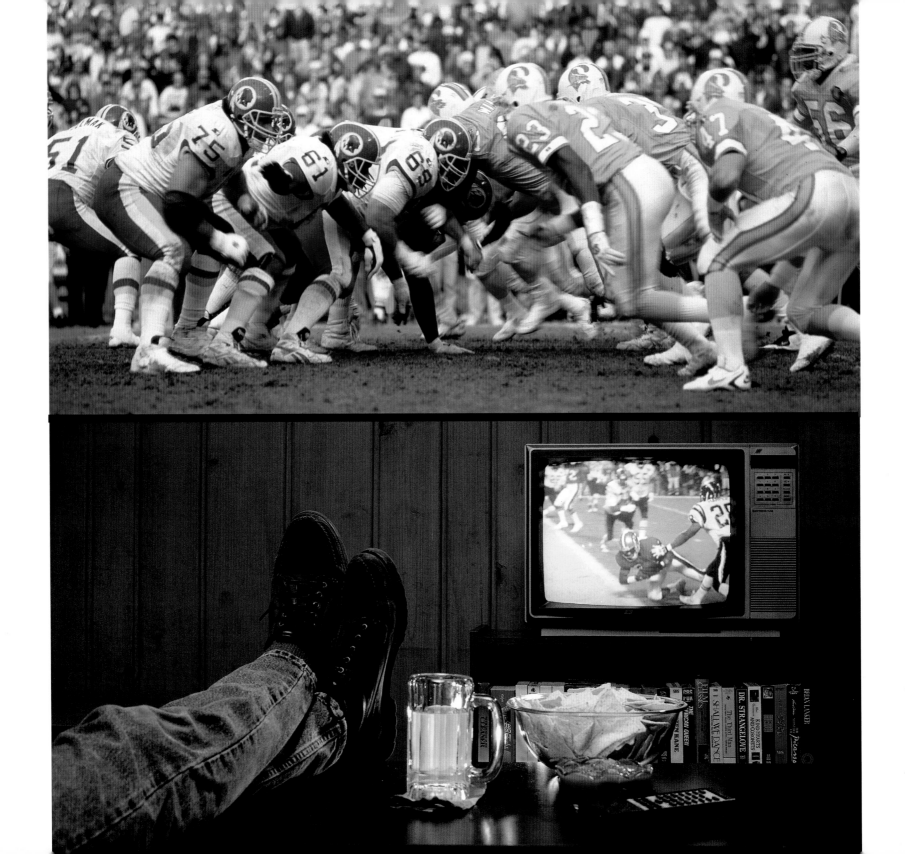

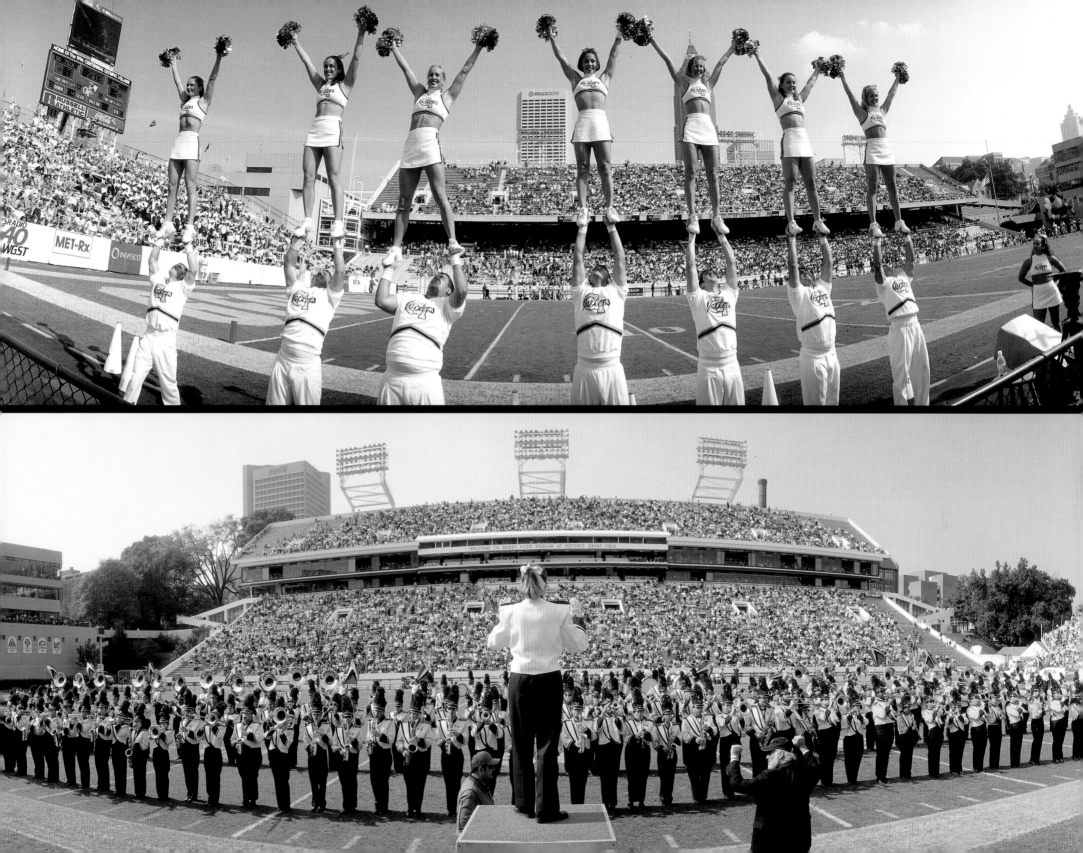

When I'm in the air, sometimes I feel like I don't ever have to come down.

Michael Jordan

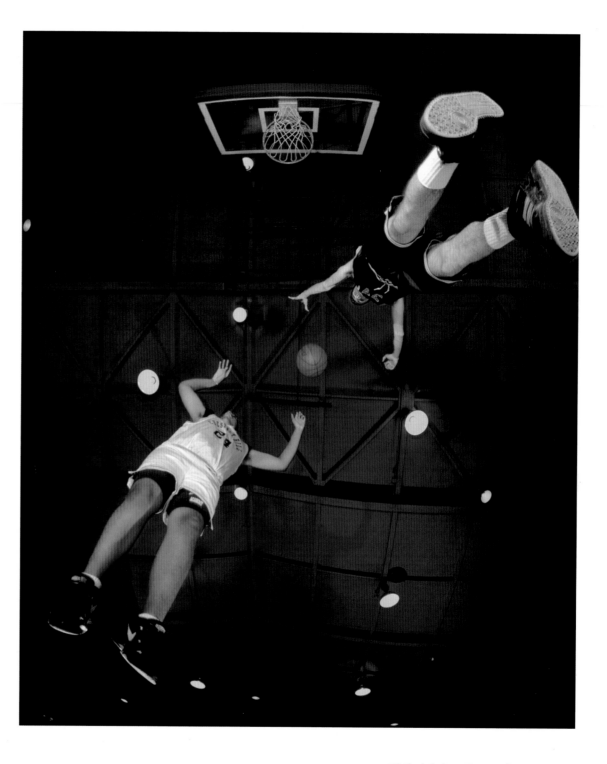

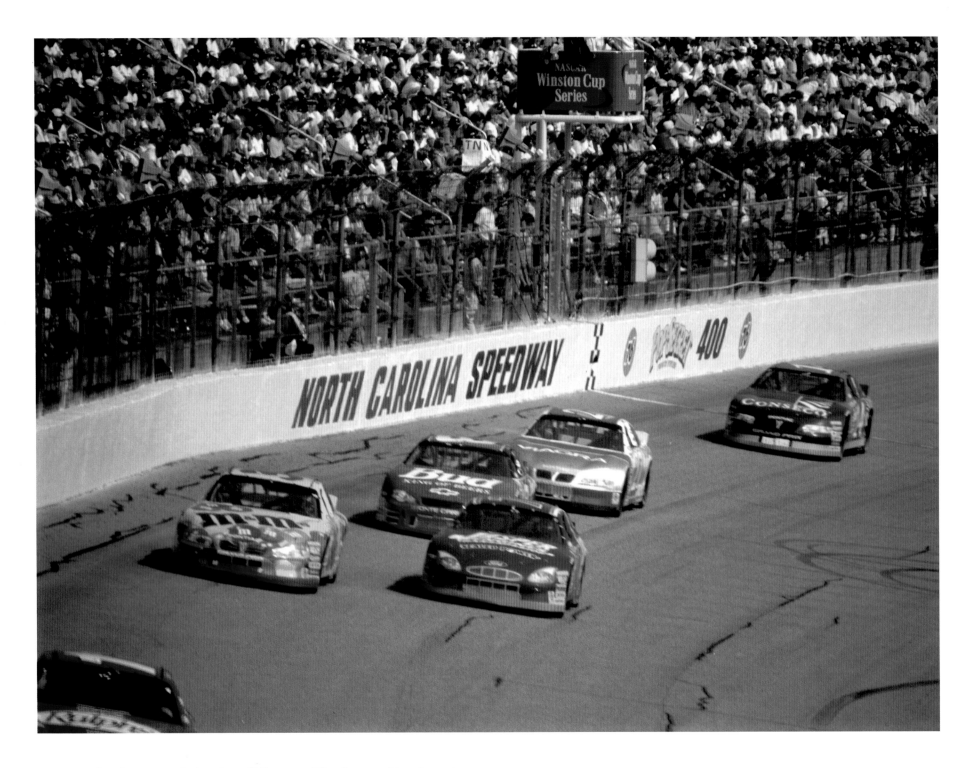

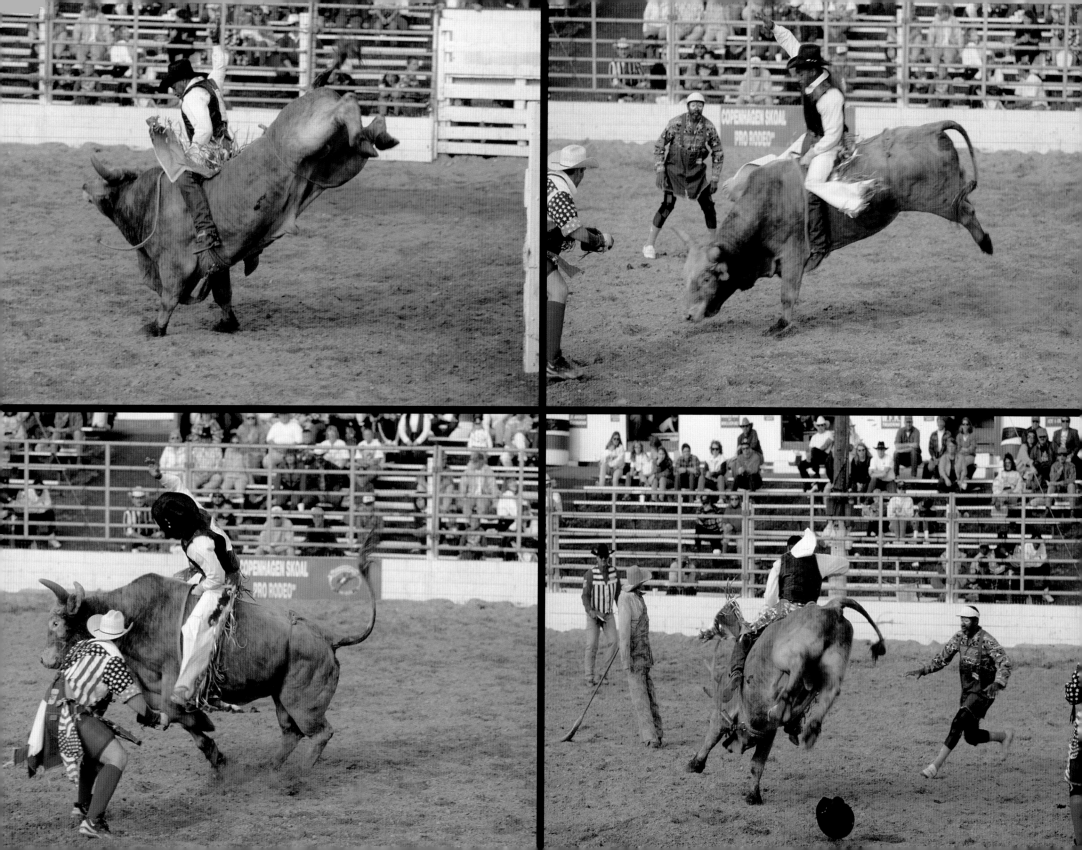

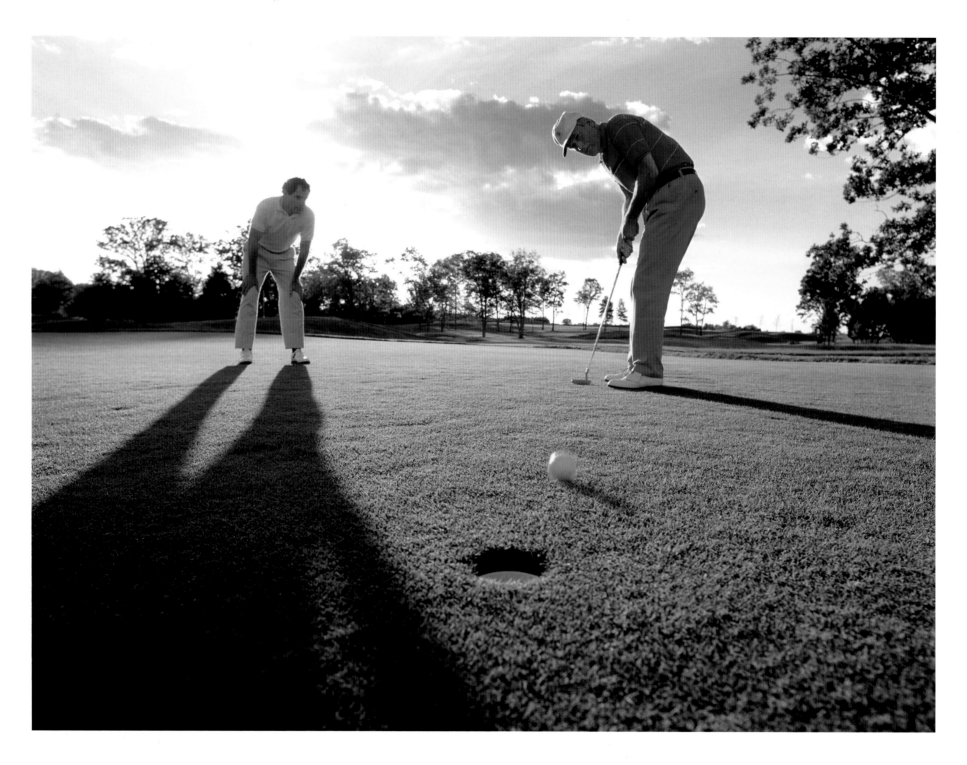

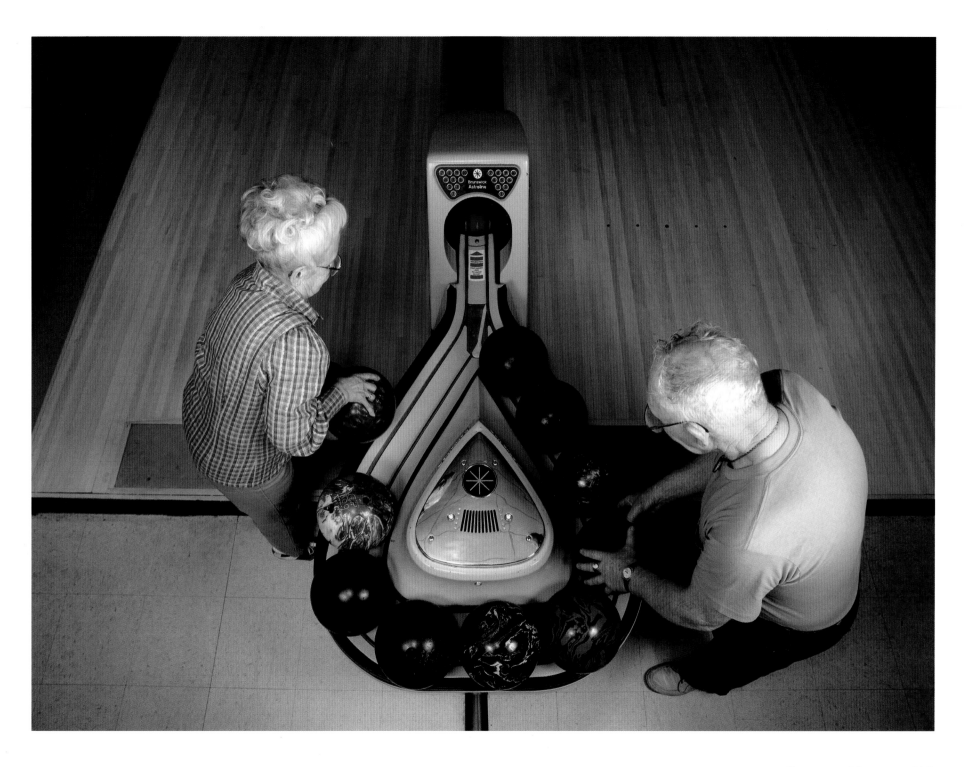

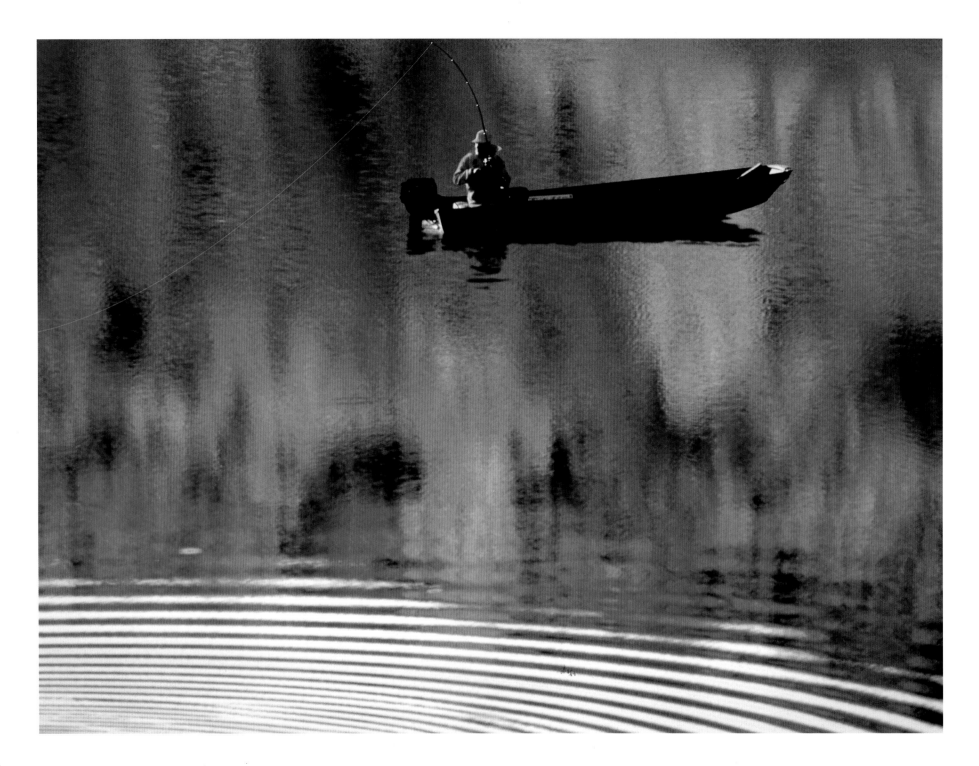

116 Susquehanna River, Pennsylvania

Bom Bom Dit Di Dit Dip
Bom Bom Dit Di Dit Dip
Surfin,' The Beach Boys

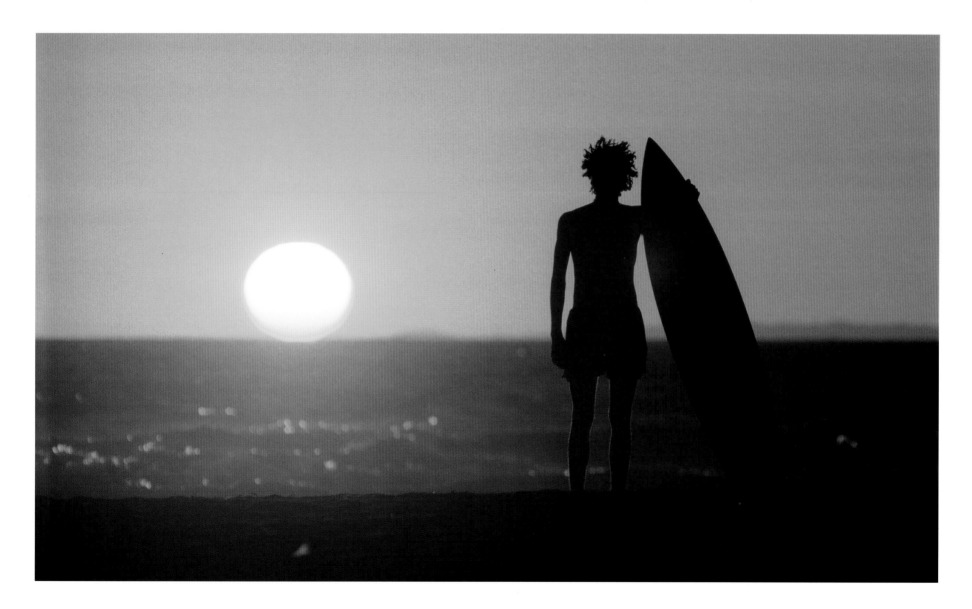

THE SPORTING LIFE

Americans are passionate about the sporting life: we play, we watch, we root, we read about, we bet on. We are more likely to be able to name the line-up of our favorite baseball team, the starting five of our basketball team and the quarterback and receivers of our football team as we are to name the nation's Vice President or either of our U.S. Senators.

When Americans talk about sports—any sports—the subject of winning is usually front and center. Our desire to come out on top is so fervent that sometimes I believe the three words we most want to hear are not "I love you," but "We're Number One." And so this chapter opened not with a shot of any particular sport but with a photo that reflects that attitude.

In discussing America's iconic sports one must begin, of course, with baseball, which is properly referred to as the national pastime because we truly pass so much time with it. As kids, almost all of us (at least the boys) played it. As adults, most of us stored our bats and gloves in the closet—except for the all-important father-son time together on the ball field—but we love to watch baseball, a fact which is reflected in the astronomical salaries of professional ballplayers and the fact that millions of us can cite team standings, batting averages and all the rest. Baseball serves, like the weather, as an almost universal subject for water cooler conversation. I've attempted to encapsulate the essence of baseball in two photos: the pitch and the play at the plate (106, 107). I felt that in photographing a pitched ball I'd get realistic results by having my camera just two or three feet from the catcher's mitt, which was truly scary; in hindsight, I can't recall why I held the camera myself rather than putting it on a tripod and firing it remotely, as I did in the basketball photo (111). (I did end up using "Photoshop" to create the illusion that the ball was just inches from my face.) In "the play at the plate" photo, I had a sharp altercation with the umpire; I wanted him to crouch down and put his arms in motion, while he insisted that to

be realistic he needed to stand tall and stolid. No one ever wins an argument with an ump.

Baseball is a non-violent game: when a pitcher hits the batter, he's penalized. But Americans also love gladiator-type contact sports, like football, where players are *supposed* to hit one another, very hard and very often. At a Washington-Tampa Bay game, whenever the players were running anywhere near my direction, I felt like a small parked car facing a pack of runaway eighteen-wheelers (108).

The game of football is intimately associated with three things that in themselves have iconic status: first, the couch potato and his favorite companions, pretzels, beer, chips and salsa; second, half-time's favorite companions, the members of the marching band, which in the case of Georgia State must exceed in numbers a major symphony orchestra; and finally, everyone's favorite companions, cheerleaders (also Georgia State), whose first "Sis, Boom, Bahhhh" was chanted just after the Civil War. Cheerleading has itself evolved into such an intensely competitive acrobatic activity that, ironically, cheerleaders sustain more injuries than the football players for whom they cheer (108,109).

A third hugely popular American sport is basketball. I caught playground action in lower Manhattan, while the jump ball was between a couple of prep school players at Chestnut Hill Academy in Philadelphia (110,111). For that second shot, my most expensive camera and lens were laying on the floor, directly under those four large, leaping feet, but I wasn't worried; basketball players are big, very big, but they move with the finesse of dancers who know how to hit a mark. (Incidentally, if this book had a chapter on "iconic clothing," then the sneakers on their feet would surely warrant inclusion.)

NASCAR racing and rodeo competitions are also enormously popular American spectator sports with devoted followings (112,113). NASCAR routinely packs 70,000 seat tracks, even those far from major population centers, like Rockingham, North Carolina,

pictured here. In contrast to baseball, football and basketball, all of which I played in my childhood, I'm relatively clueless about these two sports. While the subtleties of car racing and rodeo may escape me, both are full of intense and colorful action that make picture taking exciting, even for an unschooled observer.

I think of this chapter as divided into two sections: sports that people watch more than play (baseball, football, basketball, car racing and rodeo) and sports that people play more than watch (golf, bowling, fishing, surfing.) Golf is played by twenty-six million Americans. I caught up with these two gents putting on a Virginia course (114). As for bowling, in 1997 an astounding fifty-three million Americans bowled at least once, making it the game most people play in the United States. My "models," whom I found in an alley in Bozeman, Montana, were reluctant to take a short break from their bi-weekly senior league to pose for me. A sympathetic woman rescued me: "Horace, for goodness sake, can't you see the man needs our help; now you just put down that ball and come over here with me for a few minutes." (115). I have no idea whatsoever how many people participate in sport fishing, but at one time or another nearly everyone has thrown a line in the water...though rarely in as colorful a setting as the one I found on the Susquehanna River in central Pennsylvania, where the fisherman was so lost in thought he never saw me taking this picture (116). To close the chapter: a California surfer at sunset, reflecting on a day of riding the waves (117). Surfing—along with its progeny windsurfing, snowboarding, and skateboarding—doesn't have nearly the broad participation of the other sports in this chapter, but all are as American as, well, the Beach Boys.

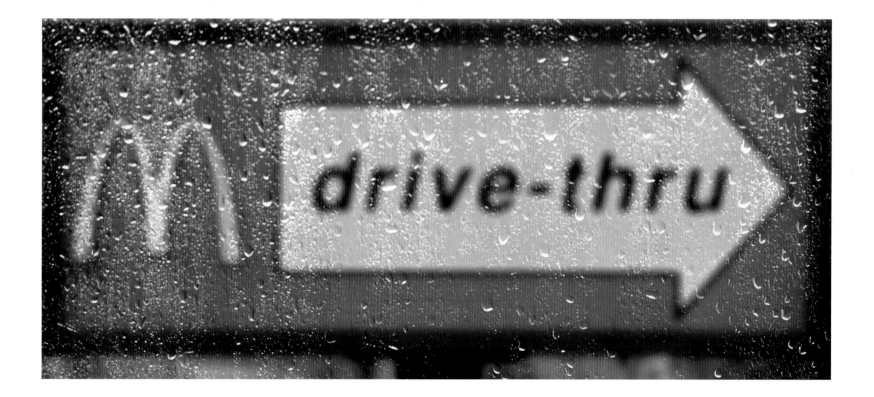

5.5 billion hamburgers and cheeseburgers were served in restaurants.
National Cattleman's Beef Association, 1997 Statistics

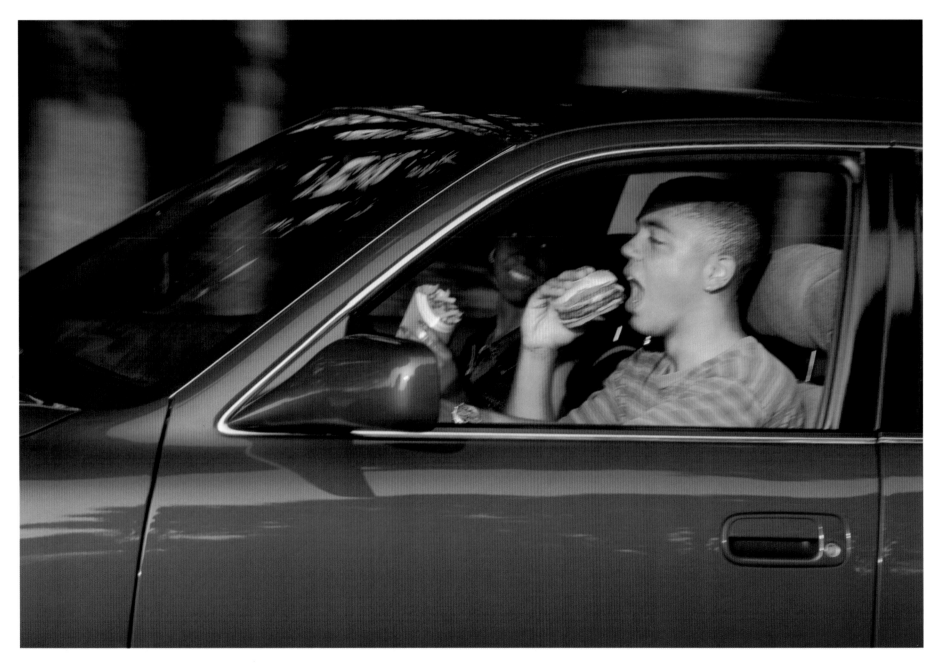

A hot dog at a ball park tastes better then a steak at the Ritz.

Humphrey Bogart (in ad to promote baseball)

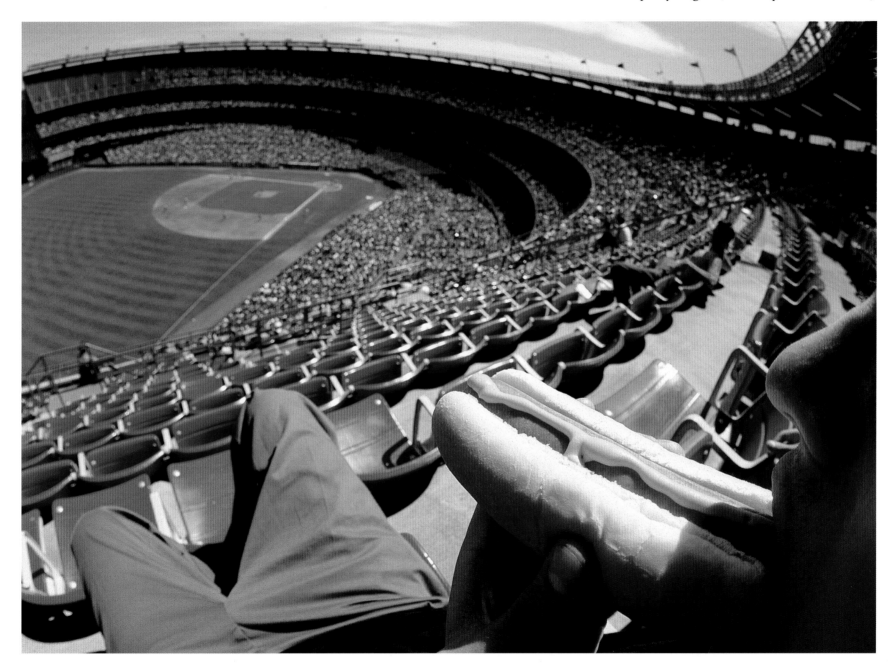

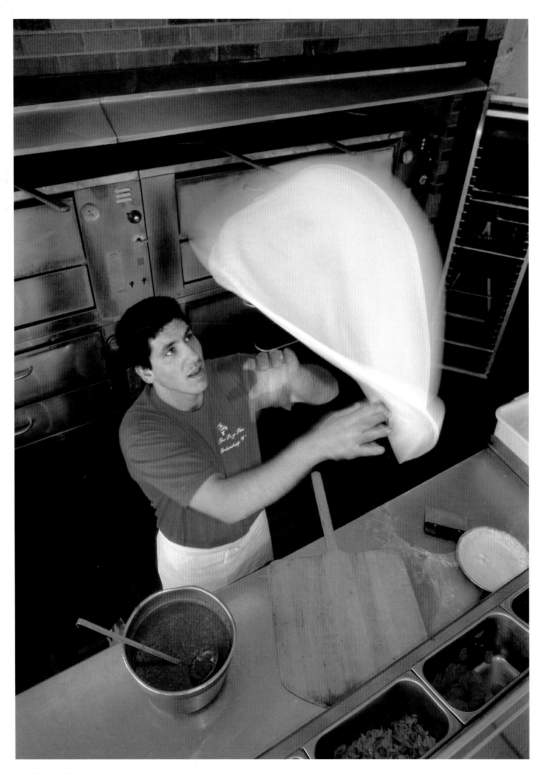

We live in an age when pizza gets to your home before the police.

Jeff Marder

We need a new bottle—a distinctive package that will help us fight substitution... we need a bottle which a person will recognize as a Coca-Cola bottle even when he feels it in the dark.

Benjamin Thomas, Coca-Cola bottler, 1910

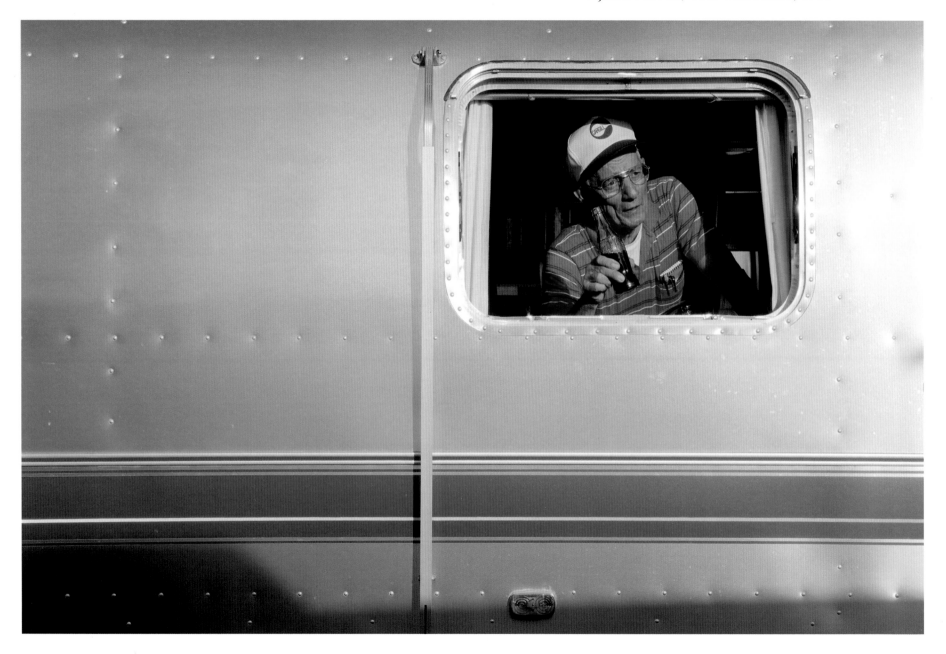

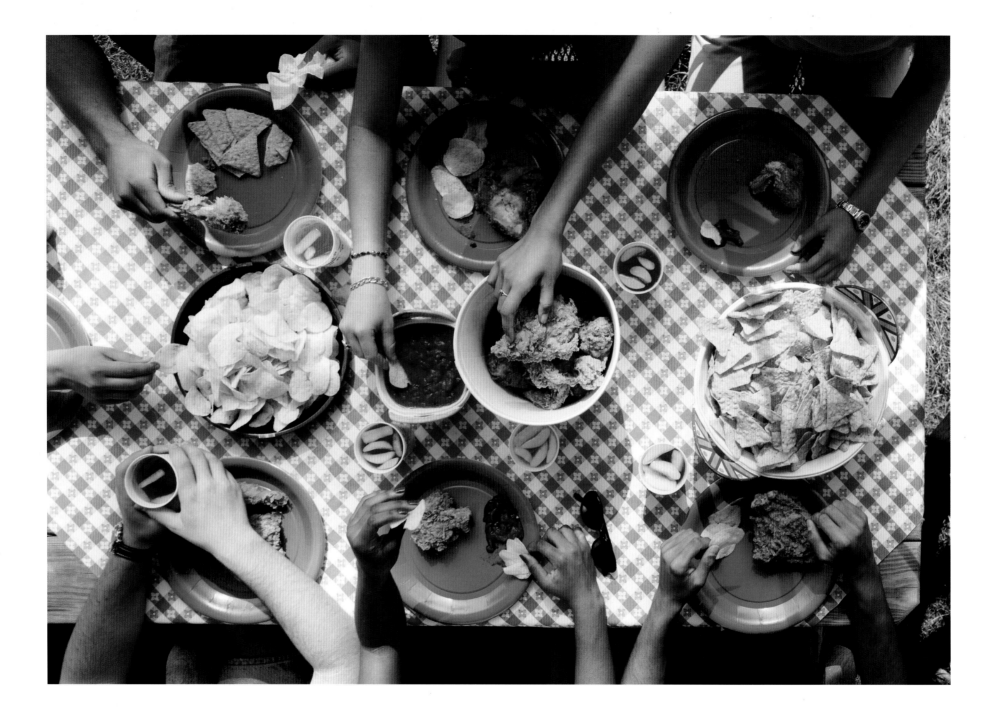

I unconsciously decided that, even if it wasn't an ideal world, it should be and so painted only the ideal aspects of it—pictures in which there are no drunken [women] or self-centered mothers...only foxy grandpas who played baseball with the kids and boys who fished from logs and got up circuses in the back yard.

Norman Rockwell

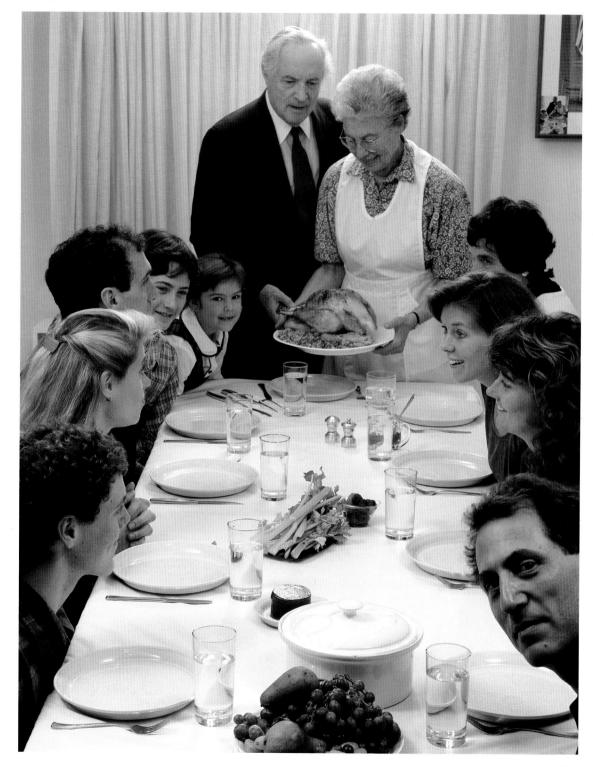

AMERICA'S PALATE

Our nation's favorite foods are characterized more by speed of delivery, convenience and predictability than by taste. We are a nation of drive-thrus, take-outs, frozen dinners and food courts. The quintessentially American foods can be cooked and served in a flash and vary relatively little from meal to meal; they can also be held in one hand and eaten without utensils...all the better for dashboard dining, my dear. I may bemoan the prosaic state of the American palate, but confess that when I'm on the road (and sometimes even when I'm at home) I've ingested my share of those billions and billions served.

My opening shot of a drive-thru sign is followed, naturally enough, by a burger being eaten at the wheel: classic American food in a classic American dining context (122). The same could be said of a mustard-topped hot dog at the ballpark (123). Yet another American classic, notwithstanding any possible native Italian connection, is pizza, now a thirty-two billion dollar a year industry. Pizza fits all the criteria of American iconic food: fast, convenient and definitely predictable—the pizza that's served in Parkersburg, West Virginia (124) was essentially the same as what I get at Sixth Avenue and Thirty-Seventh Street in Manhattan. Of course living in New York City has its distinct advantages: within three blocks of my apartment are six, yes six, pizzerias. And I have a far wider choice of toppings than the folks in Parkersburg.

In the past two decades bagels have exploded like wildfire nationwide. In addition to being fast, convenient and predictable, these doughy rings with the ethnic (Jewish) background are a multifaceted wonder: they can be eaten unadorned or with butter or cream cheese; toasted or as is, by themselves or as a substitute for sandwich bread; and they run the gastronomical gamut from "plain" to "everything." Now you might argue that the bagel needs to be part of our nation's food culture for a longer period before it becomes an icon.

If so, then let me use this platform to *nominate* the bagel for exalted icon status; like nominating a great athlete to the Hall of Fame, it's only a matter of time before there is universal agreement that the bagel be inducted.

Compiling my list of icons was very much a personal exercise, but I am always curious about other people's opinions and so I frequently ask: "What do *you* think are the greatest symbols of our country." And what answers are most common? The American Flag? Baseball? The Grand Canyon? Nope. The hamburger? The Empire State Building? Niagara Falls? Wrong again. The Statue of Liberty? Mount Rushmore? Still no. Believe it or not, as Mr. Ripley would say, the two most common icons people have mentioned to me are: diner and apple pie. There aren't many diners around any more (they've got variety but lack the speed of fast food), and I'll bet hundreds of bagels are consumed for every apple pie, but I honor the voice of the people with a shot of Philadelphia's "Nifty Fifties Diner" (a fun reproduction of the old classic) and an apple pie shot, a la mode with vanilla ice cream, the flavor that accounts for one quarter of all the ice cream sold in America (126,129). Please to note: apple pie is my only American icon food (along with the corn flakes on the next page) that requires a utensil.

The candy bar surely qualifies as an icon, but which one to choose: Snickers? Milky Way? M & Ms? I wasn't able to single out one over the others (though I did put M & Ms on the back cover), so I played it safe with a candy stand inside a movie theater (127).

"Coke": possibly the most universally understood word in the world. With some *one billion* servings of Coca-Cola Company soft drinks consumed each and every day worldwide, it's easy to see why. I found one of those servings (in a classic bottle) in the hand of a gent who was part of a gathering of owners of the distinctive aluminum-shelled Airstream trailers in Xenia, Ohio (128). He agreed to let me photograph him *only* if I solemnly promised that I would not let the

picture be used for any immoral or un-American purpose. I trust he'll find that I've kept my word.

Fried chicken, chips, salsa and soft drinks (130). If I were a judgmental individual, this would surely be an appropriate place to mention America's problems with weight and cholesterol. I might note that with regard to food, we are high on quantity, low on nutritional value. But a book about icons is not the proper place to carp so I'll hold my tongue and simply say: "Hmmm, finger-lickin' good."

At least one day a year most of the nation shuns fast food and eats a normal-paced meal. Thanksgiving Day, that great non-commercial holiday when family and friends get together to enjoy turkey and ham, potatoes, stuffing, and gravy, cranberries and pie...and each other. It's a day when food—real home-cooked food—is front and center and we express gratitude for our country's extraordinary abundance. To capture the spirit of Thanksgiving, or perhaps you might say its *idealized* spirit, I chose to replicate a famous painting by that most iconic of American artists, Norman Rockwell, using friends and members of my own family as models (131). In deference to the artist, I placed in the upper right corner of my own photo a postcard version of Rockwell's painting; it's somewhat out of focus so you can't quite make out the artist's face in the lower right corner of the postcard, looking back at himself just like, well...

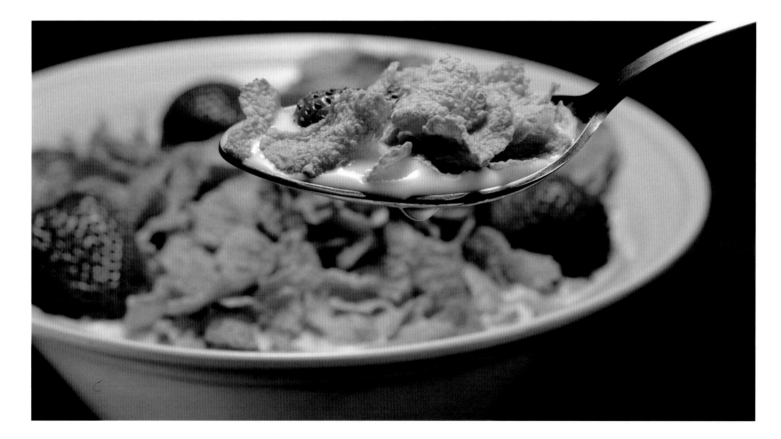

ARCHITECTURAL TAPESTRY

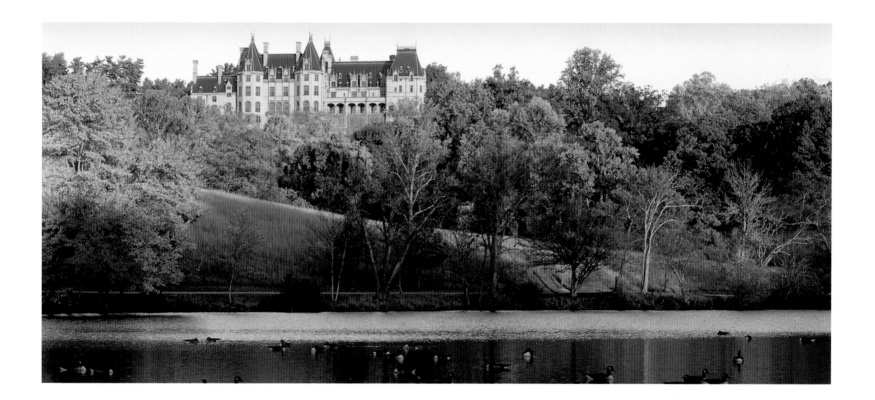

So committed was Washington to rebuilding his house that during the most intense battles of the Revolution he kept the work going, and wrote weekly from the front to his construction managers.

Paul Goldberger

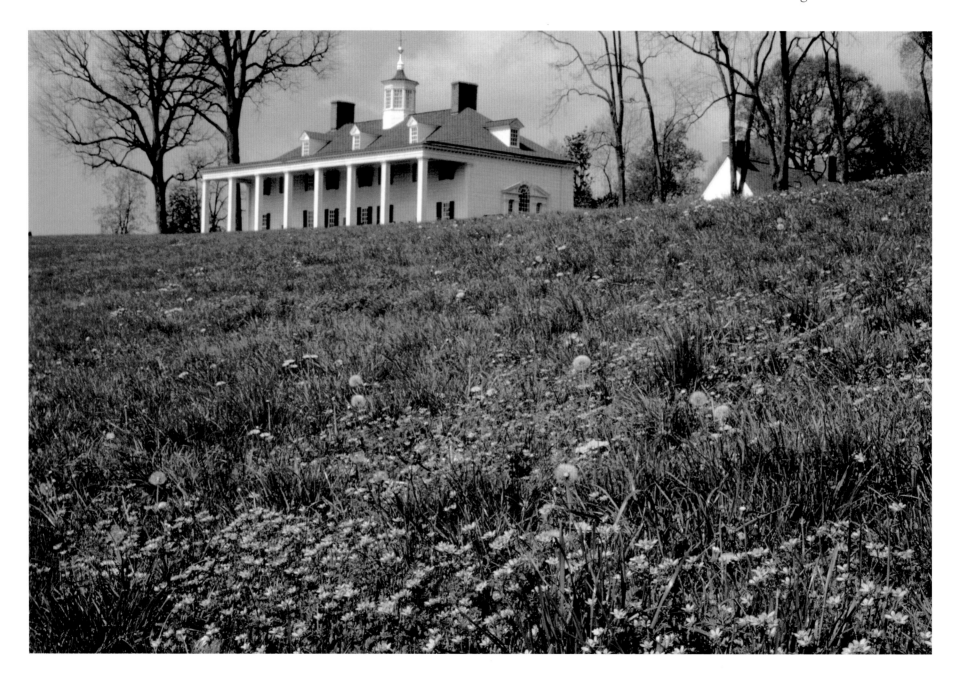

After months the cabin stood up, four walls fitted together with a roof, a one room house 18ft square, for a family to live in. A stick chimney plastered with clay ran up the outside. The floor was packed and smoothed dirt. A log fire lighted the inside; no windows were cut in the walls. For a door there was a cut to step through.

Carl Sandberg, *Abraham Lincoln: The Prairie Years*

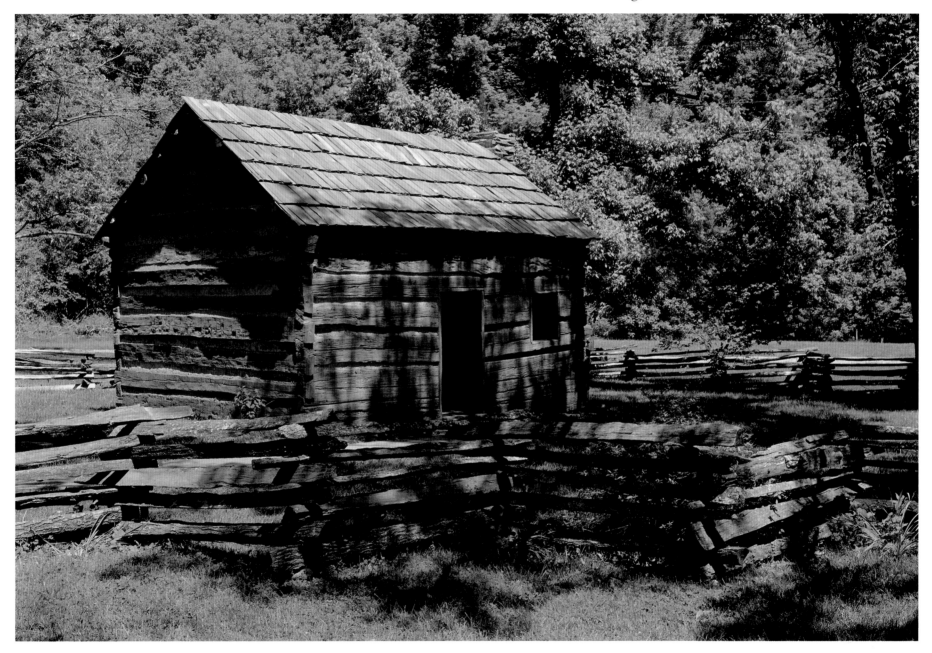

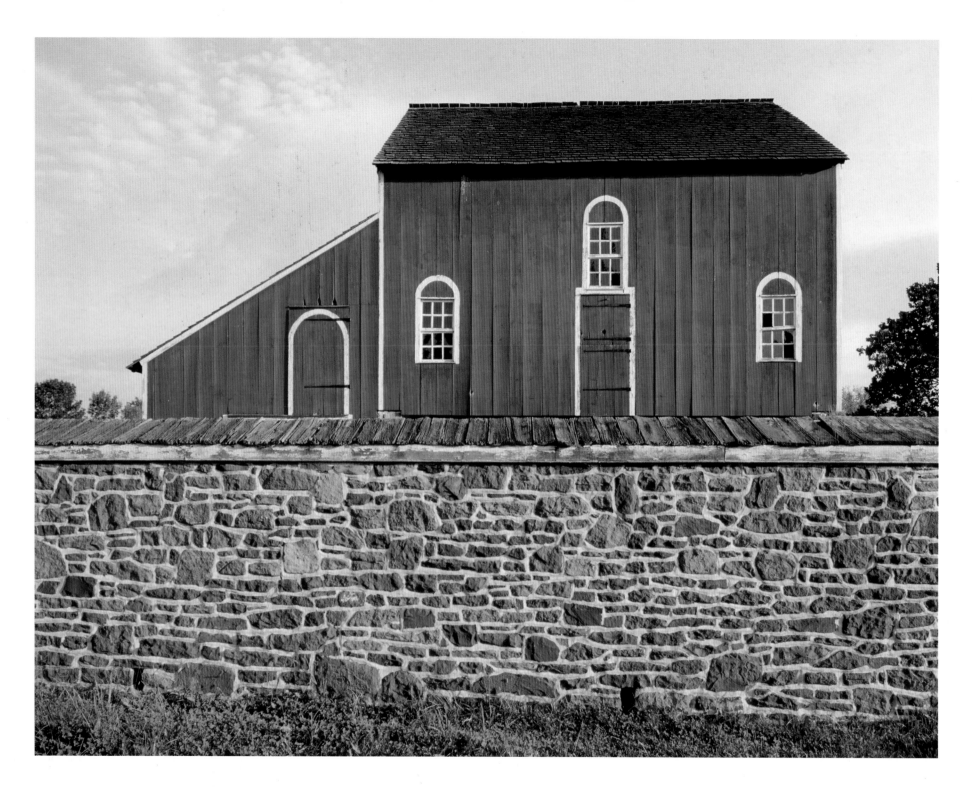

"Do you stand there Scarlett O'Hara, and tell me that Tara—that land—doesn't mean anything?....Land is the only thing in the world that amounts to anything...for 'tis the only thing in this world that lasts, and don't you be forgetting it! 'Tis the only thing worth working for, worth fighting for, worth dying for."

Margaret Mitchell, *Gone With the Wind*

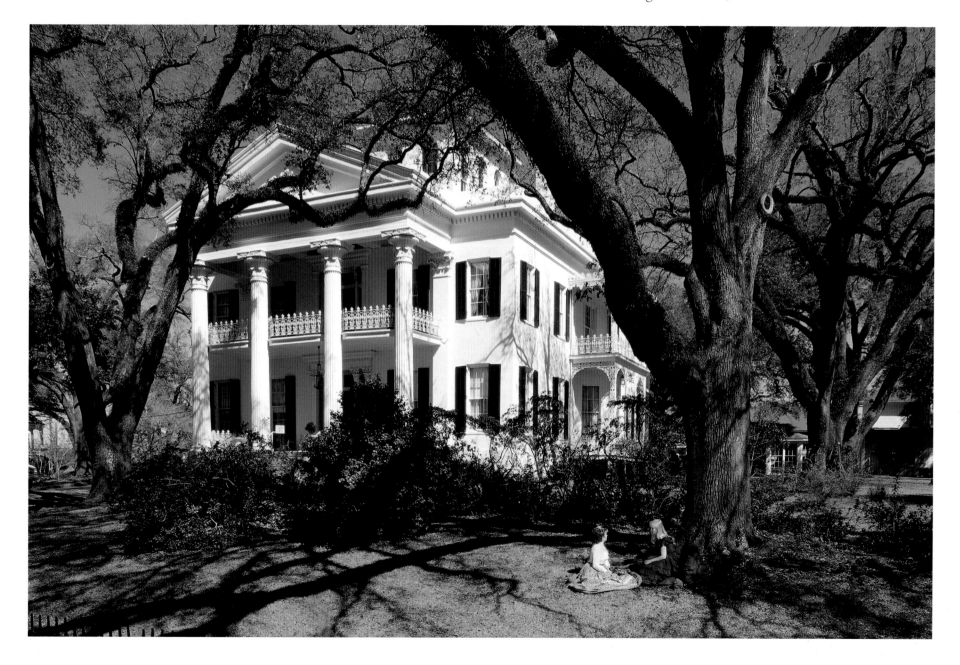

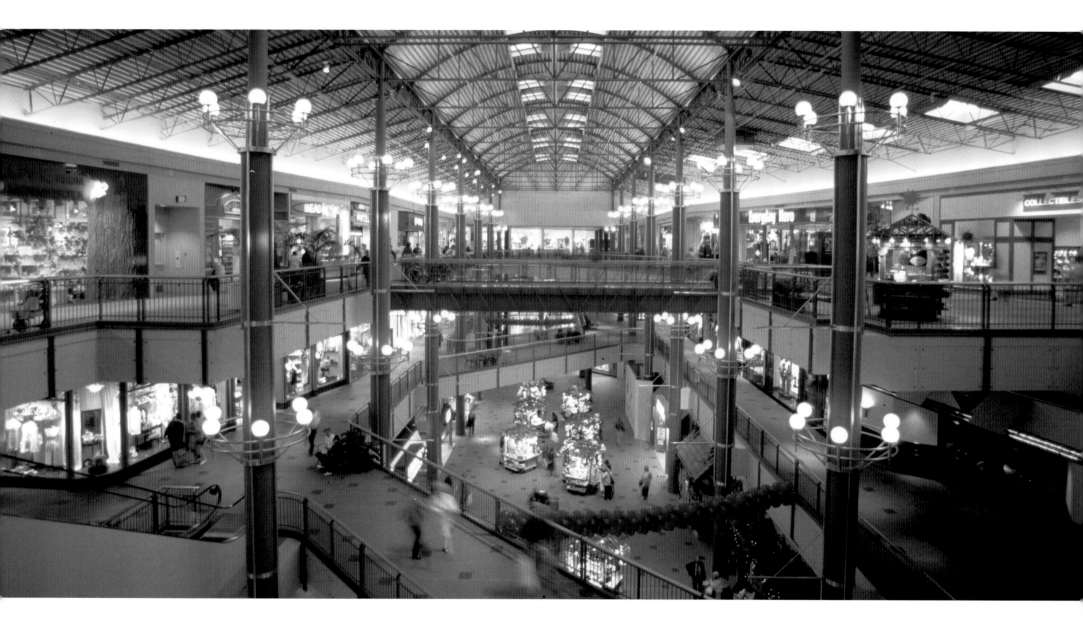

ARCHITECTURAL TAPESTRY

There is no particularly iconic style of American architecture, to my knowledge, but no survey of our nation's icons would be complete without looking at a few notable examples of architecture. First, the Biltmore estate in the rolling hills of western North Carolina (135). Sitting atop a hill on a modest plot of 125,000 acres, this is the nation's largest home (255 rooms) and the most notable of over two dozen mansions built by three generations of the Vanderbilt family. The Biltmore stands as the preeminent symbol of the many mansions built during the so-called "Gilded Age" of the late 1800s and early 1900s, many of which are stunningly clustered together in Newport, Rhode Island. I find myself simultaneously repulsed by the ostentatious display of wealth and enthralled by the extraordinary aesthetic majesty. Palatial homes are not unique to the United States, of course; what is particularly American is that they were built by private citizens, not royalty.

On top of another hill, this one overlooking the Potomac River in Mount Vernon, Virginia, lies the beautifully preserved home of George Washington, meticulously designed by the president himself (136). Also preserved are the quarters of his slaves who, significantly, were freed upon his death.

Alongside a remote Kentucky back road is a replica of the one-room log cabin where Abe Lincoln lived as a child along with five other family members. Lincoln's ascension to the presidency from such humble roots (along with the seven other presidents who were to the log cabin born) is a powerful symbol of the opportunity in our society for anyone, even those from the most humble background, to rise to the very highest positions (137). Incidentally, the caretaker waived the one dollar admission fee because I was a *professional* photographer...such are the impressive perks of my business.

The percentage of our population that is involved in farming has decreased dramatically over the years (72 percent in 1820; 37 percent in 1900; 2.5 percent in 1994), but barns are in evidence literally everywhere except within major metropolitan areas. The classic example in my photograph was on a farm once owned by the famed Appalachian mountain trailblazer Daniel Boone (138). (Incidentally, the barn was set back fifty feet from the stone wall but in a visual illusion appears to sit right on top of it.)

Many large plantation homes are preserved throughout the South, like Stanton Hall in Natchez, Mississippi. From the second story balcony of such homes, the owner could survey the lowland fields where his slaves picked cotton. These ante-bellum (pre-Civil War) mansions are forever etched in our minds as "Tara" in *Gone With the Wind* so, accordingly, I placed a couple of latter-day Scarlet O'Hara's under a tree in the yard (139).

Christmas lights symbolize not just Christmas in America but home and hearth. Behind those lights in the home's interior is our Rockwellian vision of families throwing tinsel on a tree, opening gifts, telling stories by the fire and sleeping cozily under quilts. This private home in Silver Spring, Maryland, gets so happily carried away every year with ornamentation that it has become a tourist attraction (141).

With 13,000 parking spaces, 4.2 million square feet, and a small roller coaster in its atrium, the Mall of America was, and may still be, the nation's largest shopping center (140). I can think of no more American architectural form, apart from the skyscraper, than the shopping mall; the first one opened in 1929, and now they are found everywhere. The hours and dollars that are spent within these walls are staggering. "Shop till you drop" is not a curse: it's the the great American fantasy. (Given the passion for shopping, perhaps this picture would have been better placed in the "That's Entertainment" chapter.) If I had a single hour to show the essence of America to a foreigner, I might take him or her to such a mall: consumption, variety, efficiency, convenience, wealth, and all those different faces.

Closing out this short chapter are three distinct American

architectural shapes: first, the castle of the Smithsonian Institution in Washington, D.C., the most recognizable building within the vast and most visited museum complex in the world; next, the Pentagon, home of the Department of Defense, a building so massive that unless you are in the air it is difficult to visualize the geometrical shape from which it derives its name; and finally, the grain elevator, a fixture of our upper Midwest agricultural region and generally the only visible man-made landmark on the horizon.

WAR AND REMEMBRANCE

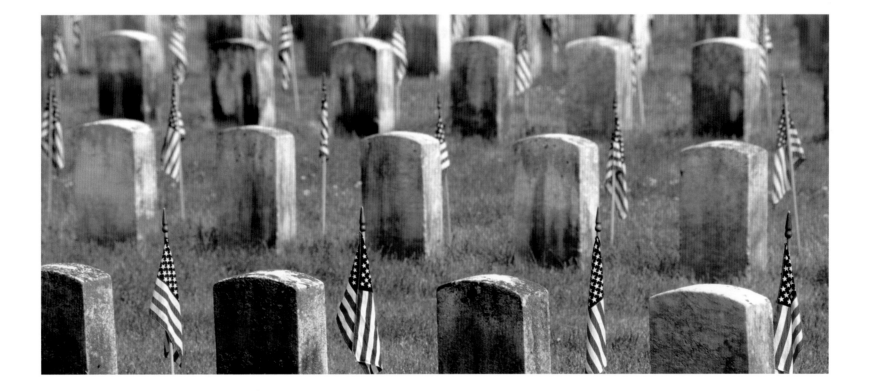

Four score and seven years ago our fathers brought forth on this Continent, a new nation, conceived in Liberty, and dedicated to the proposition that all men are created equal.

Now we are engaged in a great civil war, testing whether that nation, or any nation so conceived and so dedicated, can long endure. We are met on a great battle field of that war. We have come to dedicate a portion of that field, as a final resting place for those who here gave their lives, that that nation might live. It is altogether fitting and proper that we should do this.

But, in a larger sense, we can not dedicate — we can not consecrate — we can not hallow — this ground. The brave men, living and dead, who struggled here, have consecrated it, far above our poor power to add or detract. The world will little note, nor long remember what we say here, but it can never forget what they did here. It is for us the living, rather, to be dedicated here to the unfinished work which they who fought here have thus far so nobly advanced. It is rather for us to be here dedicated to the great task remaining before us — that from these honored dead we take increased devotion to that cause for which they gave the last full measure of devotion — that we here highly resolve that these dead shall not have died in vain — that this nation, under God, shall have a new birth of freedom — and that government of the people, by the people, for the people, shall not perish from the earth.

Abraham Lincoln.

November 19. 1863.

146 Gettysburg, Pennsylvania (preceding: Antietem, Maryland)

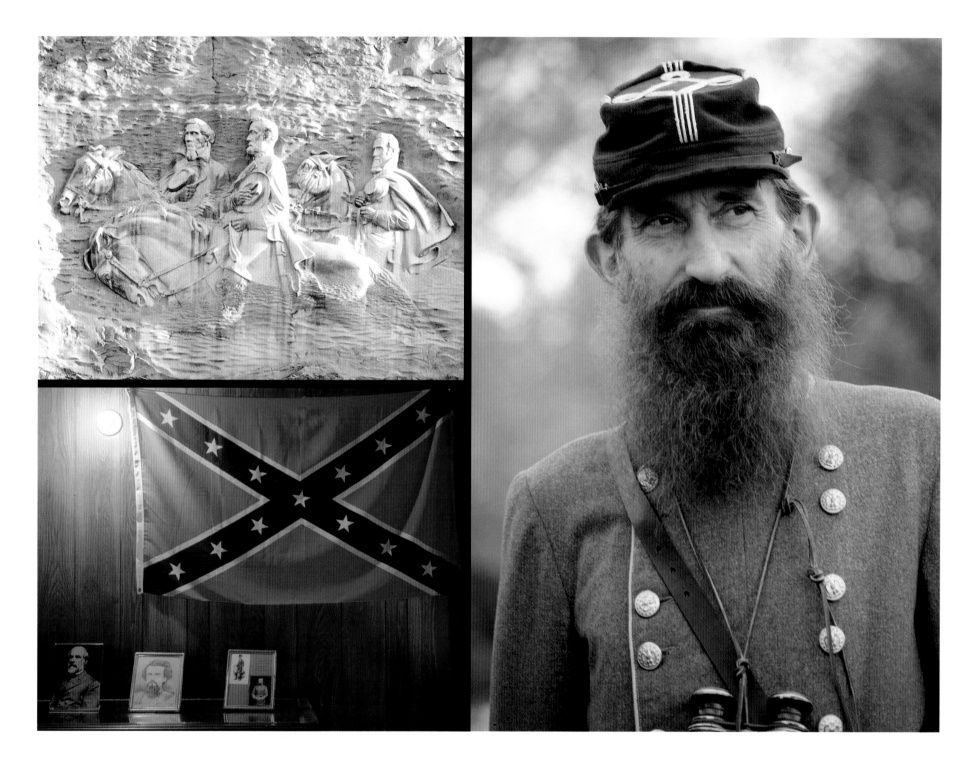

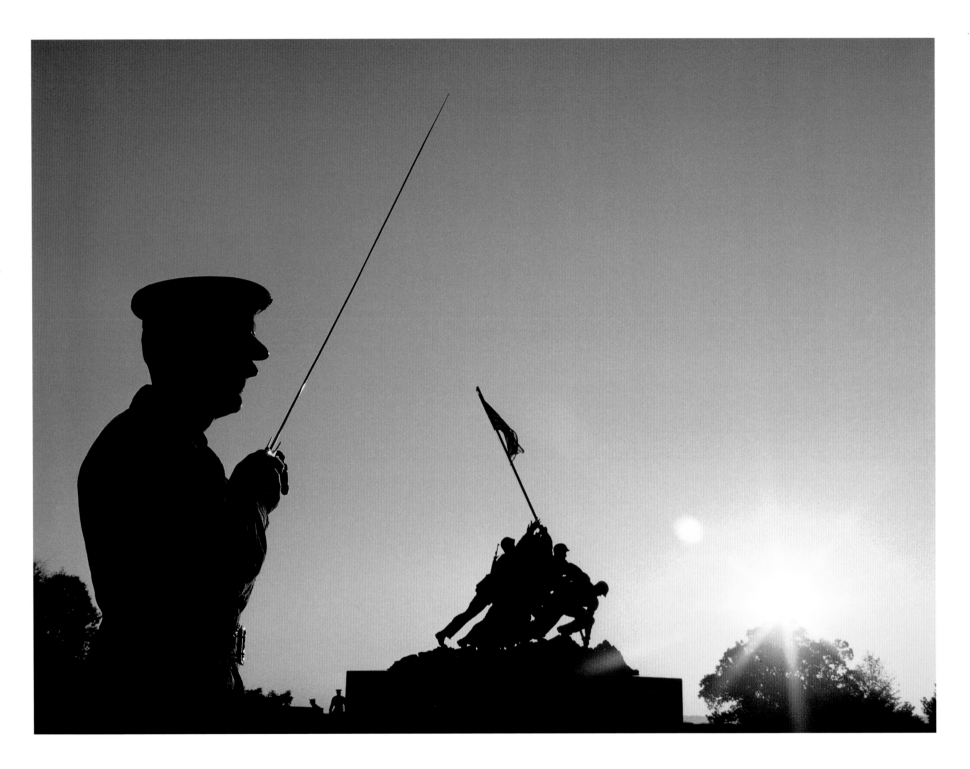

148 Iwo Jima Memorial, Rosslyn, Virginia

Patriotism is not a short and frenzied outburst of emotion but the tranquil and steady dedication of a lifetime.

Adlai Stevenson

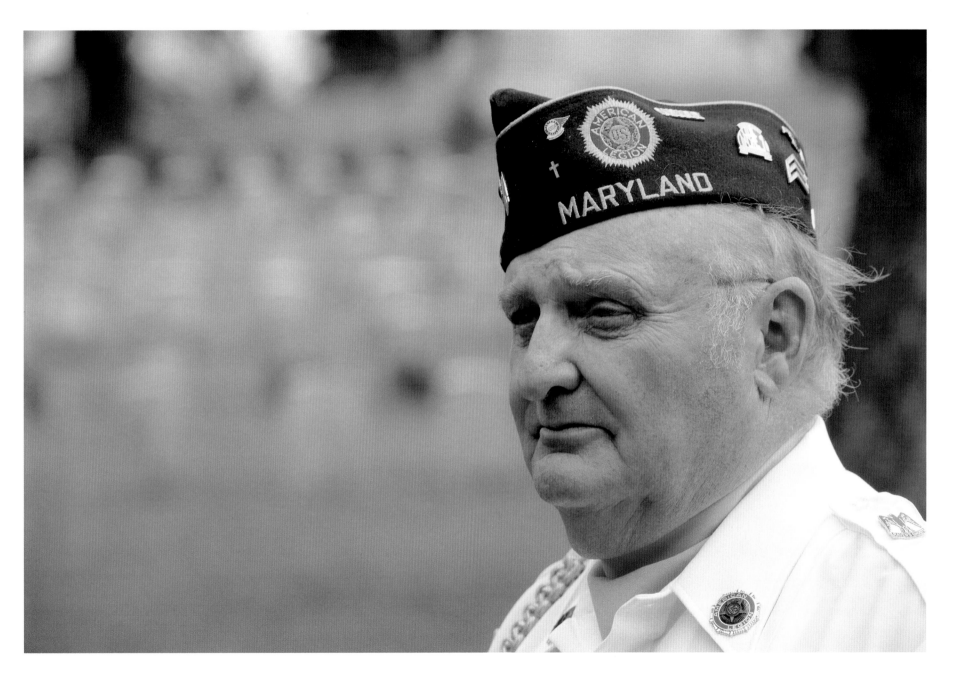

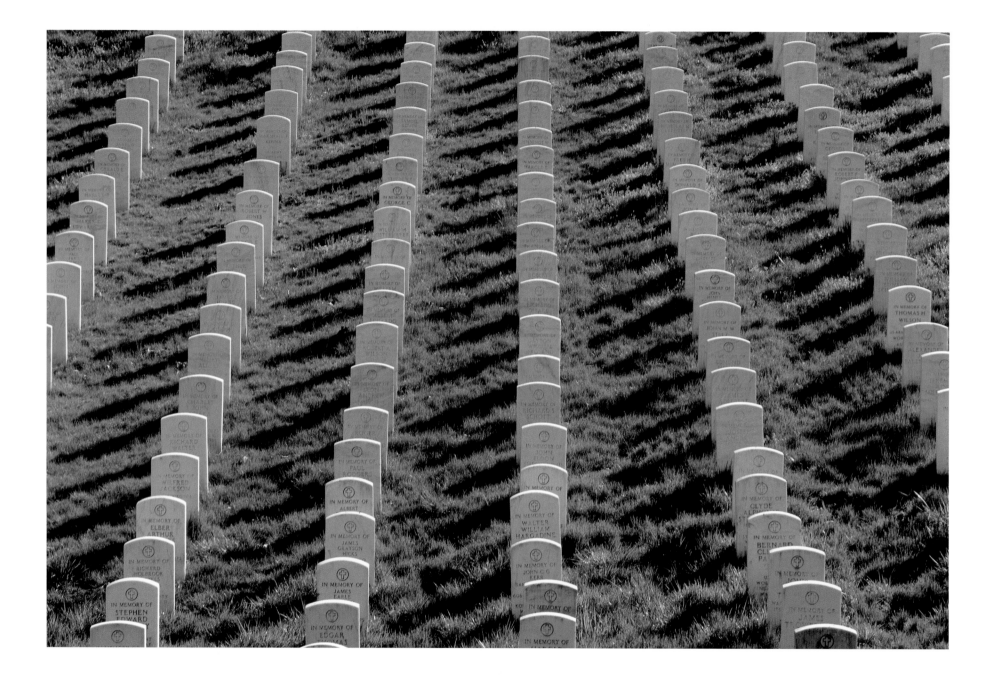

150 Arlington Cemetery, Arlington, Virginia

We shall pay any price, bear any burden, meet any hardship, support any friend, oppose any foe, to assure the survival and the success of liberty.

John F. Kennedy

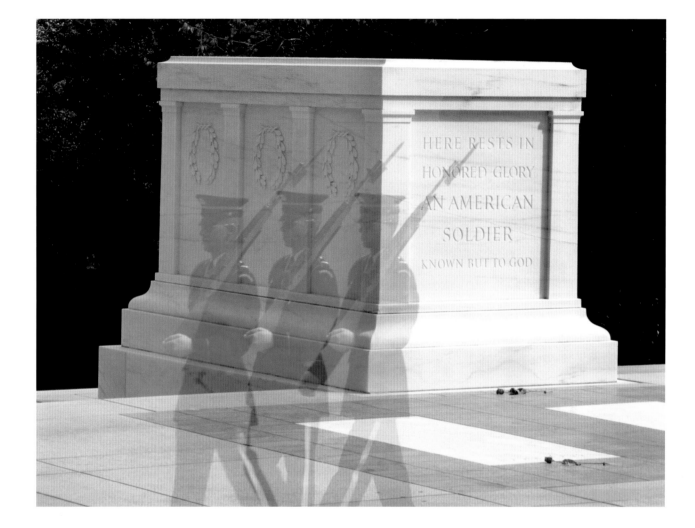

HERE RESTS IN
HONORED GLORY
AN AMERICAN
SOLDIER
KNOWN BUT TO GOD

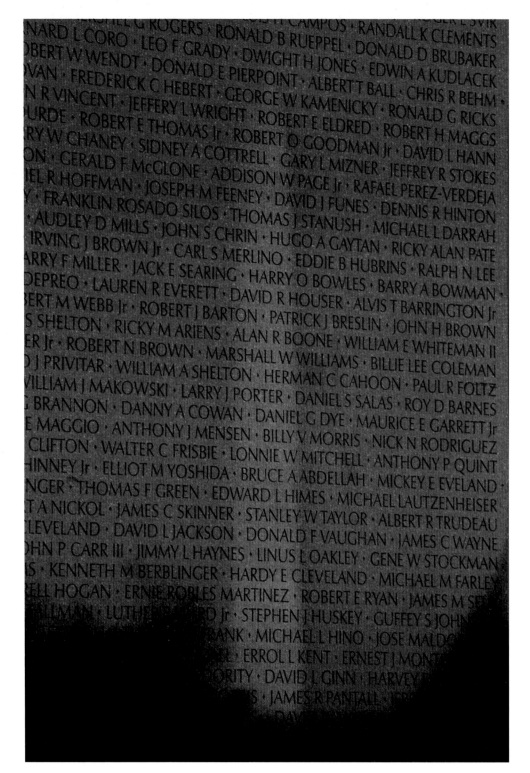

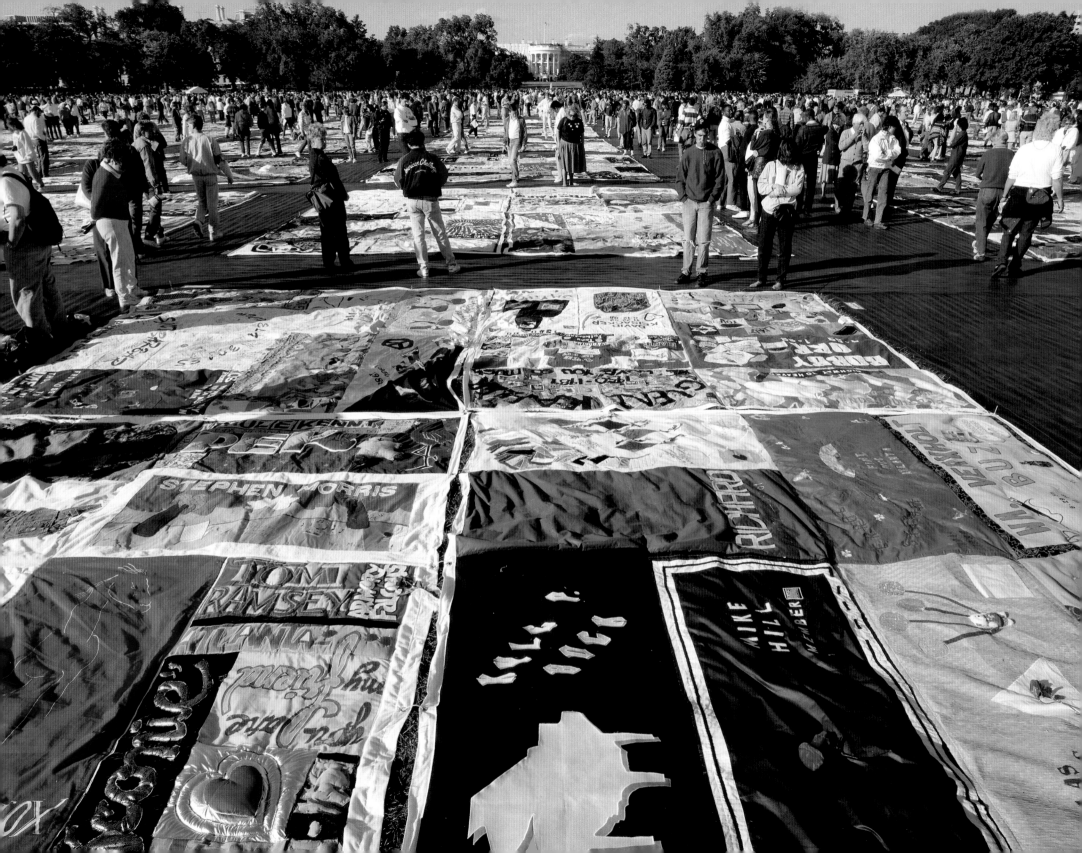

WAR AND REMEMBRANCE

Many places that memorialize those who served this country in war have taken on a hallowed, iconic significance. One such place is the cemetery at Antietam, Maryland, where Union and Confederate soldiers clashed in the bloodiest single day of fighting for American soldiers. On Memorial Day, each headstone is reverentially decorated with a small American flag (145; see also Antietam in winter, 155). Arriving in the middle of a formal ceremony, I observed a cluster of veterans standing solemnly at attention. As soon as the ceremony ended I approached one of them and simply said: "Would you mind standing over there and looking in that direction for a picture." He nodded, moved a few steps into position, and struck a bearing that said to me he might well have been thinking about World War II comrades, nearly a half-century before, who did not come back from overseas. Sensing that he wanted to return to his group, I shot quickly. I expect he had some amazing stories to tell, but circumstances don't always allow the photographer and his subject to get acquainted. I didn't even get his name. I really hope that he sees this photograph, and that he likes it (149).

Not that many miles from Antietam, Maryland, but, significantly, north of the Mason-Dixon Line boundary that divided the North from the "border state" of Maryland, lies Gettysburg, Pennsylvania, the site of the most famous battle of the Civil War. That three-day maelstrom, considered the turning point of the war, included "Pickett's Charge," the ill-fated attack of disciplined southern soldiers into a suicidal barrage of withering enemy fire, near the spot where this photograph was taken (146). My most lasting impression of Gettysburg was looking out on the field of battle before sunrise, with no one around to distract me, and listening to a cassette tape about the battle that included sound effects. Onto my shot of the battlefield, I've overlaid the text of the most famous speech in American history, the "Gettysburg Address," in which President Lincoln commemorated the battle with brief but inspired and healing words.

Periodically, reenactments are held at sites of famous Civil War battles, such as Manassas, Virginia. You cannot help but be struck by the passionate authenticity of the participants. Could anyone appear more genuine than this gentleman, who one could swear actually fought on the Confederate side in that battle and was magically transported to the present? (147). When that fellow sleeps, I wonder what century he dreams about.

When I travel down South these days, I don't see as many Confederate flags as I did some years ago—it is a deeply offensive symbol of slavery to many and its banishment is a *cause celebre* for some. To others it is an honorable symbol of states' rights and regional pride. While it may be politically incorrect to include a photograph of it here—taken in a tiny museum in Cannonsburg, Tennessee—I think it still qualifies as an American icon. To accompany this flag, I've included a picture of the large granite cliff at Stone Mountain, Georgia into which are carved the likenesses of three noted leaders of the Confederacy—Jefferson Davis, Robert E. Lee and Stonewall Jackson. I suggest you view the cliff during the day and then leave; every evening, that cliff face serves as a backdrop for a jarringly incongruous form of music video that doesn't even mention the Civil War.

Dramatically situated overlooking our nation's capital on a hill across the Potomac River in Virginia stands the large bronze representation of the Marines raising the American flag on Mount Suribachi after capturing the Pacific Island of Iwo Jima from the Japanese in 1945. I have photographed this imposing monument (which was itself based on a famous photo) at many different times. Once, I serendipitously came upon a company of Marines rehearsing their drills at sunrise in front of the memorial (148). [Note: It was

also near that spot, but from an elevated position, that I took the photograph of fireworks over Washington, D.C. found at p. 177.]

Just a very short walk from the Iwo Jima Memorial is the vast Arlington Cemetery, where soldiers and statesman, famous and anonymous alike, are buried. Arlington is best known as the site of President John F. Kennedy's grave (151), which is marked by an eternal flame, and as the home of the Tomb of the Unknowns (or Tomb of the Unknown Soldier), which remains perpetually guarded in a highly ritualistic manner (the sentry would never avert his glance to notice the roses thrown by observers.) As affecting as those two memorials are, I find even more heart-rending the row after row after row of identical headstones of soldiers who served their country (150).

The Vietnam Memorial, commonly known as "the Wall," sits on "The Mall" in Washington, D.C., a short distance from the Lincoln Memorial. The names of each of the 58,220 soldiers who did not return from that highly controversial conflict are engraved onto a V-shaped wall of polished granite, which one can reach out and touch. The intense emotional interaction between the Wall and its visitors (and mourners) makes this the only place I have been where the presence of other people becomes an integral part of, rather than a distraction from, the intensity of my own experience. For my photograph, I found a spot where the Washington Monument, a half-mile to the east, is reflected in the Wall (152). The names of several men who died in the Vietnam War can also be found on p. 172; if you look carefully at the plaque, you can see the names of soldiers from the small town of Bedford, New York who have fallen in five wars dating all the way back to the American Revolution.

A remembrance of a very different sort is the Aids Quilt—40,000 panels with more than 70,000 names—commemorating those who fought and died in quite another kind of battle. I photographed the quilt when it was laid out on "The Ellipse," just south of the White House, which can be seen in the background (153). Standing on the

quilt, which everyone does ever-so quietly and gently, creates an emotional connection to the departed, like physically touching the names on the Vietnam Wall. That quilt, like the other places of remembrance in this chapter, creates opportunities to ponder one's own mortality and to give thanks—for the efforts and sacrifices of those who preceded us and for the gift of life itself.

SYMBOLS OF FREEDOM

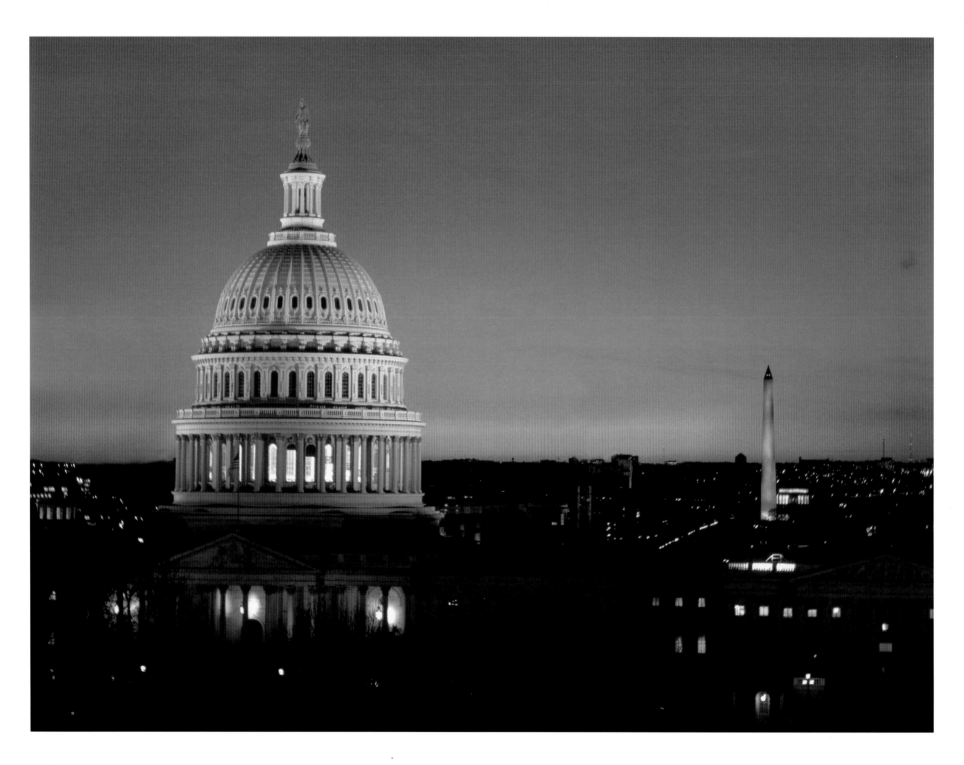

158 Capitol, Washington, D.C.

If there is any principle of the constitution that more imperatively calls for attachment than any other it is the principle of free thought—not free thought for those who agree with us but freedom for the thought that we hate.

Oliver Wendell Holmes, Jr.

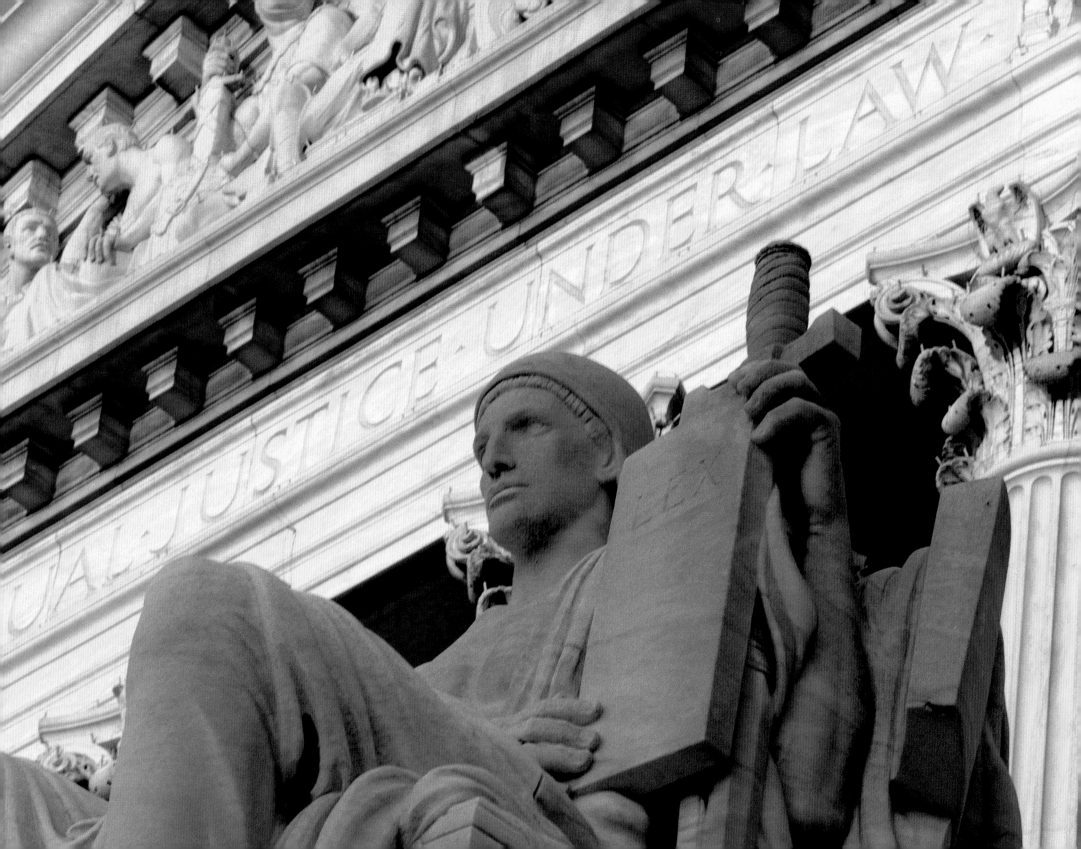

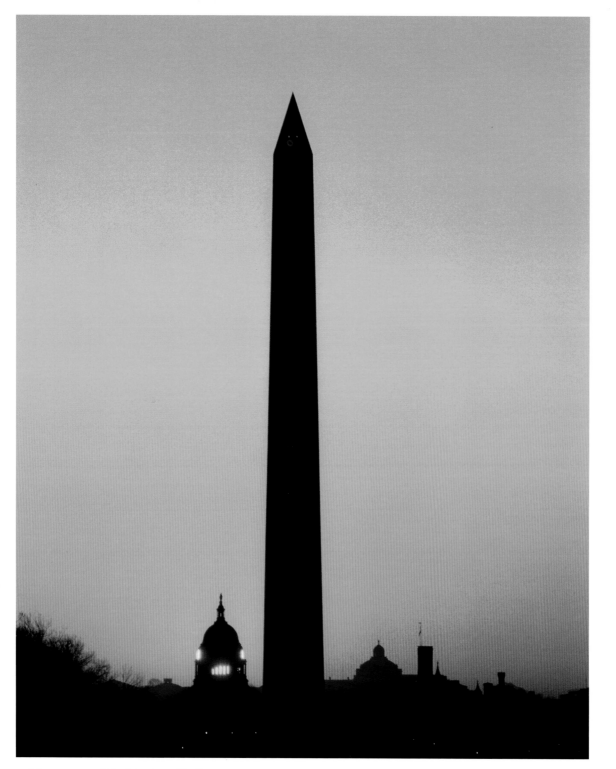

Washington was incapable of fear, meeting personal dangers with the calmest unconcern. Perhaps the strongest feature in his character was prudence, never acting until every circumstance, every consideration was maturely weighed....His integrity was most pure, his justice the most inflexible I have ever known....He was indeed, in every sense of the words, a wise, a good, and a great man.

Thomas Jefferson, 1814

162 Washington Monument, Washington, D.C.

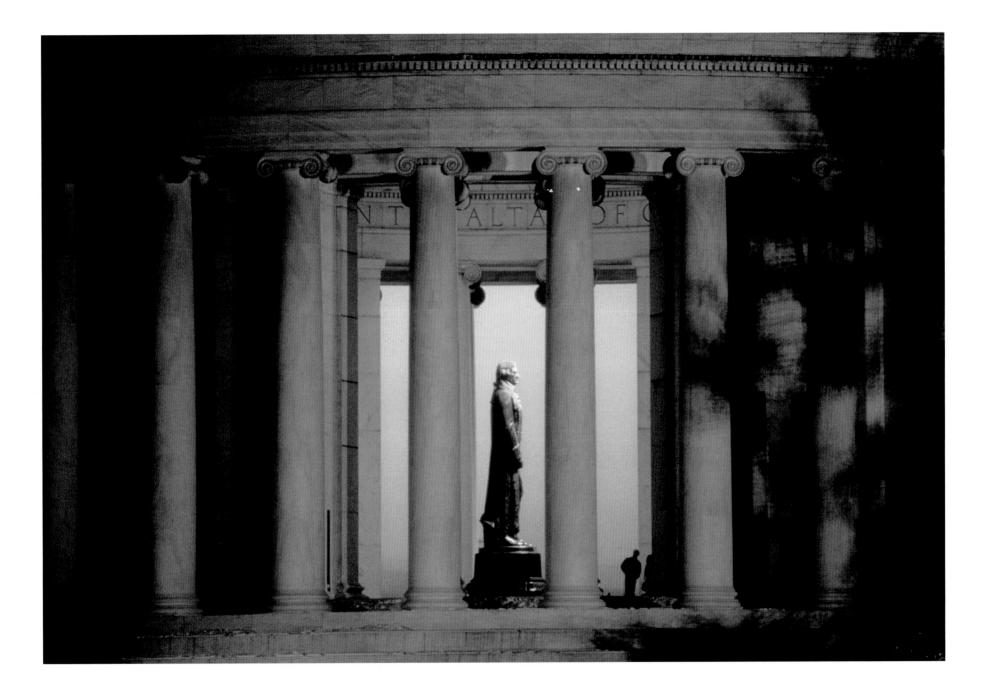

Jefferson Memorial, Washington, D.C. 163

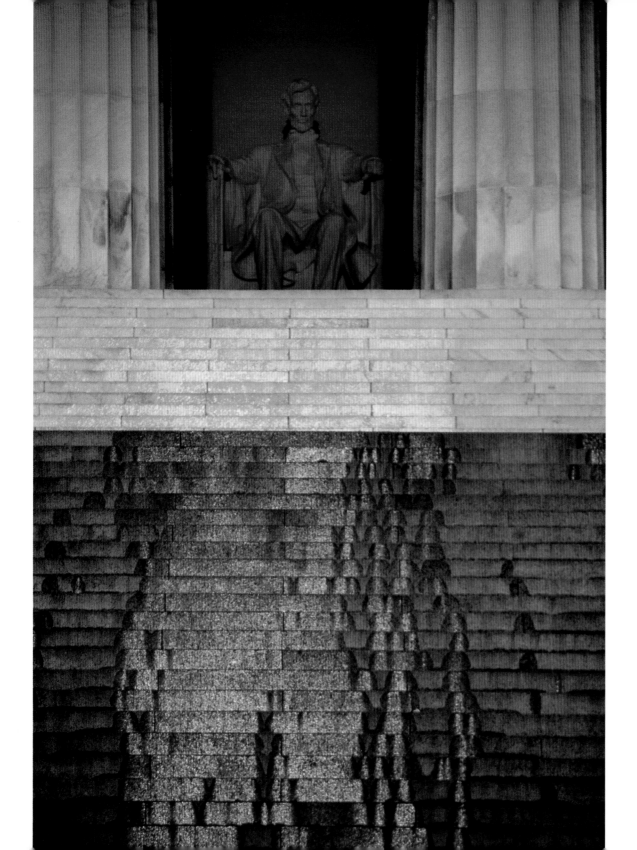

With malice toward none, with charity for all, with firmness in the right as God gives us to see the right, let us strive on to finish the work we are in, to bind up the nation's wounds, to care for him who shall have borne the battle and for his widow and his orphan, to do all which may achieve and cherish a just and a lasting peace among ourselves and with all nations.

Abraham Lincoln
Second Inaugural Address, 1865

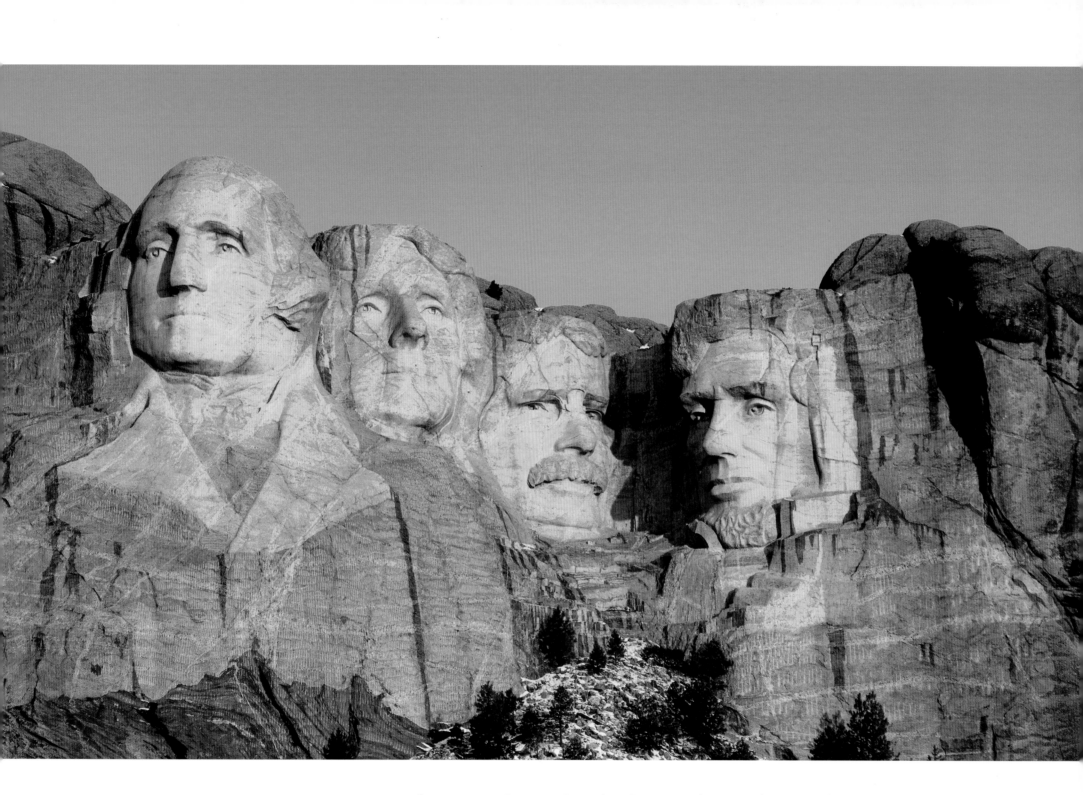

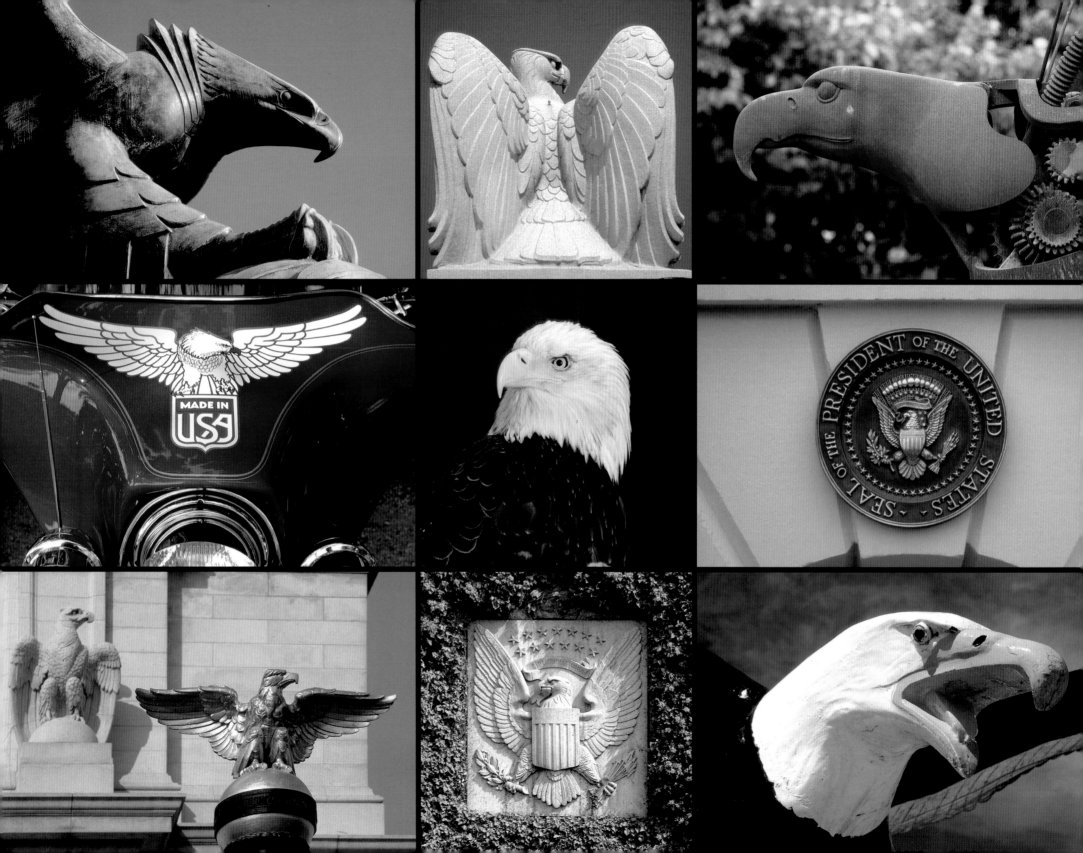

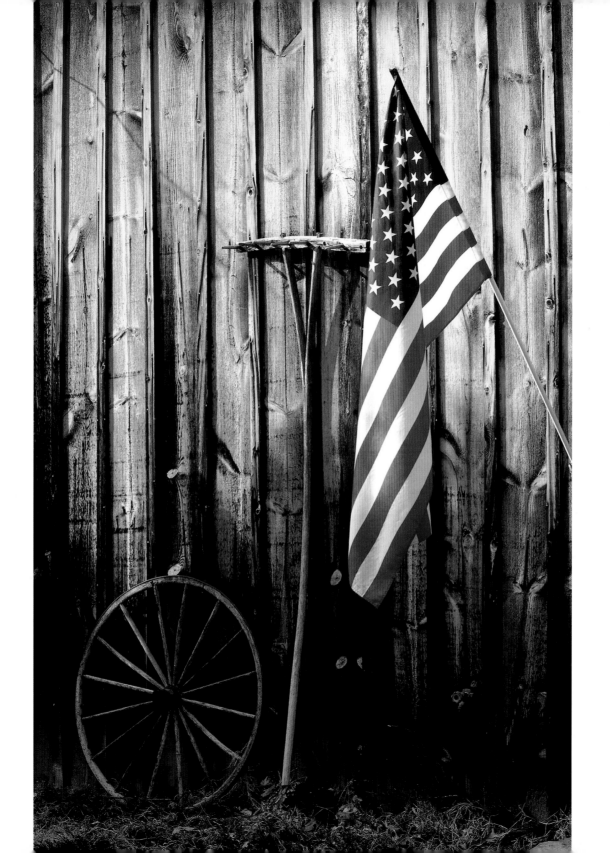

New Market, Maryland 167

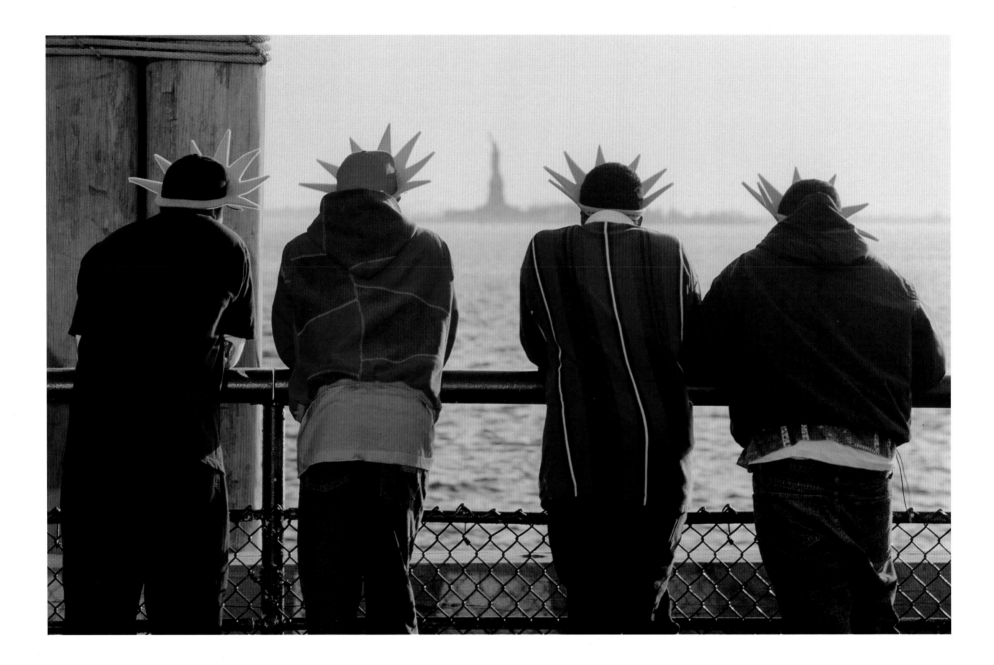

168 Statue of Liberty, New York City

First I come to tell you that I am well and in good health. Secondly, I am telling you that my sun is beginning to shine in America. Thirdly, I come to tell you, white bread and meat I eat every day, just like millionaires. Fourthly, my dear children, I have for myself a separate room, with a closed door, and before anyone can come to me, he must knock, and I can say, "Come in," or "Stay out," like a king in a palace. Lastly, my darling family and people of the village of Sukovoly, there is no czar in America.

Anaia Yezierska, *How I Found America*, 1920

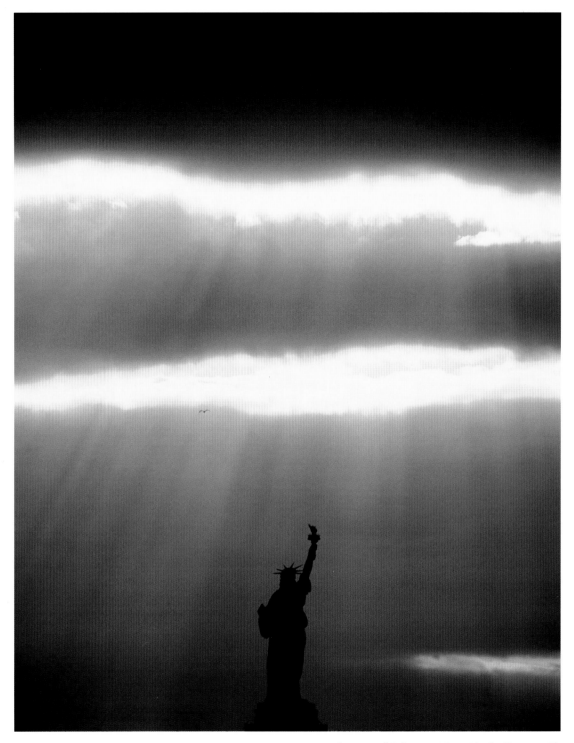

SYMBOLS OF FREEDOM

Freedom is our nation's most cherished value, and its symbols are many and varied—symbols of government, of great leaders and of our nation as an entity. This chapter's opening collage includes four symbols of our country's founding over two hundred years ago: Philadelphia's Independence Hall, where our Constitution was drafted; the Declaration of Independence of July 4, 1776, which declared our intention to break free of English colonial rule; the Constitution ("We the People…"), which established our structure of government and guaranteed our individual liberties; and the Liberty Bell, which rang out in Philadelphia when the Declaration was signed and is best remembered for its prominent crack.

Our most prominent contemporary symbols of government are the buildings housing the legislative, executive and judicial branches: the U.S. Capitol, the White House, and the Supreme Court (158,159,160&161). I see these buildings not just as symbols but as living, breathing, often contentiously howling, institutions because during the years when I was a lawyer in the 1970s and 80s I was involved with each. I attended meetings in the Roosevelt Room of the White House (and even played tennis on the White House court); I worked with Senate and House of Representatives staff in the Capitol and gave testimony several times before congressional committees; and I worked extensively on a case that was decided by the Supreme Court and sat at counsel's table (silently) during oral argument. If you'll permit me this personal note: the political-legal world that operated behind these august exteriors was fascinating and often well-motivated, but frequently too harsh, cynical, and abjectly partisan for my sensibilities. (Even the American flag—your flag and my flag, a symbol of our national unity—has been shamelessly exploited for political gain by both parties.) You could reasonably conclude that I changed careers because photographing these buildings suited my temperament more than working inside them. Now, off the soapbox and back to the photos.

In our over two hundred years as a nation, three political leaders have stood out as particularly strong beacons of freedom and we commemorate each in imposing memorials (or monuments…I'm not sure what the distinction is). Three are located in our capital city.

The majestically simple Washington Monument (162) I photographed from the steps of the Lincoln Memorial on one of the two days a year when the sun rises directly behind the Capitol dome far off in the background. (The book cover image was taken on the same day of the month, different year.) [Note: The series of American flags seen on pp. 2 & 3 are those that surround the base of the Washington Monument.] My shot of the Jefferson Memorial (164) called for standing on a ladder right in the middle of a busy road at sunset. The only day I was able to do this was on a Superbowl Sunday when the local team, the Washington Redskins, happened to be playing and the city's entire population was either at the game or glued to their television sets. The third great memorial in our nation's capital is the Lincoln, which I shot on one of those days when the sun was coming up from behind the Capitol. The warm orange color of the sunrise at my back hit Lincoln's statue directly and glistened off water that was being used to wash the marble and granite steps (163).

All three of these presidents—Washington, Jefferson and Lincoln, along with confrere Theodore Roosevelt—are also commemorated half-way across the country, in the noble sculpture at Mount Rushmore in the Black Hills of South Dakota (165). (Roosevelt is set back from the others because of a fracture that was discovered in the rock, not to express an inferior position.) One must view Mount Rushmore from so far away that even those twenty-foot noses don't seem particularly big. Dare I suggest that if you want a real sense of nose size you would do better to see the closing sequence of Alfred Hitchcock's movie *North by Northwest*?

Our proverbially wise founding father, Ben Franklin, famously suggested that the bald eagle was too aggressive a creature to serve as our national bird. While his point may have been well taken, if his proposed alternative—the turkey—had been selected instead, I doubt I would have been inspired to create a collage of turkey images. The circumstance under which I photographed the eagle likeness on the presidential seal especially stands out; it was on the South Lawn of the White House, during the historic meeting between President Reagan and the Soviet Union's President Gorbachev (166).

I can think of no more profound symbol of freedom than the Statue of Liberty, which is why my photos of her bring this final chapter to a close. My first picture was taken from lower Manhattan, with teenagers pondering the statue off in the distance (168). The second was taken from Liberty Park in New Jersey in dramatic morning light (169). On this page is a photo of the building on Ellis Island in New York Harbor, near the statue, which served as the famous entry point for millions of immigrants of previous generations.

Because we Americans have, from our earliest beginnings, been given the incomparable blessing of freedom as a birthright, it is so very difficult not to take it largely for granted. I know I do. (Perhaps we should have a national holiday in which we are *denied* our customary freedoms.) This is why I closed this chapter with a quote from an immigrant to remind myself and all of us how lucky we are: Yes, Anaia, "There is no czar in America."

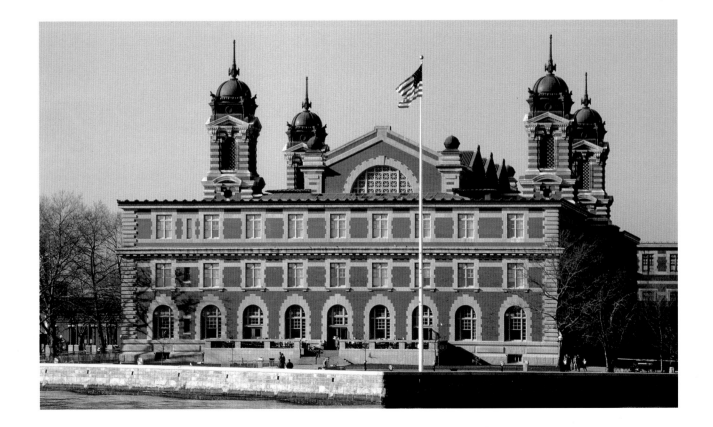

Credits: **17.** Bill Bryson, *The Lost Continent: Travels in Small Town America,* p.39 (Harper Perennial, ©1989); **22.** John Adams, Letter to Abigail Adams, July 3, 1776; **24.** Sam Ervin, *Humor Of A Country Lawyer*; **25.** Paige Rense, *Designers' Own Homes*, Foreword, 1984; **34.** Alexis De Tocqueville, *Democracy In America*, 1835; **36.** G.E. Kidder Smith, *Architecture In America, p.426 (American Heritage Pub. Co., 1976);* **37.** Eero Saarinen, *Architect Of The St. Louis Arch, (Yale University-New Haven And London, 1962);* **38.** John Roebling , Proposal For the Brooklyn Bridge, 1867, from *The Great Bridge,* (McCullough, 1972); **39.** Knopf Guides*: San Francisco*, p.242; **40.** Phil Patten, *Made In USA*, p.136 (Grove Weidenfeld, 1992); **47.** Robert Pirsig, *Zen and the Art* of *Motorcycle Maintenance*; **50.** Bern Keating, *The Mighty Mississippi*, p14 (National Geographic Society, 1974); **51.** Knopf Guides: *San Francisco*, p.68; **52.** Douglas Root, Fodor's Guide*: Pennsylvania,* p.112; **53.** Bobby Troup, Route 66 (1946, Londontown Music, Inc./MPL Communications, Inc.); **63.** Bill Bryson, *The Lost Continent,* p.237 (Harper Perennial, 1989); **64.** John Steinbeck, *Travels With Charley,* (Franklin Watts,1965); **65.** Anonymous, *New York World,* 1894 quoted in *Death Valley Lore: Classic Tales Of Fantasy, Love, and Mystery (University Of Nevada Press, 1988);* **66.** John Muir, *Our National Parks;* **68.** Jody Alesandro, *The New York Times*, September 29, 1996, p.17); **81.** Gerald Kreyche, *Visions Of The American West* (1989); **82.** Luther Standing Bear, *Land Of The Spotted Eagle* (1933); **87.** Bill Bryson, *The Last Continent*, p.214 (Harper Perennial, 1989); **92.** Nielsen's Facts, *World Almanac And Book Of Facts 2000*; **99.** Frank Deford, *There She Is: The Life And Times Of Miss America* (quoted in The New York Times, Sept.12, 1993); **106.** W.P. Kinsella, Preface, *Diamonds Forever,* (HarperCollins, 1997); **108.** Daniel J. Boorstin, The New York Times, Feb. 19, 1978; **111.** Glenn Liebman, *Michael Jordon Basketball Shorts* (Contemporary Books, 1995); **117.** The Beach Boys, *Surfin (Guild Music Company BMI);* **123.** Humphrey Bogart, quoted in *Diamonds Forever* (HarperCollins, 1997); **131.** Norman Rockwell, quoted in Washington Post, May, 1972; **137.** Carl Sandberg, *Abraham Lincoln: The Prairie Years,* p. 23 (1929); **139.** Margaret Mitchell, *Gone With The Wind, (*The MacMillan Company, 1936); **149.** Adlai E. Stevenson, Speech to American Legion Convention, August, 1952; **161.** Oliver Wendell Holmes, Jr., Supreme Court opinion, *U.S. vs. Schwimmer,* 1928; **162.** Thomas Jefferson, Letter to Walter Jones, Jan. 2, 1814; **169.** Anaia Yezierska, "How I Found America," Century Magazine, Nov., 1920, from *American Sketchbook* p. 196 (MacMillan, 1938).

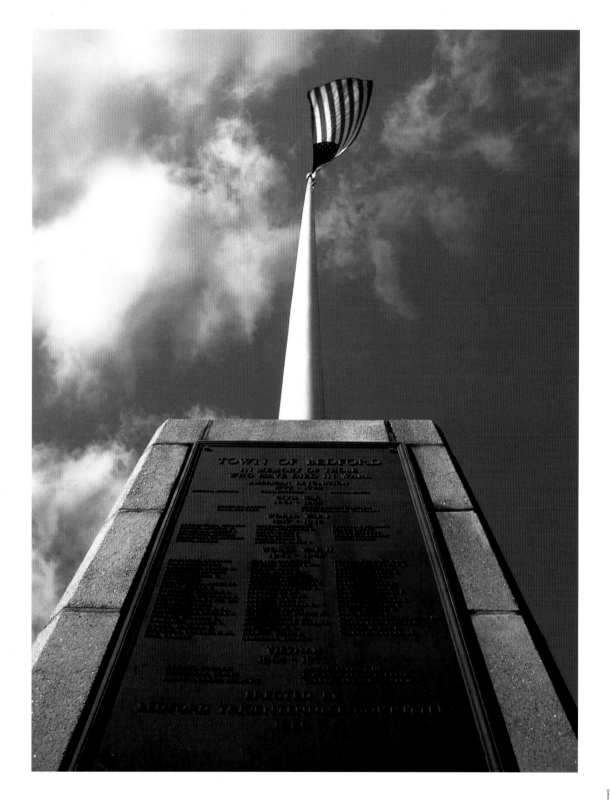

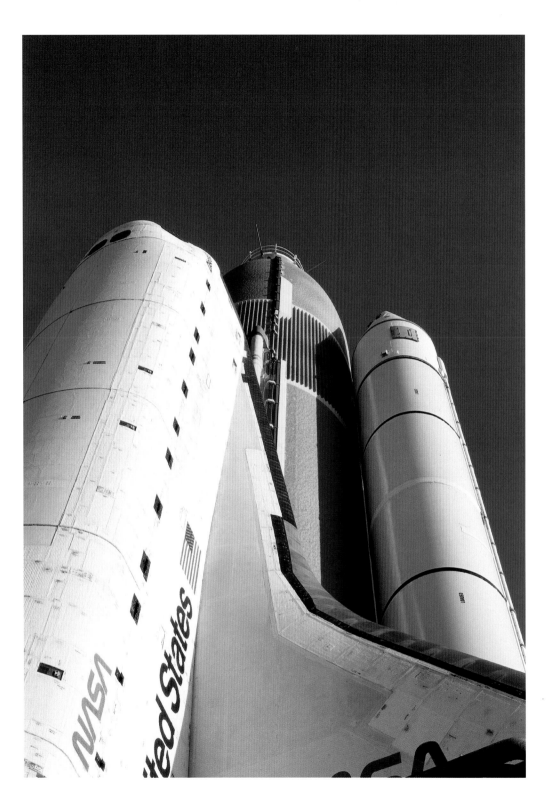

174 Cape Canaveral, Florida.

TECHNICAL NOTES

What most concerns me is the content of pictures, not the equipment used in making them nor the techniques employed, which is all second nature to me. Nevertheless, for those readers who are curious photography buffs, I offer these few words of technical information.

For this book, I used the same equipment as for my commercial work. The majority of the photographs were taken with the brilliantly designed, solidly reliable Nikon cameras, with lenses ranging from 14mm to 500mm. (The 80-200 f2.8 zoom is my favorite for the degree to which it visually compresses distances between objects and facilitates tight cropping.) I tend to keep color film in two bodies, black and white in a third, while my fourth has a specialized Polaroid back attachment which enables me to check the effect of flash before shooting film. I also use the Mamiya 645, a lightweight, easy-to-handle medium format (2 1/4) camera, with lenses ranging from the 24mm fisheye to 300mm. On occasion I call upon an unusual Cambo view camera, which uses a 2 1/4 roll film back instead of the customary 4 x 5 sheet film. Several of the panoramic shots in the book were taken with the Widelux camera, which has a moving lens that covers 140 degrees.

Most of the photographs in this book were taken under natural light, but nature often needs a helping hand, particularly when one lacks the time to remain in one location for just the right atmospherics to develop. To supplement daylight, I regularly use Nikon and Sunpak portable flash units, often several at a time. When I need a large amount of artificial light, I rely on the rugged Dynalight power packs and heads. I commonly filter my flash to give compatible, or occasionally contrasting, color balance to a scene. I also use filters on my lenses with some regularity, particularly for polarizing, warming, and color balancing fluorescent and other artificial light sources. Reflectors—silver, white and gold—are handy for kicking light into selected places.

I have relied on Kodak film exclusively since the beginning of time. The specific film depends on the circumstances; over the years probably fifteen or more different varieties of Kodak film have wound through my cameras. My standby nowadays is Ektachrome 100SW which offers fine grain and vibrant colors with a slightly warmish cast. For black and white work, I use either Agfa's Scala film, a black and white transparency film, or shoot in color and later remove it (via "desaturation") in the computer.

The photographs were prepared for the printing press by scanning them onto CDs and then importing them into my Mac G4, where they were tweaked as needed. Color was occasionally adjusted and distractions, such as telephone lines, often removed. But with some obvious exceptions (e.g., p. 94) by and large what you see here is essentially what I saw on the processed film.

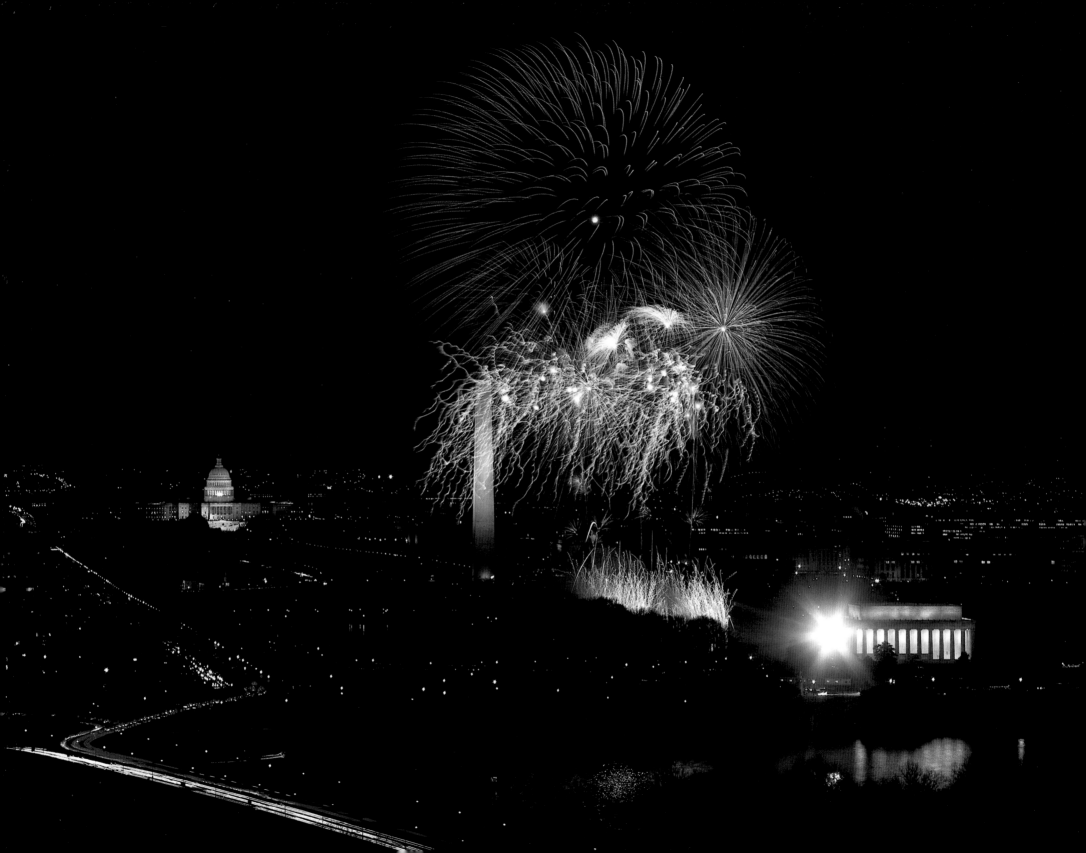

Steve Gottlieb has traveled through all fifty states photographing people, architecture and landscapes. His pictures have been published in hundreds of advertisements, annual reports and editorial stories worldwide, and he has received numerous awards in his field. Murals from his first book, *Washington: Portrait of a City*, are on permanent display in the National Building Museum in Washington, D.C. After graduating from Columbia College and Law School, he labored for ten years as a lawyer, at which point he turned a lifelong hobby of photography into a second career.